VICTORIAN PAINTING

VICTORIAN PAINTING
REVISED EDITION

GRAHAM REYNOLDS

THE HERBERT PRESS

Acknowledgments

All the pictures in this book are reproduced by kind
permission of their owners or, in the case of those
in public collections, of the trustees of the museum
or art gallery concerned. Those in the Victoria and
Albert Museum are Crown Copyright. The publishers
gratefully acknowledge the cooperation of
Anthony Barthorpe, who specially photographed
many of the paintings reproduced in this book.

© Graham Reynolds 1966, 1987
First published 1966
This revised edition first published 1987 by
The Herbert Press Limited, 46 Northchurch Road, London N1 4EJ
Designed by Gillian Greenwood
Jacket design by Pauline Harrison
Set in 12pt Bell, 2pt leaded
Revisions typeset by Merrion Letters, London
Printed and bound in Hong Kong by South China Printing Co.

British Library Cataloguing in Publication Data
Reynolds, Graham
 Victorian painting.—Rev. ed.
 1. Painting, British 2. Painting, Modern
 —19th century—Great Britain
 I. Title
 759.2 ND467
 ISBN 0–906969–72–7

Jacket front: *The Travelling Companions* by Augustus Leopold Egg
Jacket back: *No Walk To-day* by Sophie Anderson

Contents

Preface to the revised edition

Since this book was first published twenty-one years ago there has been a remarkable increase of interest in the painting of the Victorian Age. New collections have been formed, for instance by the Handley-Reads in England and by the Forbes Magazine and the McCormicks in the United States of America. Detailed studies of a number of the leading painters have been published, and exhibitions with informative catalogues have been devoted to individual artists, groups of artists and themes prominent in 19th century painting. The suggestions for further reading given on pp. 200–202 only list a selection from a much wider range which indicates how strongly the painting of this age has recaptured the imagination of our own.

In revising the text for this edition I have done my best to profit from these substantial and scholarly contributions to the study of Victorian painting. They have enabled me to clarify a number of points which are no longer obscure, to amend some errors, and to amplify the descriptions of certain plates. The main approach, which was intended to provide a general survey of the types of painting and shifts of style in a long and complex period, and the choice of illustrations, remain unaltered.

GRAHAM REYNOLDS 1987

Preface to the first edition

Thirteen years ago I gave, in *Painters of the Victorian Scene*, an account of those paintings in which the artists had dealt with life in modern dress and the day-to-day scene. In this book I have attempted to take a wider view of the whole subject of Victorian painting, including in the survey a number of its branches which are at least as noteworthy as its contemporary genre: historical painting, the anecdotal illustration of literature, and the late nineteenth-century landscape painters.

The ebb and flow of the main currents of Victorian thought can be traced in the painting of the age. There is clearly a link in time as well as content between the historical novels produced by Harrison Ainsworth and Charles Reade in succession to Sir Walter Scott, and the historical paintings of E. M. Ward, J. C. Horsley and Augustus Egg. Paintings of modern life by W. P. Frith and J. J. Tissot show a concern with living people in their proper setting comparable to that in the novel of modern manners as practised by Trollope and Meredith. The impulse towards the reconstruction of the classical past was seen not only in the paintings of Leighton and Poynter, but also in Kingsley's *Hypatia* and Pater's *Marius the Epicurean*. But the major force in the shaping of Victorian art came from its own past. Although all termini must be artificial, it is not seriously misleading to date the origins of the British school of painting from the foundation of the Royal Academy in 1768. The earlier Victorians were removed by some three generations from this decisive act. What gives them, and their successors throughout the century, their special interest is the concentration with which they pursued the idea of a national school and the confidence they felt in the work of the growing number of British painters.

Though 'insular' is the first adjective to come to mind when our nineteenth-century art has to be characterized, that quality of insularity was a source of strength in Lewis no less than in Millais. It was also the quality which most attracted the attention of foreign critics, even if it did not always appeal to them. Somehow, in a remote island which—when not lashed by rain—was wrapped in dense fog, paintings which were wholly different were being produced; they reflected the wild romanticism of Scott, Keats and Shelley and had as idiosyncratic a flavour as the islanders' beer. When the barriers of this isolation broke down at the end of the century, Great Britain was on its way to losing its national school and becoming part of an international uniformity. Even when most pronounced, this isolation was not complete. Many of the painters discussed here were avid travellers; but when a relationship is found between British painting and that on the Continent, it frequently takes the

form of a belated response to ideas formulated and almost exhausted elsewhere. The neo-classicism of Leighton and Poynter, though paralleled in Germany by Feuerbach and von Marées, was the late flowering here of the influence of Ingres; the Pre-Raphaelites gave a new sharpness to the moribund ideals of the Nazarenes.

Whilst a few painters of this period stand out above the rest—among them Rossetti, Watts, Whistler—its full content cannot be understood from their work alone. The view of Victorian art as an indigenous, self-propagating, ingrowing and original species can only be gleaned from the total impact of a considerable number of artists, many minor in themselves but all contributing to the impression of homogeneity and individuality. It has been my purpose to build up such a picture by my choice of illustrations and to trace in the text the complex variety of cross-currents which vexed the artistic politics of the time, as well as the differences of intention perceptible beneath the level surface of achievement.

The student of this period need not be afraid of rapidly exhausting its possibilities for surprise. Even the major figures have hardly been distilled into definitive monographs; still less have all the complexities of approach endemic to the age been charted. It still provides the fascination of new discoveries. The initiative in seeking out the charm which can be found in such artists as Sophie Anderson, Alfred Elmore and Atkinson Grimshaw has been taken by a handful of dealers and private collectors who have followed their own taste, often in opposition to the pressure of fashion. It is accordingly far more than a matter of form that I should express my thanks, not only to the museums and art galleries who have allowed me to reproduce works from their permanent collections, but also to the private owners who have agreed to the illustration of paintings in their possession and made them available for study. Their names are given in detail in the Notes on the Plates; here I confine myself to this more general acknowledgement of their kindness.

The quotations on pp. 12-13 and 38 are taken from Professor W. B. Pope's standard edition of *The Diary of Benjamin Robert Haydon* (Harvard University Press, 5 vols. 1960-3). The translations from Baudelaire on p. 94 are taken from Jonathan Mayne's edition *Art in Paris 1845–1862* (Phaidon, 1965).

GRAHAM REYNOLDS 1966

1 · British painting in 1837

The year in which Queen Victoria came to the throne was, by coincidence, the year in which the Royal Academy moved from Somerset House to new quarters in one wing of the building in Trafalgar Square which is now wholly occupied by the National Gallery. The annual exhibition of 1837 had been opened by her uncle William IV in the last months of his life. But there was nothing about it or its immediate successors to suggest the wonderful upsurge of a new age. An orthodoxy established in the first decade of the nineteenth century was still apparent on its walls. In fact, the most prominent artists, those who set the tone of the new reign and who are still regarded as the archetypes of early Victorian painting, were those trained in and characteristic of the late Georgian age. To understand and enter into the developments which were to come, it is necessary, first of all, to consider the dominant figures of 1837, and the trends they represented.

Among the figure painters the foremost character was still David Wilkie, who had emerged around 1805 and imposed for virtually the whole century his own brand of *genre* picture, of provincial origin. Wilkie had recently gone through a period of self-doubt and recession, and in an endeavour to acquire a new impetus had changed his style. His attempt to emulate the golden tone of an Old Master covered by discoloured varnish led him to adopt the risky medium of bitumen, or asphaltum. A tar similar to that extracted from Egyptian mummies, this gives a glaze with a rich brown glow; but it never dries completely, and the damp sodden cracks caused by its use are the despair of present day restorers. Wilkie himself had to repaint some of the pictures he made with this medium; and the prestige his use gave to the substance has led to the complete ruin of much of his contemporaries' work.

This change in Wilkie's style helps to emphasize the periodic alternation between the generations who admire paintings light in colour and those who like an overall dark tone. The opposition between Constable and Sir George Beaumont, who was of an earlier generation, hinged on this temperamental divide. Certainly Wilkie felt drawn towards the dark and the tenebrous, and these characteristics were sufficiently widespread amongst his contemporaries for the Royal Academy's annual exhibitions in the 1830s to be noted for the general sombreness of their appearance. Colour and tone apart, Wilkie's work was frequently gauche in composition, reflecting the awkwardness which he himself displayed in daily life. But there is an unforced honesty about his observation of humble people summed up in one of the few *genre* paintings he made in the new reign, 'Grace before Meat'. Many British painters at this time went astray when they attempted to render the expressions on their

characters' faces; Maclise is a prominent example of complete incapacity in this regard. Wilkie, on the other hand, never fails to observe and render them without exaggeration and with a sympathy which communicates itself to the onlooker. He was a forerunner in a number of ways. The first British artist to visit Madrid, he was a precursor in Spain of David Roberts, J. F. Lewis and John Phillip. When he travelled to Palestine in 1840 in order to render Biblical scenes with Protestant realism he preceded Holman Hunt, Seddon and Edward Lear. Above all, the lead given by Wilkie in using the scenes of daily, simple life as the subject of his painting was followed by many of his contemporaries and was still powerful, in the Scottish hands of Pettie and Orchardson, at the end of the century. With this trend went a preference for treating subjects of child life. These became increasingly popular as the century advanced; to Thomas Webster at one end may be counterbalanced Fred Morgan with his 'Playmates' at the other. But to juxtapose these two names shows the difference in their approach. Webster was a genuine humorist, and while his view of children may be amused, even benign, it is not sentimental. Still less is that of Mulready, who, as a professed pugilist and the father of four sons, was aggressive and matter-of-fact.

Unlike Wilkie, Mulready painted in light colours, and in his later pictures did not use the dangerous pigment of bitumen to glaze his work and darken it down. An exceptionally evocative example of his most mature manner is his 'Train up a Child' which he showed at the Royal Academy in 1841. All the ingredients of his vision are present here, and in a form heightened by the mysteriousness of the content. A small boy is being urged by his mother and nurse to give alms to three Lascar beggars. He is terrified by them and only with difficulty forces himself to do the task. This is the discipline which is the subject of the title. It was noted in Mulready's own day that the dogs in his pictures reflect the status of their owners and the action at which they are present. The dog in this case is himself rather uncertain of the beggars, but loyally standing by his master; he is of good breed as befits the gentility of the left-hand group. The meticulous care with which Mulready has rendered the construction of the rocks and the foliage of the trees in the grove is an illustration of his slow, deliberate methods of working. It was this feature, with his naturalism in colour, which led to his identification by some critics as a forerunner of the Pre-Raphaelites. Certainly this closeness of detailed observation adds to the hallucinatory quality of the scene; it is as though he were anticipating the mysterious arrival of the Indian jugglers described so evocatively by Wilkie Collins in the opening chapters of *The Moonstone*.

Hovering in the wings of the early Victorian art world was the grandiose figure of Benjamin Robert Haydon. He greeted the age of Victoria hopefully as the possible dawn of a new era for his own lamentable fortunes, and applied for the post of her historical painter. But he was soon to be disappointed. Before the end of the accession year he was writing with bitter irony in his diary: 'Yesterday Her Majesty sat to Sir David Wilkie for her state Portrait. Today her Majesty sat to Mr. Hayter. On Friday Her Majesty sat to Pistrucci. On Saturday Her Majesty knighted Mr. Newton, Miniature Painter. On Sunday her Majesty went to Church with Sir Augustus Calcott, the Land-

scape Painter. On Monday Her Majesty sat to Mr Tomkins, the Black Chalk drawer. On Tuesday Her Majesty sat to Jenkins, the lead pencil outline designer. On Wednesday Her Majesty knighted Smith, Tomkins, & Jenkins.' It is difficult to keep a balance between Haydon's vocal, highly entertaining and frequently just, commentary on the passing art scene and the poverty, the execrable quality of his own work. There was an almost complete divorce between his pretensions and his achievements, and the interest of his work, such as it was, declined still further in the last years of his life.

But Haydon did stand for the survival of a class of painting—heroic, or history painting, the rendering of classical scenes in the grand manner. In a sense he was attempting to reanimate a corpse, and the feebleness of his own efforts did not help the cause he had at heart. None the less his advocacy of decorations for the new Houses of Parliament led to the diversion and waste of a good deal of Victorian talent in profitless cartoons and fading frescoes.

The least unsuccessful of the other protagonists of the heroic style was David Scott. While Haydon stayed at home and fulminated, Scott travelled in Italy with a discerning eye and put into his historic pictures an element comparable with, though more provincial than, the current French experiments along similar lines.

If David Scott was the most serious of the history painters, William Etty was the most gifted in the purely technical sense, as well as possessing more agreeable ideas on subject matter. Profound his conceptions were not, but he had a genuine sensuality, that sense of *têtons* and *fesses* commended by Renoir, which communicates a pseudo-Venetian warmth to his constellations of naked women. Countless stories are told of his obsession with the subject of the nude. He once sent a model to Constable with the note: 'All in front memorably fine'. He is the first genuinely haunted painter we have yet met, in an age which produced its fair share of exotics and outsiders. His enthusiasm is infectious and there is an immediate appeal about his studies, reinforced as they are by a genuine aptitude and a carefully planned study of the Venetian painters. His historical compositions are really excuses for combining as many of these luscious and sensually presented forms in one frame as the subject allows, and their success is generally in inverse proportion to their coherence as *machines*.

Rather apart from the work of these figure painters, more allied to the field of *genre*, were the subject paintings of C. R. Leslie. He had caught from his personal sympathy with Constable, which he shows so emphatically in his biography, that looseness and breadth of brushwork which, allied to a rich sense of colour, gives his pictures their immediately perceptible style. In his subject matter he reflected his own acute interest in the theatre; but the paintings in which he embodied this are not just repetitions of stage sets or actors in character, as, for instance, are those of Clint; they are recreations of the scene in terms of his own imagination, illustrations in an interpretative sense. While the creation of dramatic character in action was certainly his *forte*, he did from time to time produce a relaxed and wholly charming piece of natural observation, as in his painting of the garden of his own house in Pine Apple Place, showing his son, G. D. Leslie (who grew up to be a member of the

St John's Wood School) playing with his toy horse and cart in the sunshine.

The use of situations from the classics of modern European literature was a device which links Leslie with Mulready. The favourite authors were Cervantes, Shakespeare, Goldsmith, Molière. The popularity of these illustrative paintings—especially scenes from *The Vicar of Wakefield*—is a characteristic of early nineteenth-century taste, and a transitional one. These embodiments of fiction well known to the general reading public—and the public in Britain was then, as now, far more versed in literature than art—formed an accessible and acceptable substitute for historical paintings, those epic scenes from Homer or Tacitus which Haydon, Hilton and Howard were endeavouring to continue. 'Curtius leaping into the gulf', a subject of heroic self-sacrifice from Livy attempted by Haydon, was not a familiar story to the new generation of merchants into whose hands patronage was passing. On the other hand, Dr Primrose choosing his wife as she did her wedding gown, not for a fine glossy surface but for such qualities as would wear well, a subject from Goldsmith painted by Mulready, was familiar; the artist was able to treat it successfully because both he and his buyer felt in sympathy with the theme. At the same time, these illustrations from novels of the recent past paved the way to those paintings of contemporary life which suddenly became endemic in the 1850s and form one of the chief features of high Victorian art.

There was no lack of contemporaneity in the subject matter of Edwin Landseer, another of the artists whose reputation was at its peak when Victoria succeeded to the throne. Even at this distance of time he is an artist whom it is difficult to estimate fairly. The sentiment he felt towards animals is probably no longer a barrier to appreciating him; though at times he displays a sort of sick relish in cruelty which is far removed from the impression of an artist solely concerned with agonizing over the 'Stag at Bay'. But this impression of ruthlessness seems to be misleading, for in 1837 he wrote to Lord Ellesmere about deer stalking:

> I quite agree with your Lordship, there are many people one could shoot with greater pleasure and greater justice. Still, with all my respect for the animal's inoffensive character, my love of him as a subject for the pencil gets the better of such tenderness.

There is a sense of incompleteness about many of his paintings, which stems not from the brilliance of his technique but from his too easy acceptance of his client's requirements. Of his precocity there can be no question, and his use of paint is in itself often a delight. He does not labour the surface of his panel or canvas, and a great deal of his work has the swiftness of a first impression. He particularly delights in the texture of an animal's coat; the wool of his sheep is rendered with fat brushstrokes of white paint, the hair of his dogs with drier, individually distinct strokes, which look as though they describe each hair but in fact give a convincing general impression. He maintains unity of tone by working over a darkish, often brown, ground and his response to colour, though subdued, is sensitive and agreeable. There is a story often told with variants in the copious memoirs of Victorian painters of how, declining one Sunday to go to church with his patron, William Wells of

Redleaf, he had completed a life-sized study of the head and shoulders of a fallow deer in the time his host was absent. In the presence of his oils this reputation for effortless facility is entirely credible.

The disappointments which can be caused by Landseer's later works are removed by the best of his paintings, such as 'The Naughty Child', 'The Eagle's Nest' and 'The Old Shepherd's Chief Mourner', all of which were bought by one of his greatest admirers, John Sheepshanks. This last work has gone through the heights and depths of appreciation. As well as touching an immediate response from the public when exhibited at the Royal Academy of 1837, it was later praised by Ruskin: 'one of the most perfect poems or pictures (I use the words as synonymous) which modern times have seen'. Then, in the early twentieth century, it fell to the same nadir of estimation as Luke Fildes's 'The Doctor'. It told a story, it was about the love of an animal for a human being, and it was emotional. It is now possible again to admire the picture for what it is, the expression of a genuine truth, fully in accord with the spartan Highland simplicity it records. The particular satisfaction it gives is derived from the admirable marriage of means and end: the dimly lit crofter's cottage, the tones of brown and grey adapted to the sentiment, the green boughs which speak of another, less involved mourner, the abandonment to grief of the sheep dog.

Landscape painting, which had played a dominant part in the English art of the last eighty years was beginning to decline from its eminence at the start of Victoria's reign. Constable died a few months before her accession, and left no immediate following. Turner, having squandered one reputation, had embarked on the course which was to gain him another through Ruskin's vindication of his later manner on the misleading ground of its truth to Nature. But the work he was doing in the last fifteen years of his life was not of a kind to appeal to his earlier public, and it has taken a century for its revolutionary nature to be fully understood. By proceeding along an entirely different line of development, mid-twentieth-century art, as an amalgam of expressionism and abstraction, has produced in the work of painters like de Stael and Rothko a harmonic way of using colour, comparable with such late Turner canvases as 'Norham Castle'.

Although none of his contemporaries was willing to make similar experiments, or trifle too far with their public reputation, there was a substantial degree of variety in the forms of landscape typical of this epoch. Romantic melodrama was expressed at its most extravagant in the vast sweep of John Martin's compositions. For theatrical effect such vast works as 'Belshazzar's Feast' and 'The Fall of Nineveh', have rarely been rivalled; they anticipate the effects of the epic film. Martin's strength lay in his understanding of the power of repetition in individual units to rouse the imagination and create an impression of overwhelming size. His weakness lies in his poor sense of colour, and coarse, blank brushwork; for this reason his quality is often better seen in his mezzotints than in the paintings themselves.

Francis Danby showed no such weakness in execution, although his colour is cold and dark. One of his pictures—one of his most important ones in his contemporaries' eyes—is a total wreck from the use of bitumen and presents a

black, undifferentiated mass to the present-day view. The loss is a regrettable one, for its subject, 'The Upas Tree', showing a legendary tree which exhaled poisonous air, was a recurrent, loaded Romantic symbol. Danby generally painted landscapes in which the theme was dictated by the human figures he placed in them, but in 'Liensford Lake' he has made a pure unpeopled landscape from the bleak and dangerous windswept rocks of the Norwegian coast.

William Collins's vision was of a more pedestrian nature. Constable, whom he had preceded as an RA and who detested him, considered him a painter of the suburbs rather than of real landscape. And indeed there is something neat, contrived and tidied up about his country scenes. Even so, a sympathetically seen detail like the little group of children pressed into the soil in 'Seaford' gives a greater sense of actuality to his picture than the unemphatic sky.

John Linnell was a more mannered but more genuine observer of Nature. Something of his early veneration for Blake seems to have seeped into his paintings of summer fields, and his response to the actual scene, the harvesting, the storm, is given individuality by the crisp, broken lights and his idiosyncratic manner. He is often reproached for his bad influence upon Samuel Palmer, but whatever may be the truth about Palmer's private life—he married Linnell's daughter—there is little evidence to show that Linnell influenced his painting for the worse. Although his religious views were uncompromisingly harsh, Linnell's feeling for landscape was healthy, even hedonistic. But the great afflatus which had enabled Palmer to produce the visionary paintings of the Shoreham period died out naturally, and the works of his middle period are similar in content and handling to Linnell's, but sometimes weaker in effect.

There are many other artists to be born in mind in assessing the landscape painting of the late 1830s. J. B. Pyne comes closest to being a follower of J. M. W. Turner, who had an admiration for his work. When the American art student Stillmann came to London in 1850 anxious to meet the leading landscape painters of the time, it was Pyne who most impressed him by the power of his mind and the fact that his art was a highly contrived one, worked out in the minutest detail. Something of the same care went into the artist's records of his own career, which are now preserved in the Victoria and Albert Museum; his attention to detail is shown by his giving a serial number to each one of his completed pictures.

As we pass from the older generation of watercolour painters in landscape we are conscious of a drop in the temperature of their originality. De Wint, Cox, Cotman, whose reputations all rose throughout the Victorian age, were all in their mid fifties when the Queen came to the throne, and were coming to the end of their careers. There was a trend towards reducing the difference between the effect of oils and of watercolours, encouraged by the rich chromatic effect sought by the watercolourists, by their large size and heavy gilt framing, and by the practice of hanging these watercolour 'paintings' by the side of oil paintings in exhibitions and private homes. Perhaps for this reason all three of these artists felt the desire to turn to oil painting in their later years. De Wint indeed had painted in oil since his youth, and it is one of the minor mysteries of English patronage that he was not able to sell these works, since the medium was well adapted to his plummy, romantic style. But

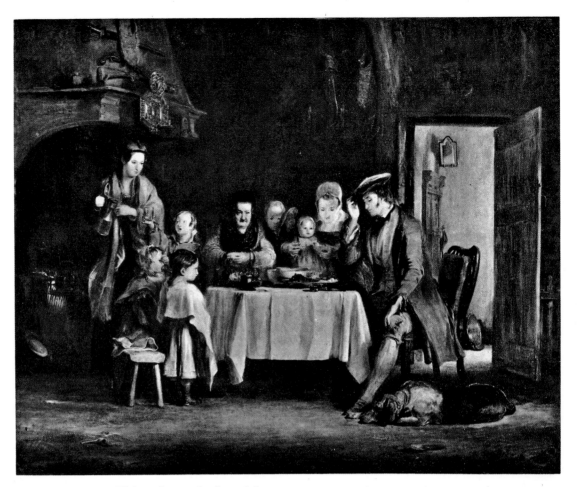

1 Sir David Wilkie: Grace before Meat

2 William Mulready: Train up a Child

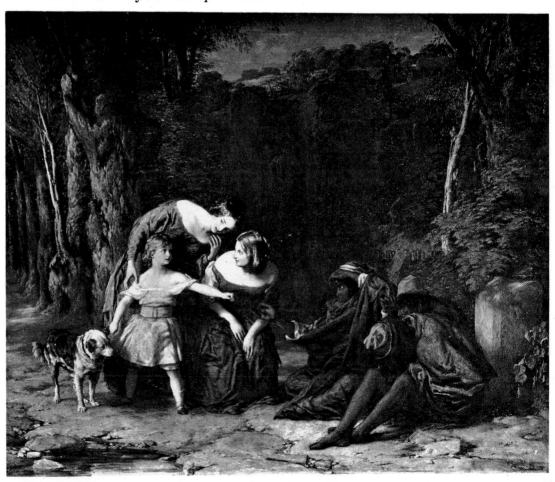

3 William Mulready: The Bathers

4 William Etty:
A Bivouac of Cupid and his Company

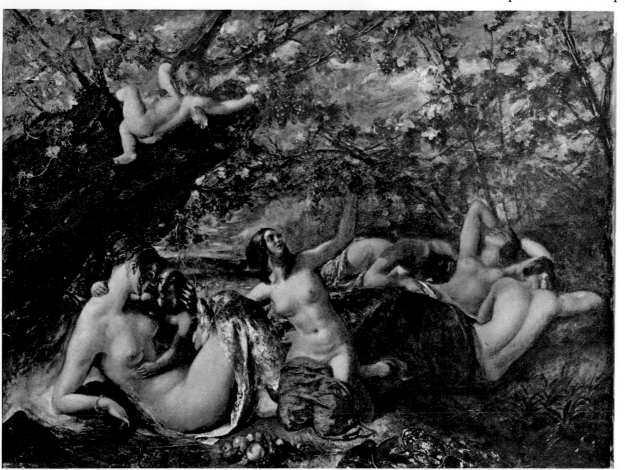

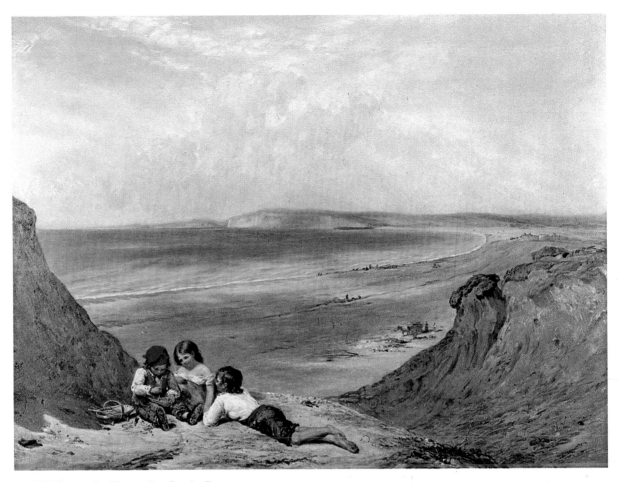

5 William Collins: Seaford, Sussex

6 Charles Robert Leslie: A Scene in the Artist's Garden

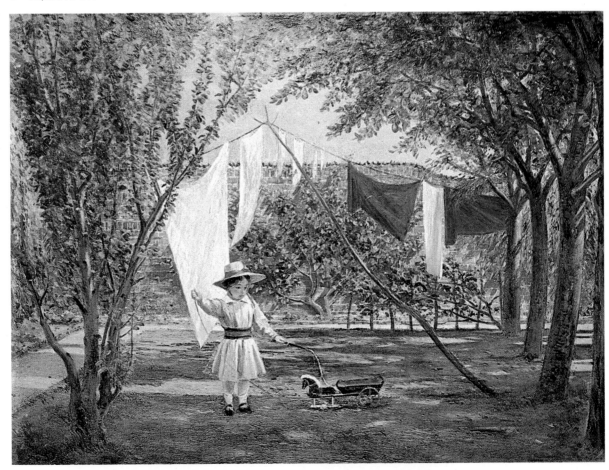

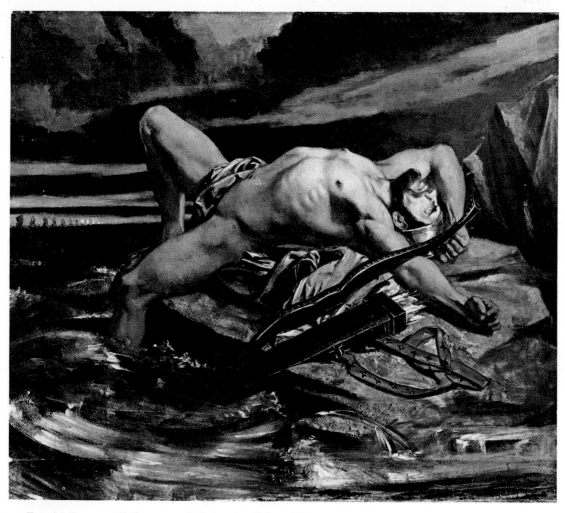

7 David Scott: Philoctetes left in the Isle of Lemnos

8 Sir Edwin Landseer: The Old Shepherd's Chief Mourner

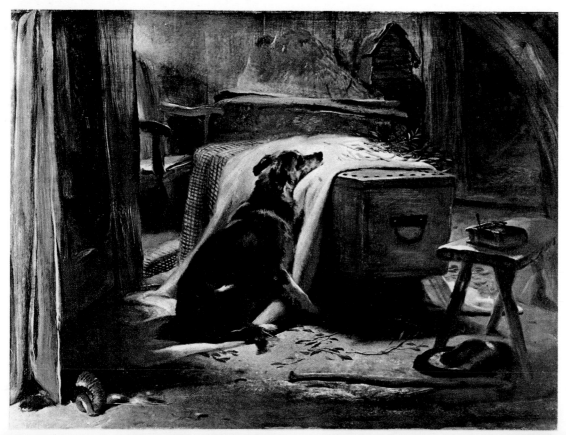

9 Francis Danby: Liensford Lake, Norway

10 John Martin: The Great Day of his Wrath

11 Joseph Mallord William Turner: Norham Castle, Sunrise

12 James Baker Pyne: Night Festa at Olivano

13 John Linnell: Wheat

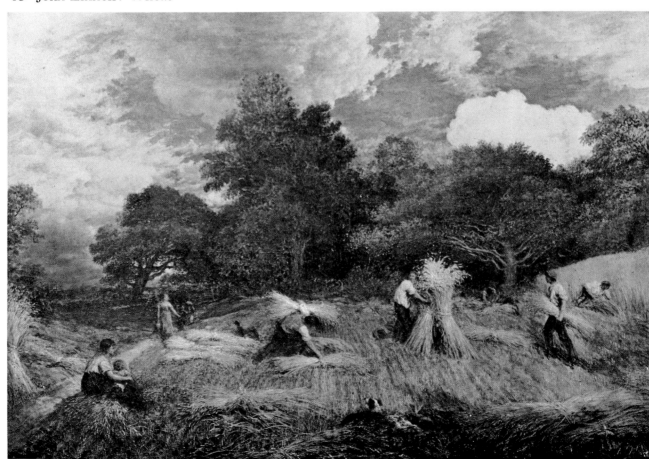

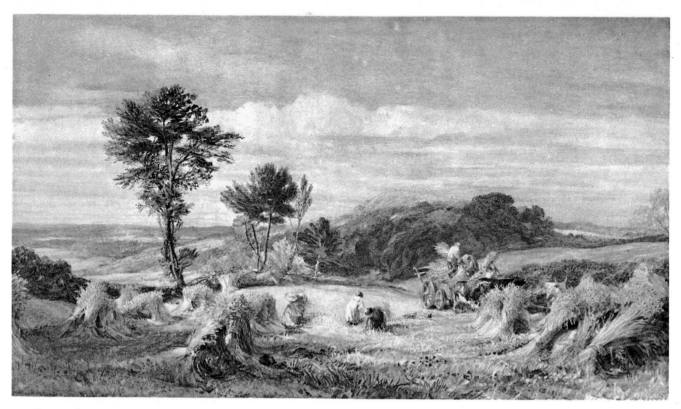

14 Samuel Palmer: Carting the Wheat

15 John Linnell: A Coming Storm

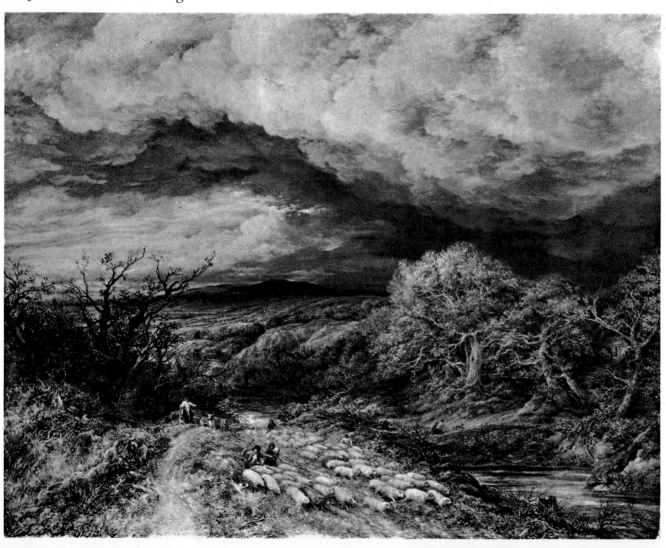

Cotman, who had experimented with pastes, showed more signs of originality at handling the technique of oil painting than Cox, whose tamer aspect it encouraged.

The heirs to the great tradition which these men transmitted were mainly exponents of the picturesque school epitomized by Prout and the followers of Bonington—that is, Boys, Callow, Holland. They catered for the taste of the travelled Englishman, who had seen the Continent and wanted a rendering of a crumbling corner of Augsburg, Innsbruck or Dieppe to hang in his home. Callow indeed produced this kind of watercolour, competent, even dashing at times but with little variation, for the entire length of Victoria's reign, dying at the age of ninety-six in 1908. He and Boys are exceptional in respecting the precise qualities of the watercolour medium: its transparency, luminosity and the ductility which gives it dash and unlaboured effect. This understanding is hardly seen in Prout, although the fact that Ruskin devoted a monograph to him shows that he occupied a central place in Victorian appreciation.

Notes on the plates 1 - 15

Measurements are in inches, height before width. Unless otherwise stated, the works reproduced are in oil on canvas.

1 Sir David Wilkie, RA (1785–1841)
 Grace before Meat
 $39\frac{3}{4}$ × 50 inches Signed and dated 1839
 City Museum and Art Gallery, Birmingham

When exhibited at the Royal Academy in 1839, the following verses by the Countess of Blessington were printed with the catalogue entry:

> A lowly cot where social board is spread,
> The simple owner seated at its head;
> His bonnet lifts and doth to Heaven appeal,
> To grant a blessing on the humble meal!

Wilkie showed this painting in the same year as his vast 'Sir David Baird discovering the Body of Tippo Sahib'; it is a variation of a group in the left background of 'The Penny Wedding'. 'Grace before Meat' was bought from the Royal Academy Exhibition by a New Orleans collector, Mr Glendy Burk.

2 William Mulready, RA (1786–1863)
 Train up a Child
 Panel, 25½ × 31 inches
 Collection of the Forbes Magazine, New York

Exhibited at the Royal Academy, 1841. The full title comes from the *Book of Proverbs*, chapter 22: 'Train up a child the way he should go; and when he is old he will not depart from it.' The painting was badly damaged by fire when in the possession of Thomas Baring, its first owner, when it was 'striped like tarnished silver in dark metallic looking strips, where the hot steam had run down it'. The artist, who would always rather repaint or extend an old picture than begin a new one, repaired it to its advantage; he considered it his finest achievement.

3 William Mulready, RA
 The Bathers
 Panel, 23½ × 17½ inches
 The National Gallery of Ireland, Dublin

One of Mulready's two known compositions of nude figures, this paraphrases in some details Michelangelo's 'Battle of Cascina'. It was painted c. 1852–3, and sent by the artist to the Exposition Universelle, Paris, 1855, where it was both praised and adversely criticized.

4 William Etty, RA (1787–1849)
 A Bivouac of Cupid and his Company
 26 × 36 inches
 Museum of Fine Arts, Montreal

Exhibited at the Royal Academy, 1838. Etty's first biographer, Alexander Gilchrist, describes the painting as a recreation of the Age of Gold peculiar to the artist: 'in this ideal world of his, groups of fair women, more or less indifferent to drapery, carelessly repose with really enviable composure, under the blue sky, on the green lawns, or in sylvan seclusion, beneath the high embowered roof of wide-stretching oaks'.

5 William Collins, RA (1787–1847)
 Seaford, Sussex
 27½ × 36½ inches Signed and dated 1844
 Victoria and Albert Museum, London

Exhibited at the Royal Academy in 1844. The painting is based on sketches made during a visit to Seaford in the Autumn of 1841.

6 Charles Robert Leslie, RA (1794–1859)
 A Scene in the Artist's Garden
 12 × 16 inches Painted in 1840
 Victoria and Albert Museum, London

The scene is in the garden of Leslie's house, 12 Pine Apple Place, near the Marble Arch end of the Edgware Road; the little boy playing with his toy horse and cart is the artist's son, G. D. Leslie, RA (1835–1921), who became a member of the St John's Wood Clique (see chapter 8).

7 David Scott (1806–1849)
 Philoctetes left in the Isle of Lemnos
 $39\frac{3}{4} \times 47$ inches
 The National Gallery of Scotland, Edinburgh

Exhibited in the Royal Scottish Academy, 1840.
Philoctetes, the greatest archer in the Greek Army, was abandoned on the way to Troy because the stench of his wound was intolerable. Ten years later he was collected by Ulysses and Diomedes in response to an oracle and took part in the Fall of Troy.

8 Sir Edwin Landseer, RA (1802–1873)
 The Old Shepherd's Chief Mourner
 Panel, 18 × 24 inches
 Victoria and Albert Museum, London

Exhibited at the Royal Academy, 1837. The Bible and spectacles, the cap and stick, the empty arm-chair in a sparse Highland bothie, evoke the austere life of the shepherd whose dog is his most sincere mourner.

9 Francis Danby, ARA (1793–1861)
 Liensford Lake, Norway
 $32\frac{1}{2} \times 46$ inches Signed
 Victoria and Albert Museum, London

Exhibited at the Royal Academy, 1841.
When shown in the Royal Academy, the catalogue entry contained the following explanatory note: 'A sudden storm, called a flanger, passing off—an effect which on their lonely lakes occurs nearly every day in autumn.'
Danby is known to have visited Norway in 1825.

10 John Martin (1789–1854)
 The Great Day of his Wrath
 $75\frac{1}{2} \times 118$ inches Signed and dated 1852
 The Tate Gallery, London

This is one of the three huge 'Judgment' pictures on which Martin was engaged in the last years of his life; the subjects of the other two are 'The Last Judgment' and 'The Plains of Heaven' (also in the Tate Gallery). It is based on extracts from the *Book of Revelations*, concerning the opening of the Sixth Seal. Danby had treated the same theme in 1826–28, in a work strongly influenced by Martin; here Martin chose, in Mr Balston's words, 'to plagiarize his plagiarist'.

11 Joseph Mallord William Turner, RA (1775–1851)
Norham Castle, Sunrise
36 × 48 inches Painted c. 1845–50
The Tate Gallery, London

Turner was occupied with this subject throughout his career. He first sketched it in 1797 and exhibited a watercolour of it in 1798 to which he added a quotation from Thomson's 'Summer':

But yonder comes the powerful King of Day
Rejoicing in the east. The lessening cloud,
The kindling azure, and the mountain's brow
Illumined . . . his near approach
Betoken glad.

In this latest version from the last years of his life he approaches more nearly to the colourful brilliance which Thomson describes in the sunrise.

12 James Baker Pyne (1800–1870)
Night Festa at Olivano
$25\frac{1}{2}$ × $35\frac{1}{2}$ inches Signed and dated 1854: opus number 357
Bethnal Green Museum, London (Dixon Bequest)

The artist recorded in his MS list in the Art Library, Victoria and Albert Museum, that he painted the picture in Rome for Mr Agnew during the winter of 1853–54.

13 John Linnell (1792–1882)
Wheat
$36\frac{1}{2}$ × $54\frac{1}{2}$ inches
National Gallery of Victoria, Melbourne

Exhibited at the Royal Academy, 1860. A note on the back identifies the scene as Red Stone Wood, Redhill, and the month of painting as April 1860. Linnell moved to Redhill, in Surrey, in 1852.

14 Samuel Palmer (1805–1881)
Carting the Wheat
Watercolour, 12 × 21 inches
National Gallery of Victoria, Melbourne

15 John Linnell
A Coming Storm
50 × 66 inches Signed and dated 1873
City Art Gallery, Glasgow

Exhibited at the Royal Academy, 1873.

2 · Rebellion and official patronage

These were the lines laid down at the start of Victoria's reign, and for the first ten or twelve years art proceeded on this path without any major revolution. There were however two episodes which gave diversity to the scene and encouraged newcomers: one an official commission, the other a youthful rebellion.

The rebellion must be described first, for it happened at the very beginning of the new reign. A group of young artists agreed in finding the Academy unsympathetic and old-fashioned, and resolved to work in concert to change it. Not only were they expressing the spirit of revolt against their fathers, which sweeps across every new generation; they were in accord with a more general spirit of criticism of the Academy which culminated in the appointment of a select committee to investigate its affairs. Such bands of rebels commonly choose a name; this group called itself 'The Clique', a name subsequently used again by the St John's Wood Group discussed in Chapter 8. The members of the original Clique were: Augustus Egg, born in 1816; Richard Dadd, John Phillip and H. N. O'Neil, all born in 1817; and W. P. Frith, born in 1819. Each of these men made an interesting and diverse contribution to the main body of Victorian painting. Indeed, however similar their original aims may have been, the full development of their careers produced results as widely different as those of the Pre-Raphaelite Brethren.

Writing some sixty years after the event a friend of this group has recalled their different ambitions: Egg wished to paint illustrations of famous literary works, Dadd works of imagination, Phillip incidents in the lives of famous persons, O'Neil incidents of striking character which appeal to the feelings, and Frith pictures of ordinary life such as would take with the public. There may be an element of hindsight in these recollections of the octogenarian John Imray, for they do to some extent reflect the careers of the five. But in so far as their work is remembered at all today, it is not for their earliest productions in the first years of Victoria's reign, but for what they accomplished in middle life. H. N. O'Neil, for example, is virtually known now only by the picture 'Eastward Ho!', painted on the subject of troops leaving England for India at the time of the mutiny, in 1857, and exhibited the following year. He was thought by his contemporaries to have interests too varied to enable him to reach the highest rank in art. Yet his obituary was written for *The Times* by Anthony Trollope. His less well-known piece 'The Opera Box' is an example of a type of painting which appealed greatly to the taste of his own time. Similar paintings by Augustus Egg and Frith were among those artists' most popular works.

In so far as the theme is an excuse to show a pretty model dressed in fine clothes and holding a bouquet of flowers, we may see in these single-figure paintings a sophisticated version of the Keepsake theme. The Keepsakes, or Books of Beauty, were the products of early Victorian society which gave most employment to draughtsmen and engravers, and, to judge by their proliferation, they clearly gave pleasure to their patrons. Half coffee-table book, half girlie magazine, they concentrate upon feminine beauty with an obsession equal to the present day's absorption in this subject. To take a few volumes almost at random, we have such titles as: *English Pearls, or Portraits of the Boudoir*, published in 1843 and containing engravings of actual portraits, beginning with the Queen and proceeding through a range of society beauties; *The Diadem, a Book for the Boudoir*, with short stories, poems and engraved figure subjects; *Cabinet of Poetry and Romance. Female Portraits from the Writings of Byron and Scott*, published in 1845, with pictures of Rebecca from *Ivanhoe*, Haidée from *Don Juan* and so on.

The common feature of these and many other books is the illustration of languid luxurious women with full figures, dressed, if possible, in historic or foreign costume. Sometimes, to add to the excitement, two of the girls are embracing one another tenderly with melting flashing eyes. The types are derivations of female portraits by Lawrence, and the emotional climate is that of virginal, romantic, abandoned love. Ephemera these Keepsake albums may be, but they embodied, even created, a standard of female beauty; and their significance for the history of early Victorian painting is that they imposed a standard of taste, and specified a subject-matter even for the more ambitious painters of the time. For instance, discussing Egg's 'Pepys's Introduction to Nell Gwynne' of 1842 Redgrave remarks, 'We miss in the "Pepys" the beauty Leslie would have given to Nelly'.

Egg's repute has been steadily rising since attention was drawn to the excellence of his drama of contemporary life 'Past and Present', now in the Tate Gallery, and has been reinforced by the more recent emergence of 'The Travelling Companions', now at Birmingham. These are both works of his early maturity—he died in 1863 at the age of forty-seven—and reflect the interest he had taken in the Pre-Raphaelite movement. He was one of the few established painters to express his sympathy with their aims and works at the outset, and was especially drawn towards their advocacy of contemporary life as a subject for art. But his career till then had been mainly based upon the production of historical and literary illustration. His first exhibit at the R.A., 'A Spanish Girl' of 1838, we may surmise to have been of the Keepsake variety. In his painting he had a refreshing freedom of handling, often revealed best in the single female figures—there is an unfinished canvas of this kind in the Victoria and Albert Museum. Besides the Pepys subject already mentioned, scenes from Shakespeare and Thackeray are prevalent. The scene of 'Launce's Substitute for Proteus's Dog', painted just before his wave of contemporary subjects, is a sympathetic example of this kind. And there are interesting points of resemblance between this painting, exhibited in 1849, and Millais's 'Lorenzo and Isabella' shown in the same year. There is less tension in Egg's work, less concern with minutiae; but the unaffected naturalness

of the figures makes it what he intended, a transcript from the stage.

If we judge O'Neil and Egg by works produced when they were well advanced in their careers, this is no less the case with John Phillip. He is known as 'Spanish' Phillip, but the Spanish episodes which gave him this name did not start till 1851. He began with no advantages, the son of an Aberdonian soldier, apprenticed to a house painter. His determination brought him to London to see pictures, and the kindly patronage of Lord Panmure provided him with the means to study at the Academy schools. His early works bear clear evidence of their continuity with Scottish *genre* painting in their titles alone: 'Presbyterian Catechizing', 'Baptism in Scotland', 'The Spae Wife'. These were recognized as being painted in a close imitation of Wilkie's manner. But in Spain he found Velazquez, and was enchanted by the proud, colourful, generous life which flowed around him. We may recall other nineteenth-century painters who so greatly admired Velazquez: Manet, Sargent, Whistler. Clearly Phillip is not in the same category of merit, but the completeness of his enthusiasm and depth of his understanding are a real testimony to his artistic intelligence. The degree of his conversion to the choice of Spanish themes is one more example of the complete way in which the warm South can take hold of the scions of the North. But the excellence of Phillip's copies of Velazquez shows to how great an extent he had penetrated into the characteristics of his new master. This insight gives a breadth and vigour to his treatment of *genre* scenes which raises them well above the commonplace. 'La Bomba' of 1862–63 is a charming, uncontrived scene in a Seville inn. The unfinished 'Woman with Guitar' well illustrates his rapidity of work, with its broadly brushed-in accents and the paint running down the canvas through the thinness of his medium. Redgrave, so frequently informative about the technique of his contemporaries, tells us that Phillip used 'to turn to account in his work the accidents of a rapid execution'. The fact that Phillip's later style was fully appreciated in the 1850s and 1860s is one piece of evidence that the world of taste at that time was not monopolized by the Pre-Raphaelites and their followers. And that Phillip himself was capable of recognizing a new generation and a fellow interest in Spanish painting is shown by his having bought Whistler's first English exhibit, 'At the Piano', of 1860.

Richard Dadd was soon withdrawn from the real world of competition and rivalry among artists by the calamity which overwhelmed him at the age of twenty-six. He had already travelled extensively in the East, bringing back scores of drawings, and some symptoms of the brain disturbance which was to have such tragic results. He killed his father at Cobham in 1843 and fled to France. He intended to carry out a more systematic programme of extermination but was soon caught and spent the rest of his life first in Bedlam, then in Broadmoor, incurably insane. But while there he was allowed to practise his painting, which developed in an entirely individual way. The extent to which he came to investigate detail independently of any Pre-Raphaelite influence is one more illustration of the way in which certain ideas are in the air at a particular time. Though his allegories are sometimes rather arid, the intensity of his observation is impelled by his obsession. Yet he is not simply the helpless observer of microscopic facts: the pattern he builds out of individual

studied facets in 'The Fairy Feller's Master Stroke' is a highly wrought and expressive one.

The action in this picture has only recently been understood, through the correct identification of the chief figure as a 'Fairy Feller'; hitherto he was believed to be a 'Fairy Teller'. Deployed in relief against a flat background, the painting with its all-over embroidered effect and absence of any specific centre of interest has much of the quality of a *trompe l'oeil* of still-life. In his childlike vision Dadd looks forward to Beatrix Potter; in his overall construction and his assemblage of discordant facts, to the Surrealists. These qualities have made him accessible to our age in a way that he could not have been to his own.

Frith, the youngest member of The Clique, was the one who went furthest in worldly success. His career virtually spans the Victorian era. He first exhibited in 1838 and last in 1902, not dying till 1909; and this unseasonable longevity perhaps made him particularly a target for the reformers of the twentieth century. It is easy to enter into the horror with which the protagonists of Monet and Cézanne gazed at 'Derby Day' when it was being shown in the National Gallery. There is also an atmosphere of philistinism about the artist's autobiography, which suggests that he approached his painting solely as a trade in which he happened to be able to make good money. But these memoirs were written when he was already seventy, and this atmosphere may be as contrived as many of the anecdotes he retails with the gusto of a good after-dinner speaker. In the heyday of the rejection of his work, Sickert saw and proclaimed its painterly qualities, and if Frith was the first of the typical Victorians to be utterly rejected, he was one of the first to be studied and rehabilitated. The exhibition held at Harrogate in 1951 assembled fifty canvases and a number of drawings from all periods of his work, and enabled a more just assessment of his qualities and defects to be made.

The full list of Frith's works contains the customary number of subject pictures in historical costume. It includes scenes from Shakespeare, Molière, Goldsmith, Scott, Boswell. But the subjects by which he himself set most store, and in which he excelled, are his scenes of contemporary life. According to his own account he had always been drawn 'strongly towards the illustration of modern life'. He thought that he had first achieved this ambition when he painted a series of studies of Dolly Varden, soon after the publication of *Barnaby Rudge* in 1841. But of course Dickens's novel was set in the late eighteenth century, and though Frith's Dolly is an engaging, up-to-the-minute minx, she is dressed in a costume of the previous decade modified to give it a historical appearance. Dickens, whose taste in painters also embraced Maclise and Egg, commissioned a replica; so did Frith's fellow artists, Creswick and Frank Stone.

Four years later we find Frith still well involved in painting the Keepsake type of female beauty. When he was commissioned to paint Norah Creina for engraving in the *Beauties of Moore*, Egg, Elmore and E. M. Ward were also represented in the book. When Frith exhibited the painting at the British Institution he was rebuked for not sending a higher type of contribution, but the critic could not forbear from passing judgment on the charms of

the sitter: 'The figure is seated so as to show the eyes in which Love, rather than Beauty, dwells'.

It was not till the Pre-Raphaelites had shown the way that, in 1851, Frith began to paint the first of his big panoramas of contemporary life. He was on holiday at Ramsgate and started to make drawings which led to his undertaking the big canvas 'Ramsgate Sands'. For so self-assured a painter this picture, with its cast of nearly a hundred figures effortlessly arranged in a variety of significant and appropriate operations, took a comparatively long time—almost two years—to complete and he was not ready to show it at the Royal Academy till 1854. It was an immediate success, being bought by a dealer and resold to Queen Victoria for a thousand guineas at the beginning of the exhibition; and its reception encouraged Frith to make a number of other epics of modern life on the same scale. So he produced 'Derby Day' in 1858, 'The Railway Station' in 1862, 'The Salon d'Or, Homburg' in 1871 and 'The Private View of the Royal Academy, 1881', exhibited in 1883.

It has been frequently remarked—in fact, Frith himself was amongst those who said it—that in these large and complicated story pictures of modern life the grouping of the figures is contrived with elegance and skill. Unlike Wilkie, who composed with a sense of strain and produced an effect of gawkiness, Frith makes his actors and actresses all appear to have good reason for their presence and be engaged in natural action. Each of the large paintings has a central episode flanked by minor ones: in 'Ramsgate Sands' the main event is the little girl being paddled in the water; in 'Derby Day' it is the young acrobat tempted by the hamper of food; in 'The Railway Station' the arrest of a criminal. Throughout all his multifarious cast of characters Frith rarely repeats a type, and shows himself always perceptive and appreciative of the latest fashions in costume—a sense perhaps sharpened in him by his apprenticeship as a painter of historical scenes. All his women are seen to be clothed according to their station in life; very much clothed indeed, for it is difficult to imagine Frith as a painter of the nude, and it is significant that when he made a picture of that hoary subject 'The Artist and his Model', the model was fully clothed and asleep.

Frith's personality as a painter can be further understood by comparing his rendering of 'Uncle Toby and the Widow Wadman' of 1865 with Leslie's better known version of this scene from *Tristram Shandy*. Leslie shows the couple sitting in the sentry box, with the map of Dunkirk above their heads; Toby, with his knee well pressed into the widow, has his face close to her, peering into her supposedly afflicted eye. He is plainly dressed, solid, and credibly an innocent, unadorned military man; her widow's weeds are simple, and she is neither too pretty nor too young. When Frith chose to paint the subject thirty-five years later, he softened the improprieties of this unchaperoned attempt at flirtation in a sentry box, by showing the couple standing; Uncle Toby with his back to the spectator, and the widow handing him his pipe with a smile which should win anyone's heart. Toby wears an elegantly cut ornate coat and much-curled wig; and though the widow is certainly dressed in black, her weeds are cut in the latest fashion and are worn with an air; her features have been copied from one of the pretty models Frith was an

adept at recognizing. In short, he has deviated a long way from the original text, which Leslie had respected, to provide a lighter, more obviously pretty piece in line with the taste of his own day. This absence of weight is apparent also in the way he handles paint, thin and miniscule in comparison with the broad, loaded brushwork which Leslie had learned from Constable.

Thinness and dryness grew upon Frith as he aged. He was an inveterate copyist of his own pictures—itself a testimony to the demand for them. The contemporary copies of Dolly Varden have been mentioned as a case in point; the practice persisted throughout his life. Of many versions of 'An English Merry-making a hundred years ago', of which the first was shown at the Royal Academy in 1847, the last was finished in 1906. The later versions are drier, and in them Frith suppresses his usually interesting colour for a monochrome; so a misleading impression of his capacity can be gained if he is judged from the copies alone.

While the foundations of the careers of The Clique were being laid during the 1840s, state patronage was having a decisive and almost wholly calamitous effect upon the lives of a number of their contemporaries. When the old Houses of Parliament burnt down in 1834, it was generally felt that a great opportunity was opening for the artists of the day. The porter of the Royal Academy said to the students, 'Now, Gentlemen; now, you young architects, there's a fine chance for you; the Parliament House is all afire!' And a number of influential people, Haydon vociferously among them, came to think that the new building designed by Barry should be ornamented with the best the country could produce in painting, sculpture and the fine arts. As is generally an architect's way, Barry was by no means so enthusiastic and made no attempt to help the artist by providing suitable spaces or adequate lighting. None the less, the intention to make an artistic demonstration on the walls and in the vast spaces of the new Palace of Westminster was an admirable and epoch-making one. For the first time the House of Commons committed itself to the view that public money spent on art was not sheer waste, but 'directly instrumental in creating new objects of industry and of enjoyment and therefore in adding, at the same time, to the wealth of the country'. The proclamation of this economic revolution led to the formation of the Victoria and Albert Museum, and ultimately to the Arts Council and municipal patronage. But in so far as the aim was to create a respectable body of historical painting in England, it was a total failure.

The newly appointed public patrons went about their task with the classic circumspection of committees. A Select Committee in 1841, on the express subject of promoting the arts in connection with the rebuilding of the Houses of Parliament, recommended the appointment of a Royal Commission. The Royal Commission recommended the use of fresco, based on the experience of the Munich school, and announced a competition for cartoons at least ten feet wide, of subjects drawn from the familiar cycle of British history, Spencer, Shakespeare and Milton. The entries were submitted anonymously in 1843, and their exhibition in Westminster Hall, with the allocation of prizes, was the climax of the whole plan. The sequel was a long drawn-out anticlimax. Having chosen the people they thought best qualified in design, they then

invited them to send small specimens of fresco to another exhibition in 1844 and held a further competition for oils in 1845. Six artists selected from this sieving operation had to submit further cartoons and frescoes before their fitness to decorate the building could be agreed upon. It seems astonishing that ultimately some decision was reached and that Dyce, the first to be commissioned, had actually finished the first fresco in 1847. The operation lingered on, with ever-diminishing enthusiasm, through the 1860s.

No one benefited from this Victorian version of 'The House that Jack Built'. The Select Committee and the Royal Commission had among their members intelligent men of taste and goodwill—Dyce, Eastlake, Prince Albert—yet they seem to have been powerless to effect their aims. The real failure was not that of the successive committees, but of the cartoons and paintings produced in response to them, which it is impossible to contemplate without boredom verging on despair. They are dutiful, schoolboy exercises, produced at the instruction of the master, on worthy subjects such as 'The First Trial by Jury', and they utterly lack the spark of life. Haydon was an early casualty; his cartoon was not among the eleven prizewinners in the 1843 exhibition. Though he was not entirely unprepared, this was a stunning blow. Yet it was a sort of rough justice: the very principles of the plan were those he had been advocating for his whole career, the erection of a school of history painting in England which, as events showed, was utterly impossible.

Yet, even though no works of art to speak of were produced, not everything was lost. The episode as a whole had a significant effect on many people's lives. It helped to lay the foundations of the official administrative pattern for the arts, which was a characteristic Victorian construction and which is still dominant in the field. Peel added to his other achievements that of being the first prime minister to vote public money for the arts. It was his decision to appoint the Prince Consort as chairman of the Royal Commission, a post in which his efficiency and enthusiasm were able to develop, leading to his more effective labours for the Great Exhibition and the foundation of museums and schools of art and design. The appointment of Eastlake as secretary of the Commission marked his progress from painter to art-administrator, a path which led to his becoming President of the Royal Academy and Director of the National Gallery. This appointment shows the change which was being made on the administrative side of the arts: for the first Director, whom Eastlake succeeded in 1843, was Seguier, an art dealer.

The train of events which led to the appointment of professionals and trained art historians to such positions had begun. Dyce succeeded rather more effectively than Eastlake in combining the tasks of organizer and artist, and merits consideration on the latter score alone. And, in this activity of committees and commissions, Sir Henry Cole emerged as the paradigm of art administrators, the Chadwick of the art world. He was successively a designer, one of the chief organizers of the Great Exhibition, and Secretary of the future Royal College of Art and the Victoria and Albert Museum; and he became one of the most energetic, able and representative figures of the middle of the century.

The tragedy of the artists who succeeded in the competitions for the Houses

of Parliament was almost as complete as that of Haydon, who failed at the first hurdle. Bad technical advice ensured that many of the frescoes began to disintegrate soon after completion; Maclise was left with the main burden. Changing to a water-glass method, he spent seven years on his two gigantic frescoes of 'The Death of Nelson' and 'The Meeting of Wellington and Blücher'. He received little admiration, and the strain of painting them contributed to his relatively early death.

Maclise has little of interest to show outside his frescoes, but this is fortunately not true of some of his fellow prizewinners. Those who won the first batch of prizes, in the cartoon competition of 1843, were almost all new, coming men. They were: G. F. Watts, E. Armitage, C. W. Cope; J. C. Horsley, J. Z. Bell, H. J. Townsend; W. E. Frost, E. T. Parris, H. C. Selous, John Bridges and Joseph Severn. Of these clearly Watts is the only giant. But there are a number of other men who were almost all comically inappropriate for epic themes but excellent on the domestic level. E. T. Parris was one of the more seductive painters of Keepsake beauties; W. E. Frost was a follower of Etty's whose work is often mistaken for his; Joseph Severn, who befriended Keats gallantly, had his own streak of poetry, which he showed in 'Ariel' and 'Nymph Gathering Honeysuckle' in the Victoria and Albert Museum. C. W. Cope had a genuine lyrical perception of everyday life, and although much of the bulk of his production was for the Houses of Parliament, his genuine vein is to be seen in the small cabinet pictures which Sheepshanks readily bought from him. Their titles are indicative of their tenor: for instance 'Palpitation' (a young lady waiting for the postman), and 'Beneficence' (a girl helping her father up the church steps). The most tender of all are his scenes on the theme of mother and child.

J. C. Horsley also had an ability in contemporary *genre* quite belied by his historical paintings. In 'Blossom Time' and 'Showing a Preference', both painted during the boom in modern life subjects of the late 1850s, he depicted without mawkishness scenes of flirtation set in the countryside. 'The Soldier's Farewell' is equally an emotional moment, seen without awkwardness or the overloaded sentiment the Victorians are usually thought to bestow upon such scenes, especially when staged among the lower classes of society.

Horsley was a member of the colony of artists who settled in Cranbrook, a picturesque village in Kent. The six artists who comprised this group had so homogeneous an attitude toward the interpretation of village drama that it seems an oversight that they did not choose a village called Cranford as their home. The senior member of the settlement was Thomas Webster. His relation, F. D. Hardy, also specialized in children observed with a comic eye; in this case aping adults, as in 'Playing at Doctors' and 'The Young Photographers'. But like many other nineteenth-century artists he showed considerable staying power, surviving well into the present century. The painting of a family party which has recently come to light shows that unpretentious informality was second nature to him. It is hardly possible to believe that such a picture could have been painted so late in the nineteenth century. It has the charm of a slice of life arrested for all time, and we feel convinced when we see it that many late Victorian drawing-rooms looked just like this. G. B. O'Neill

(not to be confused with H. N. O'Neil of The Clique) was more robust than Hardy, and his humour was of a more adult kind. It embraced such subjects as a tax-gatherer presenting a bill for church rates to a Quaker in his draper's shop, to the amusement of his customers. 'Public Opinion' shows the scene in a gallery of the Royal Academy on one of those happy occasions when the press of the visitors round 'the painting of the year' made it necessary to protect it with a rail. This happened on relatively few occasions: first in 1822 for Wilkie's 'Chelsea Pensioners reading the Gazette of the Battle of Waterloo', and six times for Frith, beginning with 'Derby Day' in 1858.

F. D. Hardy's brother George was also one of the Cranbrook colony. The sixth member of the set, A. E. Mulready, was forgotten for a long time. He has recently been discovered to be the grandson of William Mulready. His paintings show him to be in a minor way one of the most original artists of his time. He chooses his subjects exclusively from scenes of life among the poor, generally with an expressed comment. He was a sort of Mayhew in paint, acting as a pictorial journalist of the less pretty aspects of nineteenth-century life and giving his opinion on it. But the comment is restrained, and his paintings are gay and vivacious and full of the vitality of East End life. In his sympathy for the downtrodden he is more akin to Phil May than to the heavy-handed social realism of Holl and Herkomer.

William Dyce inhabited an entirely different world from that of Cranbrook. He was one of the most widely travelled and thoroughly educated artists of his day. In the course of these travels he made two visits to Rome, when he met the surviving members of the austere group of German Nazarenes. This body, quasi-monastic, quasi-artistic, was now much diminished from its original strength. Turning from the rather lush Venetian style in which he had been painting portraits, Dyce showed that his temperament was akin to the Nazarenes by the works he now produced. His 'Jacob and Rachel' is closely akin in design to the version painted by Führich seventeen years before. Its popularity in England was such that he repeated it twice. An earlier climax to the Germanic phase of his work had been reached in his 'Joash shooting the Arrow of Deliverance', exhibited at the Royal Academy in 1844. By his effective treatment, specifically in the taut contour, sharply directed side light and highly polished surface, Dyce was setting the pace for the historical pictures which should have emerged from the cartoon competition of 1843. Being his own master in this matter, he limited the figures to the two essential ones and increased the narrative as well as the formal power of the work. So frequently the Victorians dissipated their own energy and that of their viewers by spreading out their action, and the tension of it, too thinly over too many protagonists. Dyce himself made this mistake when he painted frescoes for the House of Lords.

He had not been in the original exhibition of cartoons, but the success of 'Joash' (he became an ARA the year it was shown) ensured his being chosen to decorate a garden pavilion at Buckingham Palace and the central space behind the throne in the House of Lords. However, these were only the tithe of his labours. Like Eastlake, he undertook formidable administrative burdens. He toured Europe to report on systems of art education and became the first

superintendent of the government's schools of design. But comparison with Eastlake throws up points of contrast. Eastlake was successful as an administrator at the expense of his art. Dyce was judged to have failed in his official work. 'He did not possess the power of controlling other men to work in harmony with him, nor of subjecting his own will, in things indifferent, to those who were his colleagues in labour or in aim', say the Redgraves; and Richard Redgrave, who succeeded him in the schools of design, had doubtless many a brush with his Aberdonian temperament. Yet in the midst of all this artistic intrigue he was able to summon up the tension and energy expressed in the painting of 'Joash'. This was made the year after his resignation from directing the design schools, and the arrow doubtless embodies some of his own yearning for freedom. The year before, Haydon had recorded his position in a telling passage of his diary: 'A Situation like Dyce's destroys all energy. . . His painting room . . . announced lassitude, bad habits, & the Art given up. He acknowledged it. This is the misery of such Situations!—because their duties require a certain number of hours, they give the hours they might command & their minds go to wrack.'

Yet Dyce not only painted some of the evident masterpieces of early Victorian painting—'Jacob and Rachel', 'Joash', 'George Herbert at Bemerton', 'Pegwell Bay'—while laying the foundations of a new system of art education; he also composed church music, wrote on electromagnetics and took a leading part in the controversy about church ritual. If about his total artistic achievement there is a sense that he did not do enough for long enough, we must consider that his temperament was one of those which thrived on diversity of occupation.

To Haydon, Dyce was the embodiment of the hateful German school of taste which was being fostered by the Prince Consort, and which Eastlake was conspiring to introduce at the expense of the true, Italian style. For J. R. Herbert, who was Dyce's disciple, he could only have complete contempt. 'Dyce, a most vicious Artist, he (Eastlake) recommends, then Herbert, another—and both German. The result will be frightful . . . a race will come out who will poison & must poison the Art.' And indeed Herbert's best known painting, 'Our Saviour subject to his Parents at Nazareth', shows a keen and sympathetic study of the works of the Nazarenes. The impulse to the Early Christian style of painting was given by Pugin, under whose influence Herbert became a convert—or in the more tendentious phrase current at the time, pervert—to Roman Catholicism. The subjects which he treated amongst the frescoes included 'The Judgment of Daniel' and 'Lear disinheriting Cordelia'.

An additional interest in the painting of the Holy Family is the way in which it is a forerunner of Millais's 'Christ in the House of His Parents', now in the Guildhall Art Gallery, exhibited three years later. It is hard to believe that Millais did not see and remember this painting and set out to improve upon it. The theme of Joseph at his carpentry is in both, but while the three characters in Herbert's painting, Joseph, Mary, and Christ, are the idealized Venetian types to be expected in religious painting, Millais chose more matter-of-fact, ugly models, in the cause of realism.

E. M. Ward was a painter of historical subjects with a lighter touch in his canvases. The early training he had in Munich, on his way back from Rome, neither fitted him technically for the fresco painting he hoped to be employed on nor destroyed his sense of style. In his easel pictures, of which typical themes were 'Dr Johnson in the Ante-Room of Lord Chesterfield waiting for an Audience', and 'The Royal Family of France in the Prison of the Temple', he showed that sense of period and of historical costume which marks the good illustrator and gives a sense of identification with the action akin to an actor's interpretation of an historical role. His handling of oils could be free and fairly dashing, as it is in 'Charles II and Nell Gwynne'. Surprisingly he consulted Delacroix when he received his commission for the corridor of the House of Commons.

Notes on the plates 16 - 35

16 Augustus Leopold Egg, RA (1816–1863)
 The Travelling Companions
 $25\frac{3}{8} \times 30\frac{1}{8}$ inches Signed
 City Museum and Art Gallery, Birmingham

The view out of the carriage window is of the coast near Mentone. The picture was accordingly painted in 1862 when Egg was travelling in Southern Europe and North Africa for reasons of health.

17 Henry Nelson O'Neil, ARA (1817–1880)
 The Opera Box
 Panel, oval, $10\frac{1}{2} \times 8\frac{3}{4}$ inches
 Blackburn Museum and Art Gallery

Both Frith and Egg painted similar subjects in the 1850s; it gave a reason for presenting the single figure of a beautiful girl in fashionable clothes.

18 Richard Dadd (1819–1887)
 The Fairy Feller's Master Stroke
 $21\frac{1}{4} \times 15\frac{1}{2}$ inches Signed and dated 'quasi 1855–64'
 The Tate Gallery, London

 The subject has been interpreted as implying that all the figures are under a spell from which the Fairy Feller will release them as he cracks a nut. The artist was encouraged to paint while at Bedlam Hospital, and ceased working on this picture when he was transferred to more open conditions at Broadmoor.

19 John Phillip, RA (1817-1867)
 La Bomba
 $35\frac{1}{4} \times 44\frac{1}{2}$ inches
 The Art Gallery and Regional Museum, Aberdeen

 The painting is also known as 'The Wine Drinkers'.
 According to the D.N.B., it was painted in 1862–63.

20 John Phillip, RA
 Woman with Guitar
 $44\frac{1}{2} \times 19\frac{1}{2}$ inches
 City Museum and Art Gallery, Nottingham

 This unfinished painting illustrates the rapidity of handling which impressed Phillip's contemporaries, and shows his understanding study of Velazquez.

21 Charles West Cope, RA (1811–1890)
 The Young Mother
 Panel, 12×10 inches Signed and dated 1845
 Victoria and Albert Museum, London

 Exhibited at the Royal Academy, 1846.

22 John Callcott Horsley, RA (1817–1903)
 The Soldier's Farewell
 24×20 inches Signed and dated 1853
 Collection of Sir Geoffrey Agnew

 This is an example of the less ambitious works in which the artist painted the contemporary scene. An admirer summarized their characteristics as 'Sunshine and pretty women'.

23 William Powell Frith, RA (1819–1909)
 The Lovers' Seat
 $23\frac{3}{4} \times 19\frac{1}{2}$ inches Signed and dated 1877
 Collection of Sir David Scott, KCMG, OBE

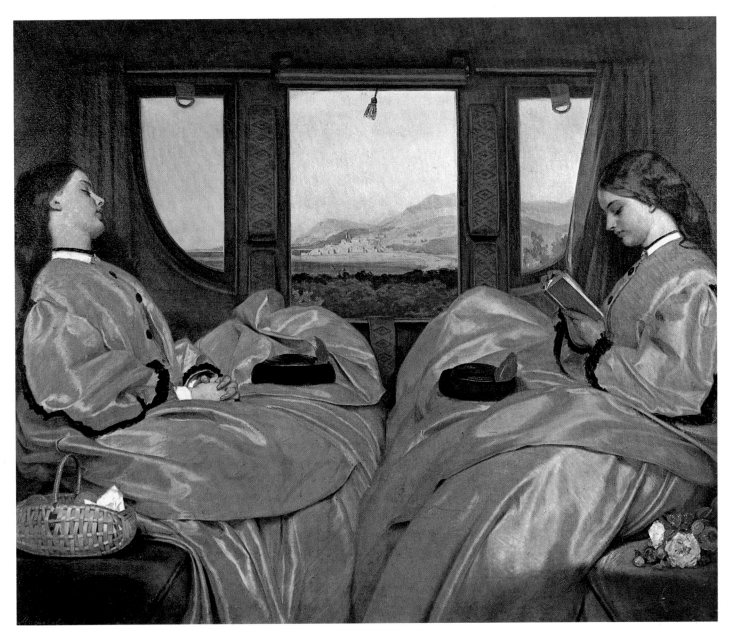

16 Augustus Leopold Egg: The Travelling Companions

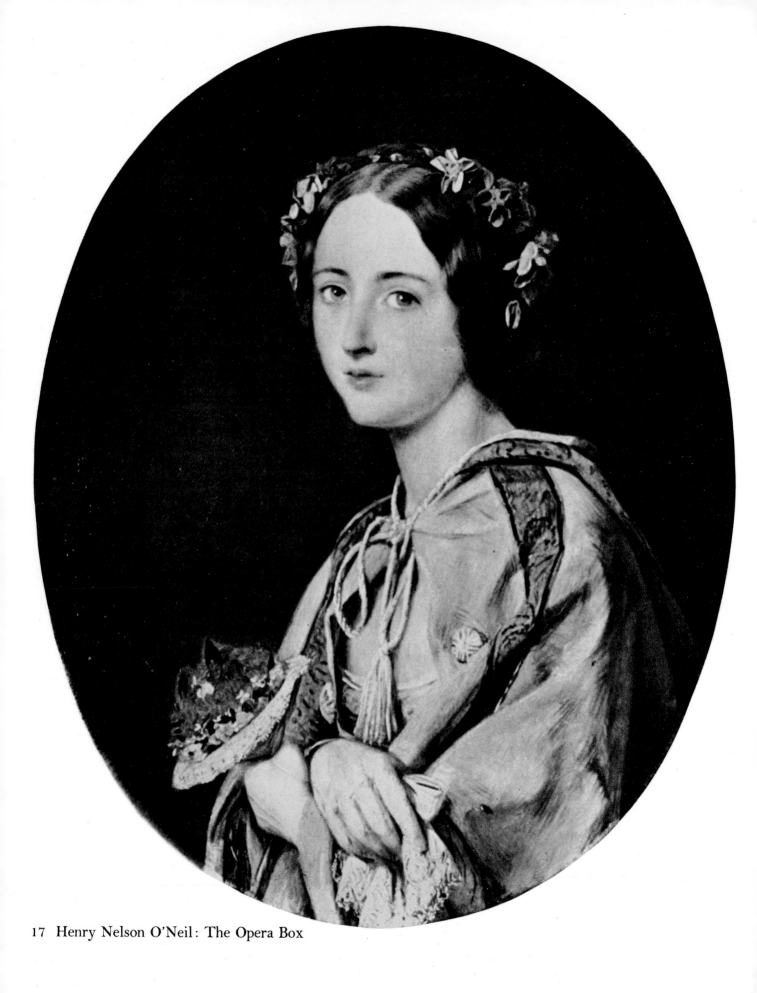

17 Henry Nelson O'Neil: The Opera Box

49

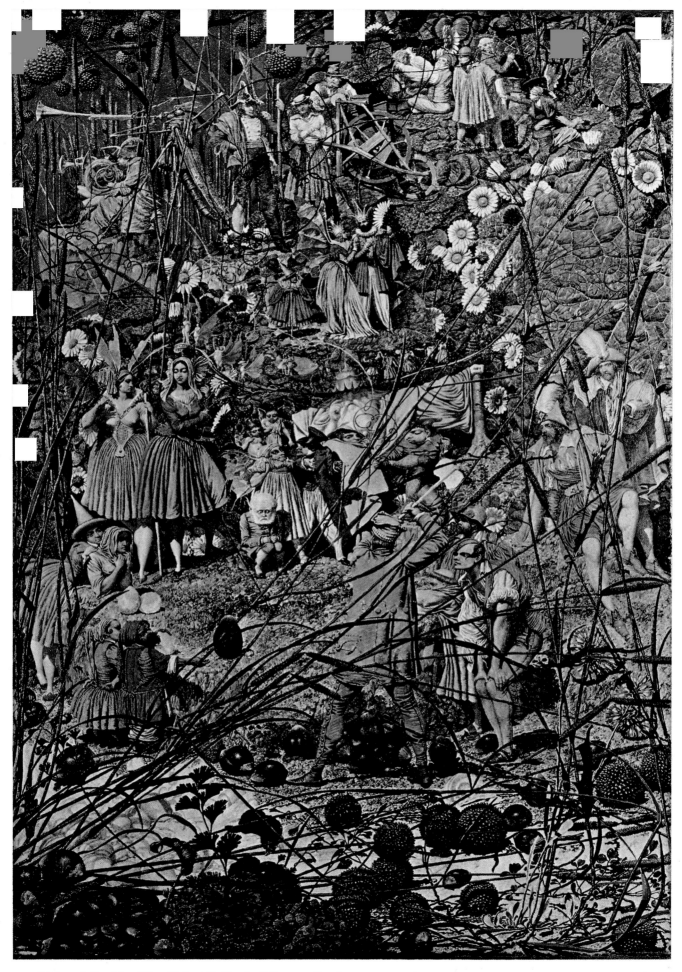

18 Richard Dadd: The Fairy Feller's Master Stroke

19 John Phillip: La Bomba

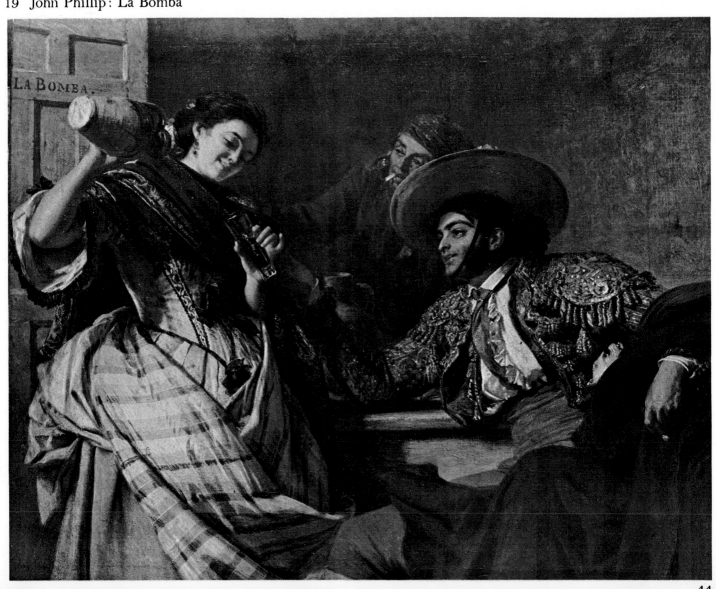

20 John Phillip:
Woman with Guitar

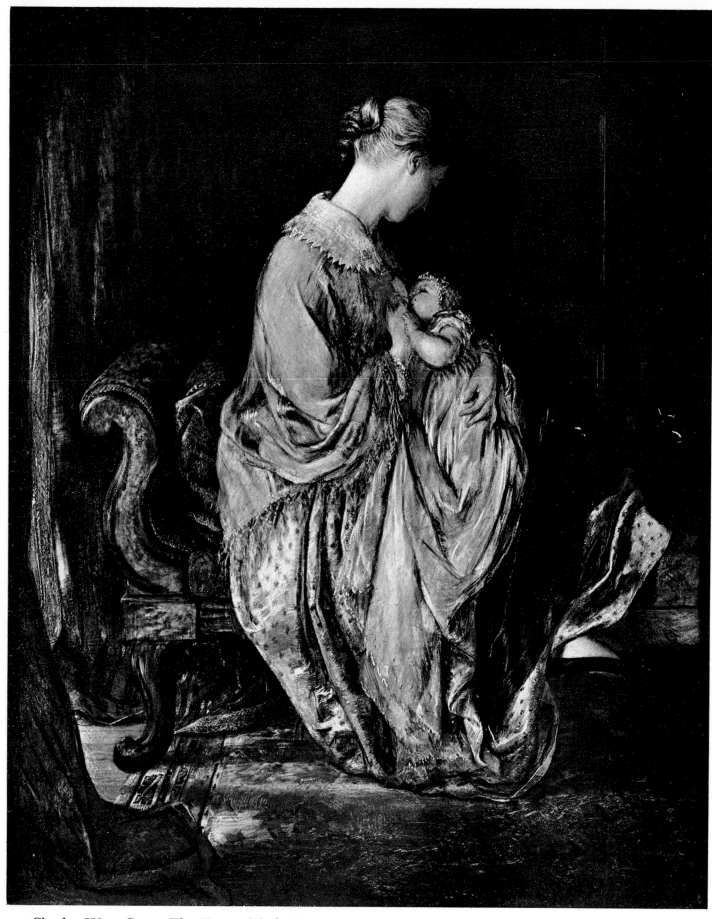

21 Charles West Cope: The Young Mother

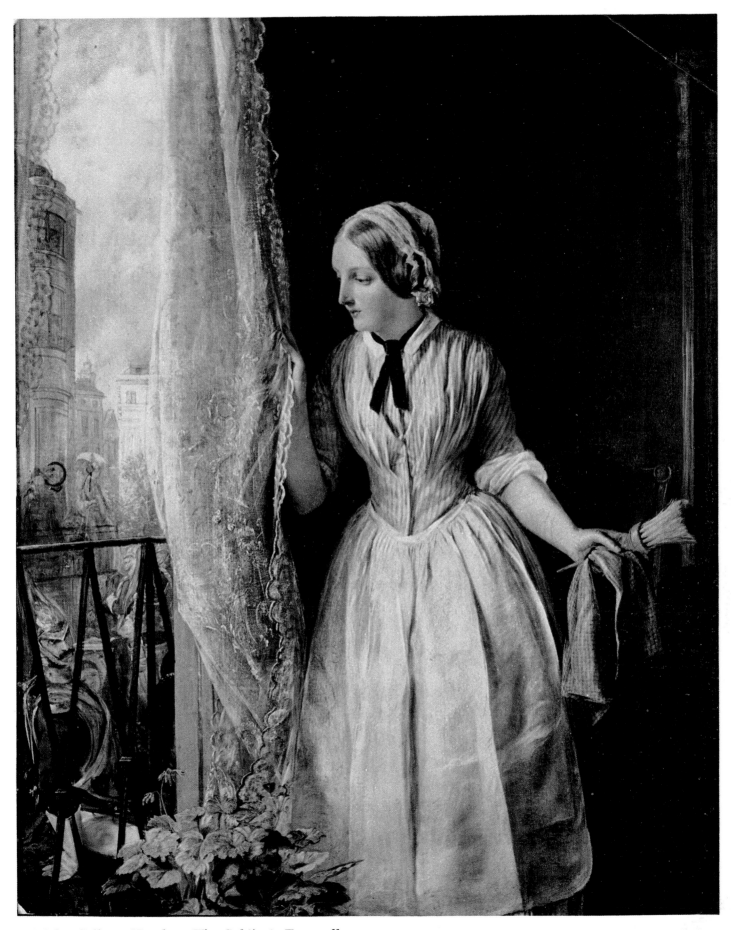

22 John Callcott Horsley: The Soldier's Farewell

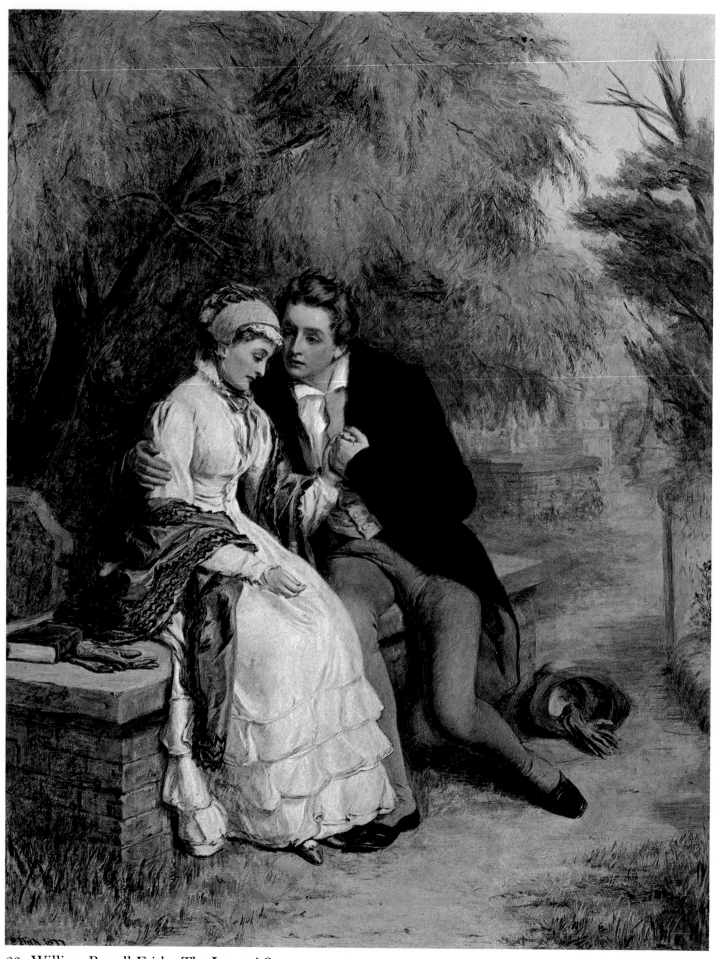

23 William Powell Frith: The Lovers' Seat

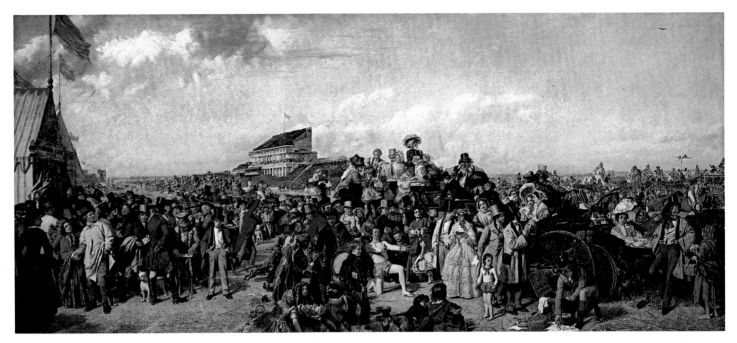

24 William Powell Frith: Derby Day

25 William Powell Frith: The Salon d'Or, Homburg

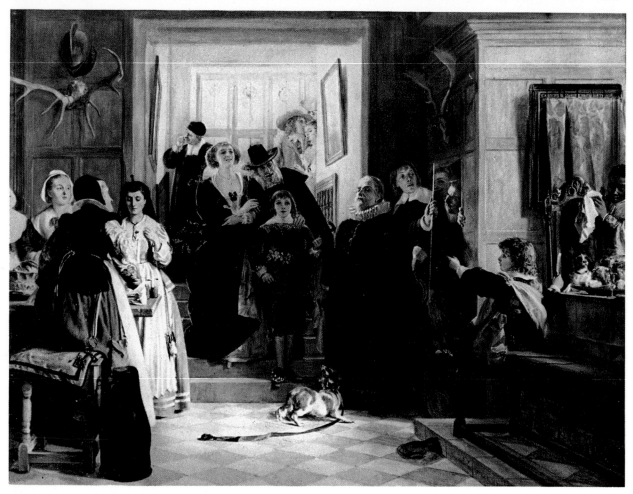

26 John Callcott Horsley: Coming Down to Dinner

27 Augustus Leopold Egg: Launce's Substitute for Proteus's Dog

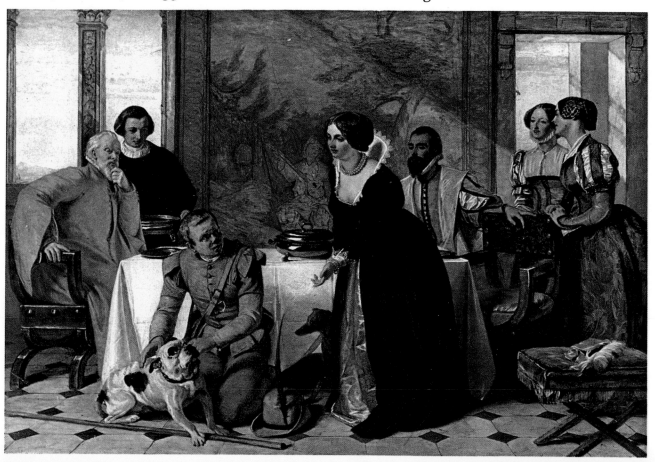

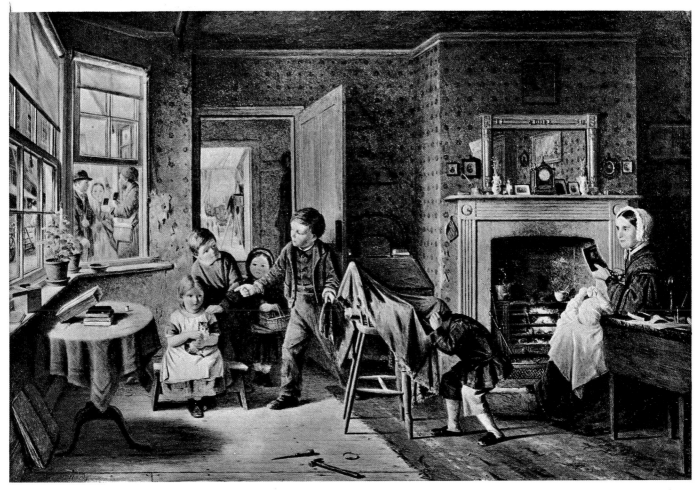

28 Frederick Daniel Hardy: The Young Photographers

29 Frederick Daniel Hardy: A Family Group

31 William Dyce: Jacob and Rachel

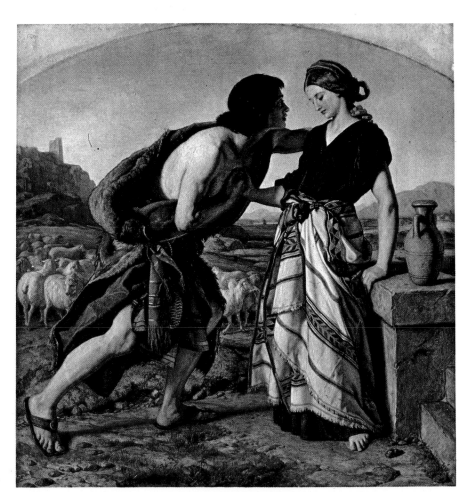

32 William Dyce:
Joash shooting the Arrow
of Deliverance

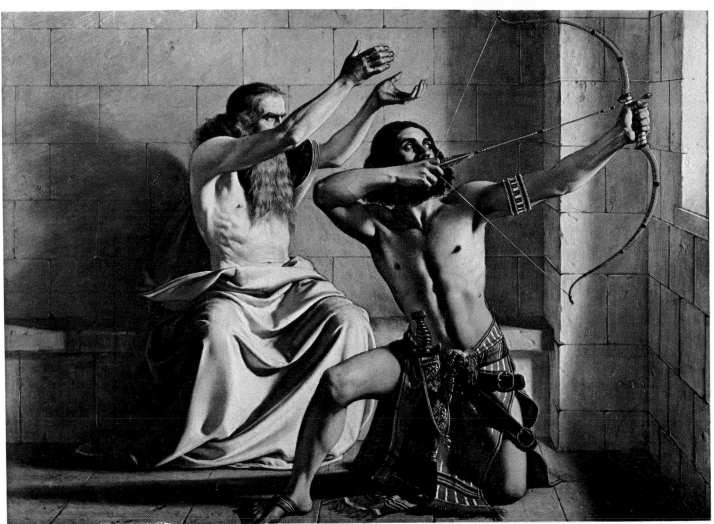

33 George Bernard O'Neill: Public Opinion

84 A. E. Mulready: A Sunny Day

35 Edward Matthew Ward: Charles II and Nell Gwynne

The painting depicts Shelley's courtship of Mary Godwin. Frith describes the subject in his autobiography as 'one of the love scenes between the poet and Mary Godwin in Old St. Pancras Churchyard . . . I failed to realise my own idea of either of the personages'. Frith exhibited 'The Lovers' Seat' at the Royal Academy in 1876; in view of the date on this version it may be a repetition.

24 William Powell Frith, RA
 Derby Day
 40 × 88 inches Signed and dated 1858
 The Tate Gallery, London

Exhibited at the Royal Academy, 1858. This was Frith's second ambitious essay in the painting of scenes from modern life, the successor to 'Ramsgate Sands' of 1854 (in the collection of H.M. The Queen).

It was so popular when shown at the Royal Academy that it had to be protectively railed—the first time this had happened since the exhibition of Wilkie's 'Chelsea Pensioners' in 1822. The action of the figures centres round what Frith describes as the 'Principal Incident': a hungry boy acrobat whose performance has been interrupted by the sight of the laden hamper.

Originally Frith hired acrobats from Drury Lane for this, but they found maintaining the pose too tiring and he hired their clothes for professional models instead.

25 William Powell Frith, RA
 The Salon d'Or, Homburg
 17½ × 35½ inches Signed
 The National Gallery of Canada, Ottawa

This is a sketch, begun in 1869, for the painting which was exhibited with great success at the Royal Academy in 1871. The exhibited version is in the Rhode Island School of Design. Frith resolved to make a study of gamblers for his modern morality 'The Road to Ruin', and visited the rooms at Homburg, from which he derived the subject of this painting. He wrote to his sister at the time: 'Instead of the noisy, eager gamblers I expected to see, I found a quiet, business-like, unimpressionable set of people trying to get money without working for it.'

26 John Callcott Horsley, RA
 Coming Down to Dinner
 48½ × 64 inches
 City Art Gallery, Manchester

By contrast with No. 22, the artist represents a scene in seventeenth-century costume. It was painted in 1876, with Haddon Hall as the setting.

27 Augustus Leopold Egg, RA
Launce's Substitute for Proteus's Dog
$21\frac{5}{8} \times 31\frac{1}{4}$ inches Signed and dated 1849
Leicester Museums and Art Gallery

Exhibited at the Royal Academy, 1849. The painting illustrates the scene in *The Two Gentlemen of Verona*, Act IV, in which Launce delivers a dog to Sylvia as a gift from Proteus. After the dog's bad behaviour Launce has to explain that the original one was stolen, and the culprit is his own, which he had substituted.

28 Frederick Daniel Hardy (1827–1911)
The Young Photographers
15×21 inches Signed and dated 1862
Tunbridge Wells Museum (Ashton Bequest)

Exhibited at the Royal Academy in 1862.

29 Frederick Daniel Hardy
A Family Group
Panel, $14\frac{3}{8} \times 22$ inches Signed and dated 1890
Private Collection

Hardy was the son of a professional musician and his continuing interest in musical performance is the theme of many of his later paintings.

30 John Rogers Herbert, RA (1810–1890)
The Judgment of Daniel
$48 \times 25\frac{1}{2}$ inches
Harris Museum and Art Gallery, Preston

Exhibited at the Royal Academy, 1851. This is a study for a figure in the decoration painted by Herbert for the House of Lords. The composition was to have been one of nine frescoes by him in the Peers' Robing Room illustrating 'the idea of Justice on Earth, and its development in Law and Judgment'. Herbert's attempts at fresco were not a success, and eventually a version of 'The Judgment of Daniel' in oil on canvas was hung in the Peers' Robing Room in 1880.

31 William Dyce, RA (1806–1864)
Jacob and Rachel
$23 \times 22\frac{1}{2}$ inches
Kunsthalle, Hamburg

Exhibited at the Royal Academy, 1853. Dyce made a number of versions of this composition, and one of them was copied by W. Holman Hunt in 1850. The first exhibited version, shown in 1850, portrayed a bearded Jacob. A

variant is in the Leicester Art Gallery, and there is a drawing in the Aberdeen Art Gallery. The design has affinities with the 'Jacob and Rachel' of Joseph Führich. Dyce met many of the Nazarenes in Rome and formed close ties with them.

32 William Dyce, RA
 Joash shooting the Arrow of Deliverance
 30 × 34 inches
 Kunsthalle, Hamburg

Exhibited at the Royal Academy, 1844. The success of this painting led to Dyce's election as an ARA in the year of its exhibition and to his patronage by Prince Albert. It illustrates the passage in the second book of *Kings*, chapter 13, at the point where Joash, King of Israel, visits Elisha in his last illness: 'Then Elisha said Shoot. And he shot. And he said, the arrow of the Lord's deliverance, and the arrow of deliverance from Syria.'

33 George Bernard O'Neill (1828–1917)
 Public Opinion
 20 × 32 inches
 City Art Gallery, Leeds

Exhibited at the Royal Academy, 1863. The scene is set in the annual exhibition of the Royal Academy, then housed in a wing of the present National Gallery in Trafalgar Square. The public are looking at a painting which is so popular that it has had to be protected by a rail. The most recent instance of this rare occurrence was for Frith's 'Derby Day' in 1858 (Plate 24).

34 A. E. Mulready (1855–1938)
 A Sunny Day
 29 × 19½ inches Signed and dated 1874
 Private Collection

Exhibited at the Royal Academy, 1874. A. E. Mulready liked to combine his studies of street life with allusions to the theatre. Here the placard advertising 'The Rivals' comments on the relation of the two girls to the young gallant.

35 Edward Matthew Ward, RA (1816–1879)
 Charles II and Nell Gwynne
 13¾ × 11¾ inches Signed and dated 1854
 Victoria and Albert Museum, London

The painting illustrates the episode described by Evelyn in his diary entry for 1st March 1671: 'I thence walk'd with him thro' St James's Parke to the garden, where I both saw and heard a very familiar discourse between (the King) and Mrs Nellie, as they cal'd an impudent comedian, she looking out of her garden on a terrace at the top of the wall and (the King) standing on ye greene walk under it. I was heartily sorry at this scene.'

3 · The Pre-Raphaelites

There is no doubt that the emergence of the next generation of rebellious young men, banded together in a kind of playful secret society called the 'Pre-Raphaelite Brotherhood', marked a decisive change in the direction of British painting. The difficulty is to decide how much they alone were responsible for the change and what proportion of the significant painting of the 1850s and 1860s was produced by them and their immediate followers. Almost by accident they carried out one of the most successful pieces of promotion by self-advertisement in the history of art. 'Puffs' by friendly, or venal, journalists for struggling painters seeking commissions were frequent in England in the eighteenth century, but the press campaign which raised the P-R.B. to the status of acrimonious discussion in every artistic home would have left a modern public relations officer standing at the post. Wildly ignorant attacks by Dickens, equally wild and indignant replies by Ruskin, the apparently unconscious leakage by Rossetti of the meaning of the initials P-R.B., the horror at this blasphemy towards the established idol, Raphael; the process is familiar to us in the promotion of 'pop' and 'op' art, but was the more effective in the mid-nineteenth century through its sheer novelty. And its result still goes on with apparently undiminished power. For every study of William Mulready or Albert Moore there are hosts of articles and books on the Pre-Raphaelites.

Yet when all this has been admitted it remains true that the course of English art changed radically in 1850, largely through the influence of Rossetti, Millais and Holman Hunt, and that these three artists, with some help from Ford Madox Brown, contributed to the next two decades some—though by no means all—of its most interesting and exciting paintings. Those paintings reveal very different temperaments and visions at work; yet it is possible at the outset of the painters' careers to generalize about their aims and motives, in spite of the fact that different accounts of them have been given not only by later commentators but by the founding members of the Brotherhood themselves.

We can dismiss at once the aim 'to return to Nature', because this is the parrot-cry of every new generation of artists, and means a different thing to each one—Romantic, Barbizon, Impressionist, Cubist, Abstract Expressionist. The Pre-Raphaelite revolution was woven of two natural enough skeins; it was a revolt by young men against their immediate seniors, akin in kind to that staged by The Clique eleven or twelve years before; and at the same time it was the embodiment of trends latent in the painting of the last two decades, now to become dominant rather than hidden. What they were rebelling against was conveniently listed by Holman Hunt: 'Monkeyana ideas

(Landseer), Books of Beauty (The Keepsakes), Chorister Boys, whose forms were those of melted wax with drapery of no tangible texture (H. Barraud's paintings).' The trends they were bringing to fruition were the German tastes so loathed by Haydon, but influentially favoured by Eastlake, Dyce and the Prince Consort. This is the moment of triumph of the Albertine phase of Victorian painting. The ideas were in the air: a new taste for Italian primitives, an interest in mediaevalism as such, the knowledge of German painting, particularly that of the Nazarenes, increased as a result of the parliamentary fresco competitions; and these found their embodiment in such paintings as Rossetti's 'Girlhood of Mary Virgin', Millais's 'Lorenzo and Isabella' and Holman Hunt's 'The Hireling Shepherd'. The precepts of the Nazarenes led to the technical change whereby light colour on a luminous ground replaced the dark Venetian or Rembrandtesque harmonies hitherto so popular in the English school. Study of other German sources—for instance, the outline engraving of Retzsch—encouraged that attention to contour which is another distinguishing mark of Pre-Raphaelite painting. It also had the less desirable result of a perverse interest in ugliness, in distorted grimacing features and awkward, deliberately ill-posed bodies. Originally adopted as an affectation, *pour épater le bourgeois*, this became second nature to some of its protagonists. It explains both the hostility of the earlier reception, and the circumstance that it is even now hardly possible to look without nausea at some of Brown's caricatured features or Hunt's discordant colour combinations.

Another idea floating in the air at the time and crystallized by the Pre-Raphaelites was the painting of modern life. The process by which they encouraged this trend is not clear, but it is none the less well-established. They themselves rarely attempted a modern dress composition; indeed, Rossetti's one essay in this field obstinately remained unfinished. But the manifesto by J. L. Tupper in the group's magazine *The Germ* specifically commends the possibilities of subjects from modern life, even urging a strain of political criticism or social realism. And, after the P-R.B. explosion, Frith painted 'Ramsgate Sands' with great popular success, and the whole school of *genre* of the 1860s, discussed in the next chapter, arose in its wake.

Rossetti remains the most attractive and most gifted of the Brotherhood, though the one least seriously attached to its party line and most disposed to be cynical about it twenty years after the event. In reviewing his career as a painter it is possible to feel a sense of wasted genius, of gifts squandered through hasty over-production, and of emotional dissipation. It is hard to see the mystic fervour of 'The Girlhood of Mary Virgin' and 'The Wedding of St George and the Princess Sabra' in the later studies of Janey Morris and Fanny Cornforth under such titles as 'Bocca Baciata' and 'La Donna della Fiamma'. These later, single figure paintings are in a sense the resurgence of the Keepsake beauty, made more fleshly, more overtly sensual, and with a hint of 'stray breaths of Sapphic song that blew through Mitylene' to titillate the more hothouse palates of the second half of the century.

But it would be unjust to judge Rossetti by these works. In the 1850s, when he was fully master of his powers, he produced a series of paintings which are unique in English art for their mystical effectiveness and magical

intensity. His subjects from Dante, such as 'Dante drawing an Angel on the Anniversary of Beatrice's Death' are quite unlike the literary illustrations which passed as current at the time; they give an entrance into the poetical significance of the *Divine Comedy* by a man who was himself a poet and who was deeply imbued with the spirit of the work. The strangeness of these paintings reflects the immigrant alienation of Rossetti's family life; his father, a political refugee, had spent years interpreting the symbolic meaning of Dante's text, and Rossetti himself drew his strength from not being fully absorbed into the reticence of English manners. His work is frequently at its best when in watercolour. Although he spoke cynically of the speed of the medium, this need not be taken too seriously. The speed with which he could work in it, by contrast with his halting early or slapdash later oils, made it possible for him to fix in the medium the substance of that 'golden dim dream' of the middle ages of which James Smetham wrote.

Rossetti is the genuine mediaevalist of the group, the one to whom that age was more real than the present day; and he did not labour at archaeologically exact detail to give a counterfeit of the truths he felt so keenly in it. William Holman Hunt was precisely the contrary. The apparatus of eastern robes, lamps, saws, and the Aladdin's cave from which he could draw his props have a fine comic ring about them when described by his grand-daughter in *My Grandmothers and I*. But they placed too many obstacles in the way of his art. When he laboured heroically in Palestine, camped by the Red Sea, to make a factually correct 'The Scapegoat' he created one of the most disturbing images of mid-nineteenth-century art.

Hunt was the self-appointed high priest of the Pre-Raphaelite movement. By his staying power and the undeniable consistency of his work, he succeeded in causing his interpretation of the creed of the group to pass current. If Hunt is to be seen fairly, or rather favourably, a rigorous thinning out of his work is needed. In some of the paintings he made in the first flush of his enthusiasm for the Pre-Raphaelite cause, such as 'Valentine rescuing Sylvia from Proteus' of 1851, his mannerisms have not overlaid his impulse. It is a Shakespearian illustration in the wake of Horsley and Egg, but seen in much sharper focus and realized with a purely Pre-Raphaelite attention to detail. But here the minutely observed leaves and mushrooms, costly fabrics and mediaeval armour do not swamp the narrative of the painting, and Hunt's weakest side, his sense of colour, is not unpleasantly in evidence. The attention to detail is equally acceptable in 'The Awakening Conscience', where it fits psychologically into the girl's mood of grief remembered. The success of 'The Importunate Neighbour' is due to the understanding seen in it of moonlight in a garden, not to the supposedly correct shape of the seat and the seven-branched candlestick over the door. And the detail is quite unacceptable in 'The Shadow of Death', where the grotesque attitudinizing of Christ is fitted into a store of bric-à-brac. Hunt's simple, literal mind was not adept at translating symbolism into visual terms, as this composition reveals. But it must be admitted that he struck a vein of sympathetic response in the fundamentalist obviousness of 'The Light of the World', which has become a universally known religious image.

In a sympathetic comment on the naturalistic qualities of Hunt's 'Strayed Sheep' (1853), Mr Boase remarks 'We wonder how these men could have been so blind to much that Constable could have taught them.' And indeed it is a remarkable instance of how an unrealistic effect can be obtained from realistic intentions. Constable had criticized the faults of the same approach in the French landscape painting of his time. By their method of *découpage*, the Pre-Raphaelites could get each individual detail apparently right; but in doing so they lost all sense of its relationship to the total effect. And in Hunt's case the effect is exacerbated by his personal idiosyncrasies of colour vision and his quasi-Oriental love for garish combinations of yellow, pink, gold and purple.

The Pre-Raphaelite phase of J. E. Millais is generally taken to extend from 1849, when he exhibited the remarkable 'Lorenzo and Isabella', till 1856, when he painted 'The Blind Girl' and 'Autumn Leaves'. Pre-Raphaelitism in this context means the minute rendering of detail and the study of important passages out of doors. In this period of seven years Millais, between the ages of twenty and twenty-seven, produced a series of paintings, each of which was of capital importance in itself and a milestone in the progress of the movement. 'Christ in the House of his Parents (The Carpenter's Shop)' of 1850, when exhibited at the Royal Academy, sparked off the storm which led to Dicken's denunciation and Ruskin's later defence, gaining notoriety for the group. In the following year the Academy showed that they were unshaken by criticism by their acceptance of three paintings by Millais: 'Mariana', 'The Woodman's Daughter' and 'The Return of the Dove to the Ark'. Of these 'Mariana' represented for the first time a subject chosen from Tennyson, and 'The Woodman's Daughter', based on a poem by Coventry Patmore, was the first theme by the leading P-R.B. taken from contemporary life. In the following year, 1852, his two exhibits 'Ophelia' and 'A Huguenot' met favour with the public, and marked the end of the short battle for recognition which the Brethren had had to fight.

Millais' abandonment of his earlier, closely wrought, miniaturist's technique for a broader manner is frequently regarded as an act of apostasy. This certainly was the view held by Holman Hunt, with his quasi-religious attitude towards keeping the tenets of Pre-Raphaelitism in all their purity. But a precociously brilliant young artist may be permitted to change his manner as he matures; Turner did, Monet did, Samuel Palmer did, countless others have done, and the fact is accepted, though people generally have a clear preference for the earlier or later styles. What is surprising and disturbing about Millais' development is that the intellectual power and the emotional content of his pictures declined in such a marked degree; the sloppy, deplorable painting of some of his later canvases is more an index of mental laziness than abdication from Pre-Raphaelite principles. Indeed, it is perhaps more remarkable that in his early works the close attention to technique imposed so much concentration and discipline upon his pictures that they transcend the fundamental triviality of his mind. 'The Return of the Dove to the Ark' has a sense of intensity and tenderness imposed upon it by the simplicity of the composition, the clarity of colour, and the sharp focus of the vision. But in the following year 'A Huguenot' is beginning to reveal the

characteristic search for an easy way to popular success; Millais was not temperamentally suited to be for long the supporter of an unpopular cause. And, also in 1852, 'Ophelia' had, for all its power, some of that breadth of manner which was so soon to become carelessness.

By the time he painted 'The Rescue' in Barwell's studio in 1855 the decline in power is apparent. It is not just that it is a picture of contemporary life which many others might have painted; it is worse than Stone or Calderon or Bowler, because we have a sense in it of wasted capacities, of an artist playing down to his public. But the decline was not complete, and in the twenty-five years of his most active career Millais painted some works more worthy of his powers, such as 'The Ruling Passion' and 'The North-West Passage'.

The products of his early twenties reveal Millais as the most German, Nazarene, Early Christian of the Pre-Raphaelites. The affinity with Herbert's 'Our Saviour Subject to his Parents' has already been noticed. The brilliance of colour was achieved, as with Holman Hunt, by painting on a white wet ground. In much of this work there is a wilful introduction of ugliness which raises a doubt as to whether in these paintings also Millais is playing to the gallery, deliberately alienating the spectator. The plainness of Joseph in ' Christ in the House of His Parents', which so upset the visitors to the Royal Academy in 1850, the gesture of the little boy in 'The Woodman's Daughter' are of this nature. They are another piece of evidence for the German influence in Millais' work since they are derived from the figures in Retzsch's outline etchings, illustrations to Schiller and Shakespeare. None the less this deliberate awkwardness has its expressive effect, and is less distasteful than Hunt's colour extravaganzas or Brown's caricatures of human grimaces.

Of the other originating members of the Pre-Raphaelite Brotherhood there is little to say in a survey of Victorian painting. Woolner was a sculptor; F. G. Stephens destroyed all but a handful of his paintings and became a prolific writer. As art critic of *The Athenaeum* he stepped into a position from which earlier occupants had attacked his friends. His capacity for sustained enterprise is illustrated by the British Museum's *Catalogue of Political and Personal Satires*, inaugurated by him in 1870. W. M. Rossetti, Dante Gabriel's elder brother, worked for forty-nine years as a civil servant and still contrived to write criticism and look after the interests of the group, his brother's foremost of all. He seems a sympathetic character, for his correspondence with Swinburne shows him as urbane, unshockable, amusing, a man of the world. But meeting them in the 'eighties, Graham Robertson said of F. G. Stephens and W. M. Rossetti, 'to tell the shameful truth, they both seemed to me rather dull old gentlemen'.

There remains James Collinson. Rossetti thought when he saw 'The Renunciation of Elizabeth of Hungary' that he had found in its painter, Collinson, an artist whose ideals were exactly those of the other Brethren. But this essay in mediaeval history was little different in class from those of Maclise, Horsley or Elmore; and Collinson's later work marks him as a charming but minor observer of contemporary moods and manners, in no way the spearhead of a revolutionary movement.

The first fruits of the Brotherhood were derived by a sort of telepathic

infection between the three young men, Rossetti, Millais and Hunt. Of them, Hunt supplied the literalism and the obstinacy which held him to Pre-Raphaelite tenets throughout his life; Millais supplied the technical facility, and Rossetti supplied the poetry and the exaltation of ideas. So disparate a gathering could not hold together in unity for long, and when they separated to follow independent careers their works became as diverse as those of any other chance assemblage of Victorians.

In such a situation the key to the puzzling question 'What exactly was Pre-Raphaelitism?' is answered more easily by looking at the paintings of the artists who were admittedly closely influenced by them, and judging what qualities they chose to emulate. Of the admitted discipleship there are two generations. The first consists of contemporaries, or near contemporaries, who felt the enthusiasm in the early 1850s. Among them are Ford Madox Brown (in fact, senior to the group), Arthur Hughes, W. H. Deverell, John Brett, R. B. Martineau, Henry Wallis, Frederick Sandys, W. L. Windus. The second wave, the 'Oxford Movement' of the group, took place in the next decade, centering round Burne-Jones and Morris. In their succession lie Walter Crane, Henry Holiday, J. W. Waterhouse and Sir Frank Dicksee.

To the earlier of these two groups the salient points of Pre-Raphaelitism were: the contemporary scene, situations charged with frustrated passion, such as that of severed lovers or forsaken women; in technique a bright key of colour and the sharp focus of their rendering of natural objects. They followed more closely the trend set by Millais and Hunt, though in doing so they approximated to the general temper of mid-Victorian art, and it is hard to draw a line between painting influenced by the Pre-Raphaelites and that which would have existed as it was in any case. The later group—from Burne-Jones till its final appearance in the present century in the hands of Dicksee and Cadogan Cowper—were more swayed by the other-worldly mysticism of Rossetti and sought the unfamiliar in subject and treatment.

Of the members of the first group of followers the position of Ford Madox Brown is most unusual. He was a fully formed artist before he came into contact with the Brethren, and, as has often been pointed out, the only one in their circle who had been trained on the Continent. Baron Wappers had taught him the high Belgian line; and he had actually met the Nazarenes in Rome. Yet there is little Nazarene about his painting; it is a retardatory Baroque, emphasized no doubt by the training in Belgium, where Flemish traditions of the grand manner lingered still.

The first painting in which he is said to have shown his sympathy with the cause of Rossetti, Millais and Hunt is the vast canvas of 'Chaucer at the Court of Edward III' exhibited in 1851 and now in Sydney. Yet this has a close connection with several of the frescoes made a little earlier for the Houses of Parliament scheme; for instance, C. W. Cope's 'Prince Henry acknowledges Judge Gascoigne's Authority'. Brown had been an unsuccessful competitor for one of these commissions. In 'Work', 'Pretty Baa-Lambs', 'The Last of England' and some of the outdoor landscapes of the 1850s, he shows a more convincing parallelism with the new wave, though the landscapes are consistent with the general development discussed in Chapter 7. Even at this time

65

there is an element of caricature in his painting which accords ill with the apparent seriousness of his intention. Either he could not handle human expression or, with the same wilfulness as Millais and Hunt, he sought to emphasize ugliness and awkwardness. This fault grew on him; it is apparent in 'Take your Son, Sir' and by the time he came to paint 'The Death of Sir Tristram' or 'Crabtree watching the Transit of Venus' it almost amounts to dementia. When, uncharacteristically, he controlled his impulse to exaggerate, he could produce a work such as 'The Finding of Don Juan by Haidée' in which there is a sense of space and agitation of line entirely original.

Brown was unfortunate in not receiving the same measure of success as many of his contemporaries. But it is certain that his best work was produced as a result of his association with the Pre-Raphaelites. Their younger enthusiasm and sense of purpose released him for a time from some of his shackles. In particular they helped him to experiment in a lighter and more 'open-air' key of colour; and they induced him to paint a short series of *plein-air* landscapes which are among the more interesting of their time.

But if Brown was an older man on whom the P-R.B. had a beneficial influence, it can be argued that they had a disastrous effect on the career of W. L. Windus. Windus was a year younger than Brown, and as a leading member of the Liverpool Academy had been working in a style of historical painting comparable with that of Egg, Maclise and Horsley, though with a particularly individual twist. His 'Morton before Claverhouse' of 1847 and 'The Interview of Shaxton with Anne Askew' of 1849 show his wholly original sense of *clair obscur* and an unusual intensity of pose in the main figures which stemmed from an exciting and unusual mind.

These were both shown in his home town, at the Liverpool Academy. Being urged to go to London to see the new trends in painting, Windus visited the Royal Academy exhibition of 1850 where he became a convert to the revolutionary cause through his admiration for Millais' 'Christ in the House of his Parents'. The total contrast of its transparency of colour with his opacity, and its labour over detail with his breadth transformed him into a passionate advocate of the rising school. This had two results. Windus became the foremost protagonist in encouraging the Pre-Raphaelites to show in Liverpool, and in arranging the award of the first prize to them at more than one annual exhibition. This first occurred in 1851, when Holman Hunt's 'Valentine rescuing Sylvia' was awarded the prize of £50; Millais received it for 'The Huguenot' in the following year. After other awards to Hunt and F. M. Brown, the row which followed its award to Millais' 'The Blind Girl' in 1857 led to a split in the Academy. Even William Huggins, whose bright and careful studies of animal plumage might have qualified him to fight under the new banner, resigned in protest: and the upheaval led first to the discontinuation of the prizes, and shortly after to the collapse of the Liverpool Academy.

The second result on Windus of his contact with the new ideas was the radical and complete transformation of his style into that of a convinced follower of the movement. He was now a slow and hesitant worker, diffident of his power, and the main product of his Pre-Raphaelite period, outside a number of small sketches, consists of two pictures, his only exhibits at the Royal

Academy in London. These are 'Burd Helen' shown in 1856 and 'Too Late' shown in 1858. Both deal with the sorrows of womanhood dear to the movement. 'Burd Helen' illustrated the mediaeval ballad in which the heartless lover rides while his girl runs, dressed as a page, to avoid being deserted. In 'Too Late', his only essay in modern dress, the dying girl is confronted by her repentant, dilatory lover and spurns him, a more severe version of the ending of *Traviata*. It was especially unfortunate that, having put so much intensity of feeling into the picture, the artist should have encountered Ruskin in one of his more unbalanced moods. He had praised 'Burd Helen', but confronted by the morbidity of 'Too Late' gave Windus the sort of advice with which a hearty doctor with an archaic literary style dismisses a neurotic patient: 'Frequent the company of rightminded and nobly souled persons; learn all athletic courses and all delicate arts . . . be just and kind to everybody; rise in the morning with the lark and whistle in the evening with the blackbird'. Far from following this advice, Windus virtually ceased to practise his profession, and became lost to the history of art. Dramatic as the intervention was in his own case, the episode reveals how powerful the pull of new ideas could be on an established painter in a provincial school.

In Arthur Hughes we meet for the first time an artist whose sympathies were entirely captured by the Pre-Raphaelites, and who was of the same generation. A year younger than Millais, he was, as a student, convinced about their cause. W. M. Rossetti wrote that had there been any elections at the relevant time he would doubtless have been added to the Brotherhood. Be that as it may, his technique, his subject matter and his strong sense of pure, transparent colour all show his knowledge of the work of Millais and his determination to proceed along the same lines. Once again we find that the afflatus given by this enthusiasm was not sufficient to sustain a lifetime's career. Shy and retiring, though less nerve-racked than Windus, Hughes moved from the centre of London to the suburbs in 1858 and the change seems to have symbolized his withdrawal from the world of artistic conflict to a far lower pressure of production and achievement. In a sense he was unfortunate in his longevity; when he died in 1916 there were few to remember the excellence of his full period of achievement, the late 1850s and early 1860s.

In that short time he added to the repertoire of English painting some of its most intense and colourful figure subjects: to name them almost in their entirety, 'April Love' (1856), 'Home from Sea' (or 'The Mother's Grave'), shown in its first form in 1857; 'The Long Engagement' (1859); 'Aurora Leigh' ('The Tryst'). In all these works the precarious balance between emotion and sentiment, detail and clutter, colour and garishness, is beautifully controlled. In later paintings—such as 'Home from Work'—his fine sense of judgment fails a little, showing what a precarious tightrope had to be walked to produce a perfect Pre-Raphaelite painting.

It has frequently been observed that there is an ambiguity between the figures and the landscapes in the Pre-Raphaelite painting: if the landscape is painted out of doors in all the merciless exposure of daytime light, figures painted in the shelter of the studio will belong to a different field of vision. Hughes carried this dichotomy to its limit. 'The Long Engagement' began as

a Shakespearian subject, called 'Orlando in the Forest of Arden', with Orlando carving the name of Rosalind on the tree. When this was rejected by the Royal Academy in 1855, Hughes painted out Orlando, preserved the *plein-air* landscape with the tree, and converted the subject into the entirely diverse one of a curate who had been so long engaged that the ivy had begun to obliterate his girl's name 'Amy' carved on the tree trunk. In this guise it was acceptable when submitted four years later. Similarly, 'April Love' had originated with a girl in period costume, instead of the present protagonist in contemporary dress. Again, the story of 'Aurora Leigh' has only just been unravelled. Formerly known as 'The Tryst', it was commissioned at Ruskin's suggestion as an illustration to a spirited scene in Elizabeth Barrett Browning's poem. Far from being the scene of adolescent love it appears to be, the girl is furious with the boy for criticizing her Greek verse, and he is offended by her refusal of him. Even the colours explicitly described in the poem—in it Aurora Leigh has a white dress—are disregarded in the painting for proper reasons of decorative effect. Ruskin approved of the picture, but said to Miss Heaton, who had commissioned it, 'It is not Aurora Leigh in the least', and to the artist, 'But wasn't Aurora tremendously angry?' And Hughes justified changing the colours described in the text: 'The dress is not a white one—which I thought would not be agreeable, but a sea-green tint; a white could only be very slightly tinted in places from the landscape near'. In short, to Hughes, the supposed subject, Shakespearian or contemporary, illustrative or allusive, was a mere excuse for the display of his extreme and sensitive, though short-lived, virtuosity.

In their wake the Pre-Raphaelites exercised a pervasive influence on the painting of their time; one aspect of this is examined in the following chapter on *genre*, another is seen in the work of certain landscape painters of the 1850s and 1860s. Indeed, the phrase 'influenced by the Pre-Raphaelites' can be misleading if it implies that a rigid distinction can be drawn between two groups of people, many of whom, on either side, were responsive to new ideas. At the same time the phrase may help to conceal a variety of different artistic personalities.

But amongst all the painters of the 1850s and 1860s who may be called Pre-Raphaelite because such ideas were generally in the air, it is possible to single out some whose relationship was closer and more direct, though no two lists are likely to agree at all points. Besides Ford Madox Brown, W. L. Windus and Arthur Hughes, this closer circle of associates may be taken to include W. H. Deverell, John Brett, Henry Wallis, C. A. Collins, and R. B. Martineau. The precise edge which was given to essentially short-lived talents by this association is seen in Brett's well-known figure-subject 'The Stonebreaker'. Once again Ruskin appears in the light of an evil genius, forcing him to paint eye-teasing pictures, as interesting as a coloured photograph, of the Val d'Aosta, in the interests of geological accuracy. And again the boost to short-lived powers is seen in the two pictures by which Henry Wallis is known: 'The Death of Chatterton' and 'The Stonebreaker'. This latter work is one of the gloomiest and most intensely felt essays in social realism to which this frequently chosen subject lent itself. Landseer had treated it as early as

1830, diversifying the distressing quality of the main figure by including a pretty Highland daughter and a dog. The lot of the stonebreaker seems to have been generally felt to be one of the most depressed and poverty-stricken which fell to the labouring classes in the nineteenth century. There is little of this feeling in Brett's 'Stonebreaker', a well-set-up boy mainly introduced to give human action to a fine landscape of Box Hill. But just as Courbet had painted, in 1849, a realistic 'Casseurs de Pierres' which became a social protest, Carlyle had taken this occupation as the subject of one of his dithyrambs in *Sartor Resartus*. It was this text which Wallis prefixed to his genuinely felt and compassionate exploration of the paradox of poverty, fatigue and death in the midst of scenic beauty by coincidence exhibited in the same year as Brett's treatment of the subject.

Henry Wallis played a disturbing role in the private history of the Pre-Raphaelite circle. Having used George Meredith as the model for 'The Death of Chatterton', he eloped with his wife two years later; a situation curiously parallel with that of Millais and Ruskin, though in that case the portrait of Ruskin was completed after the desertion of the wronged husband. The course of the estrangement is the subject of Meredith's sonnet sequence *Modern Love*.

With Martineau, who progressed from 'Kit's Writing Lesson' to the less doctrinaire 'The Last Chapter' and 'The Last Day in the Old Home', Wallis, Brett, Windus, and Hughes form the branch of followers whose Pre-Raphaelitism consists in their aiming at literalism and imitative accuracy. In that sense they follow Millais and Hunt. The so-called second generation Pre-Raphaelites, Burne-Jones, Morris, Sandys, Simeon Solomon, took and developed in their own way the entirely different characteristics which Rossetti had brought to the movement—poetry, mystery, mediaevalism, and a more complex treatment of colour. With them the Pre-Raphaelite woman, that sexless, swaying androgynous creature, the *femme fatale* of Pater and Swinburne, becomes a stereotyped theme. It was this strand which proved the longer lived of the opposing forces in the movement, to be perceived in later followers such as Walter Crane, Waterhouse, Holiday, Spencer Stanhope, Evelyn De Morgan, and continuing into and down to the 1920s in the work of Sir Frank Dicksee. Its greater survival power has contributed to the common view of Pre-Raphaelitism as solely a 'golden dim dream' of etiolated Arthurian heroines, whose eyelids are a little weary. This too was the contribution of the movement to the Aesthetic Movement of the 1880s and the sinuous line of the Art Nouveau of the 1890s.

The second wave of Pre-Raphaelitism began in 1857 with the attempt, under Rossetti's leadership, to paint frescoes on the walls of the Oxford Union. So far as enduring results were concerned, this was as calamitous a fiasco as the House of Parliament's frescoes, on which Maclise was at this very time still labouring away; they had collapsed within twelve years. But the importance of the project lay in the enthusiasm it induced in the participants, particularly Morris and Burne-Jones. Inventive though he was as a designer, Morris's painting is too derivative to need further discussion. But Burne-Jones is quite another matter. It has taken a long time for his far-out compositions to become acceptable again, but now that a physical type approximating

to his pale-faced, remote beauties with large black-shadowed eyes has emerged once more, there is less distance between the spectator and his work. With Burne-Jones the retreat from the subject-matter of a painting, already noticed in the way Arthur Hughes could switch his canvases from Shakespearian to modern themes, becomes more absolute. Constant attempts to draw from him an explanation of the material of his allegories or legends met with failure, and he placed his figures without regard to the laws of perspective as then understood.

The driving force behind his career was his enthusiasm for the work and the personality of Rossetti. The atmosphere by which he and Morris were surrounded during the first years of their friendship with the older man was described as that of a new religion. Indeed it is no surprise that both Morris and Burne-Jones had intended to take Holy Orders at Oxford, and that their dedication to an artistic career superseded this vocation.

The great originality and enduring appeal of Burne-Jones's painting consists in his unusual and exquisite sense of colour relationships. In contradistinction to the transparent clarity aimed at by Millais and Holman Hunt, Rossetti made his watercolours glow with scumbles of red and blue and orange. Burne-Jones carried this richness of texture further still, and whilst Rossetti composed mainly in variations on the primary colours, Burne-Jones composed in the secondary ones. There are juxtapositions of brown and green, grey and grey-blue which are like shot silk in his work, and give it a glow of rich colour and a quality of surface unlike any other British paintings of his time.

Because he was indifferent to subject, he manipulated the languid maidens of his legends in the way a constructivist manipulates coloured squares. His 'Golden Stairs' has as much in common with Duchamps' 'Nude descending a Staircase' as with Rossetti's Dantesque world. This concentration on formal qualities, with his exquisite colour sense, makes him a forerunner of abstract painting. It is all the more ironic that he should have been reluctantly dragged to give witness on Ruskin's behalf in the libel action against Whistler, for it was with him and the future that he had so much in common.

Frederic Sandys came into the Pre-Raphaelite circle by the classic method of succumbing to the theme he had caricatured. His 'A Nightmare' was a visual parody of Millais' 'Sir Isumbras at the Ford' which is still funny. Soon Sandys himself was producing, in such a spirited scene of incantation as 'Morgan-le-Fay', a fully convinced interpretation of the mediaeval theme. His main contribution to the art of the nineteenth century lies in his line drawing: 'If', 'Danae in the Brazen Chamber', 'The Little Mourner' are among the classics of the book-illustrations of the 1860s, a fertile period of collaboration between draughtsman and wood-engraver in which the impress of Pre-Raphaelitism is clearly seen.

Walter Crane shared not only the formal principles but the political ideas of William Morris. A staunch Socialist, he designed a banner embroidered by May Morris and published a book of *Cartoons for the Cause* in 1896. It is as a designer and decorative artist that he is now chiefly remembered. But in entering his career he too practised as a painter, producing in his most ambiti-

ous work, 'The Renaissance of Venus', a composition which looks forward to the Slade School of the 1920s as well as backwards to Botticelli. His wife was a daughter of Frederic Sandys who had suffered inordinately from her father's philandering. Accordingly she forbade the use of female models. On seeing Crane's Venus in this picture, Leighton at once recognized the form of Alessandro di Marco, the most popular male model of his time. But, as Graham Robertson, who tells the story remarks, 'She was a fine, upstanding slip of a boy'.

Henry Holiday devoted a great part of his career to designing stained glass. He shared that impulse for the betterment of the human race which was especially linked with the practitioners of the applied arts at this time—Morris and Crane among them—and included anti tight-lacing among its aims. In his zeal for a rational costume, one of the goals of the Aesthetic Movement, he edited *Aglaia*, the journal of the Healthy and Artistic Dress Union. The difficulty of maintaining the impetus of Pre-Raphaelite principles is illustrated by Holiday's 'Dante and Beatrice', one of the most reproduced of all the best sellers of the late nineteenth century. Meticulously accurate in its topography, severely correct in its reference to Dante, and an illustration of a key moment in the mediaeval world of ideas, it misses so much of the poetry which Rossetti could have injected into the scene. Yet twenty years earlier he had made a study of the meeting of Dante and Beatrice as children. This was a theme which linked the older and newer Pre-Raphaelites.

Simeon Solomon had made a strange, perverse study of this same theme in 1863. Solomon was too convinced an advocate of the cult of beauty to which Pre-Raphaelitism led as it fringed Aestheticism. It is difficult not to feel sympathy with the thoroughness with which he plunged into the logical consequences of the artistic creed of his period and admiration for the gaiety which went with his later years of poverty and the collapse of his talents. That he was greatly gifted is apparent both from his early work and from the admiration of Rossetti, Swinburne and his other friends. After his conviction for homosexuality, these friends all conspired to act as though he had never existed. Swinburne's defection is the most inexcusable, for he probably shared these leanings and encouraged Solomon in his dissipation. But the collapse, both moral and artistic, was complete; and the later work is virtually a parody of the yearning intensity of the movement.

J. W. Waterhouse reversed the expected chronological order in his development. He started as a follower of Alma-Tadema; his earlier exhibits include so Greek a subject as 'The Temple of Aesculapius' in 1877; then, as late as the 1880s, he felt the pull of Rossetti's influence, and his paintings from then on are heavy with the impress of the *femme fatale*. Sometimes he reverts to the subjects from Tennyson which had attracted Millais and Hunt, dealing twice with the Lady of Shallott, whom he painted weaving her web and also floating down the river (1888). At other times, as in 'Hylas and the Nymphs' (1897) he returns to a Grecian theme, but re-interprets it in terms of the Middle Ages.

Sir Frank Dicksee, who had learned much from Holiday's interpretation of Pre-Raphaelitism, achieved an early success when he showed his 'Harmony' at

the Royal Academy, at the age of twenty-four in 1877. This familiar picture shows a youth gazing rapturously at a girl playing the organ; the scene is irradiated by a stained glass window. The window might well have been designed by Holiday and the organ case by the firm of Morris; and the scene is more nearly akin to a St John's Wood studio than a mediaeval home, in spite of the costumes. In 'A Reverie' he tackled a contemporary subject which had been painted, without the ghostly visitant, by Orchardson in 'Her Mother's Voice'. Dicksee's election at the age of seventy-one to be President of the Royal Academy is a striking instance of the detachment of that body in the 1920s from too acute an awareness of contemporary fashion, and was perhaps the last official salute to the survival of Pre-Raphaelitism into recent history.

Notes on the plates 36 - 59

36 Dante Gabriel Rossetti (1828–1882)
 Sir Galahad at the Ruined Castle
 Water and body colour. $11\frac{1}{2} \times 13\frac{1}{2}$ inches Signed
 City Museum and Art Gallery, Birmingham

This is a watercolour version of a design originally made by Rossetti to illustrate Moxon's edition of Tennyson, 1857. The corresponding passage from Tennyson's source, Malory, is: 'Then Sir Galahad came unto a mountaine where he found an old chappel, and found there nobody, for all was desolate. And there hee kneeled before the altar, and besought God of holsome counsaile: so as he praied hee heard a voice that said thus: "Go now, thou adventurous Knight, unto the Castle of Maidens, and there doe thou away all the wicked costumes".'

37 Dante Gabriel Rossetti
 Dante drawing an Angel on the Anniversary of Beatrice's Death
 Watercolour, $16\frac{1}{2} \times 24$ inches Signed and dated 1853
 Ashmolean Museum, Oxford

The picture illustrates a passage in Dante's *Vita Nuova*, which Rossetti translated:
'On that day which fulfilled the year since my lady had been made of the citizens of eternal life, . . . I betook myself to draw the resemblance of an angel upon certain tablets.' Ruskin wrote his first letter to Rossetti to praise this 'thoroughly glorious work'. Elizabeth Siddal is portrayed as the young women on the left.

36 Dante Gabriel Rossetti:
Sir Galahad at the Ruined
Castle

37 Dante Gabriel Rossetti:
Dante drawing an Angel
on the Anniversary of
Beatrice's Death

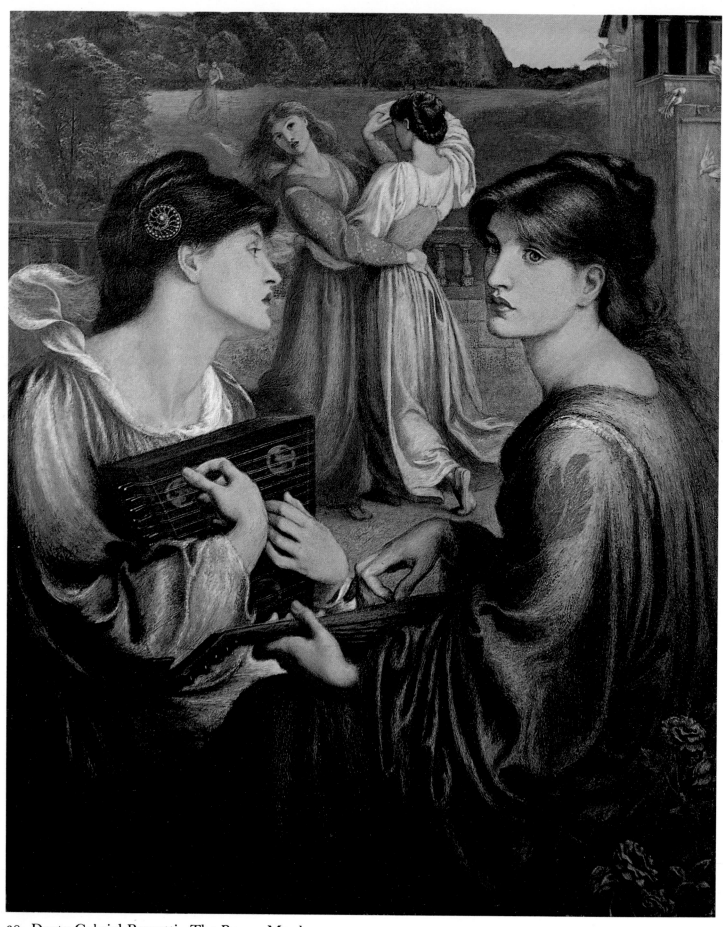

38 Dante Gabriel Rossetti: The Bower Meadow

39 William Holman Hunt: Valentine rescuing Sylvia from Proteus

40 Sir John Everett Millais:
The Return of the Dove to the Ark

42 Sir John Everett Millais:
The Woodman's Daughter

41 William Holman Hunt:
The Importunate Neighbour

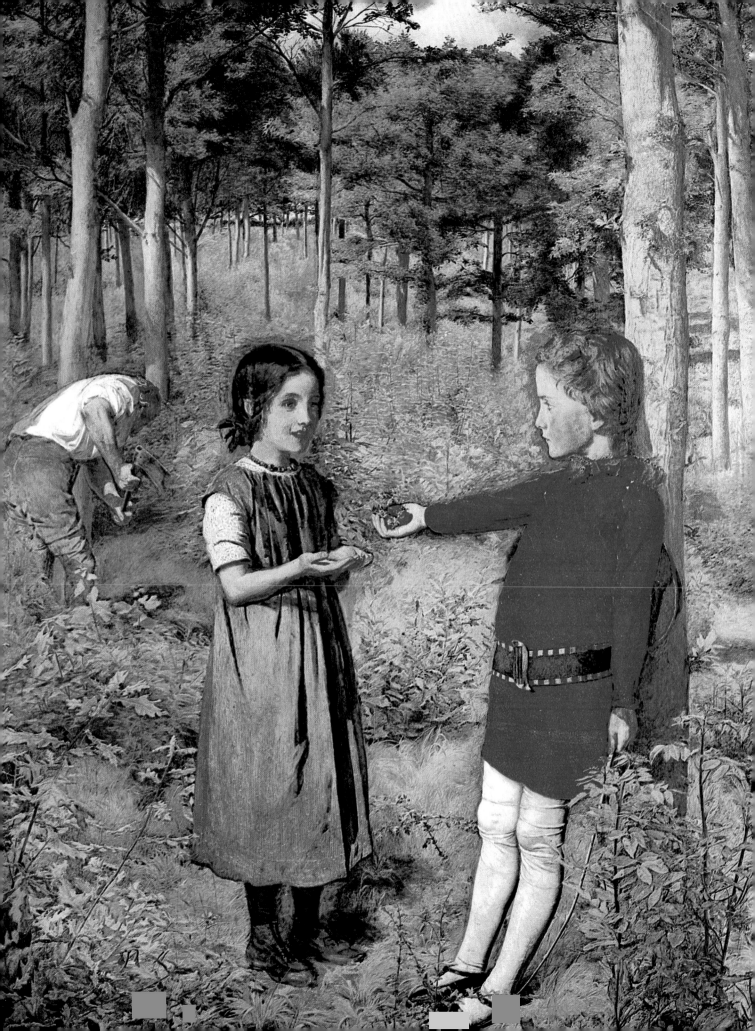

43 James Collinson: Childhood

44 William Lindsay Windus: The Interview of the Apostate Shaxton, Bishop of Salisbury, with Anne Askew, in Prison

45 William Lindsay Windus: Morton before Claverhouse at Tillietudlem

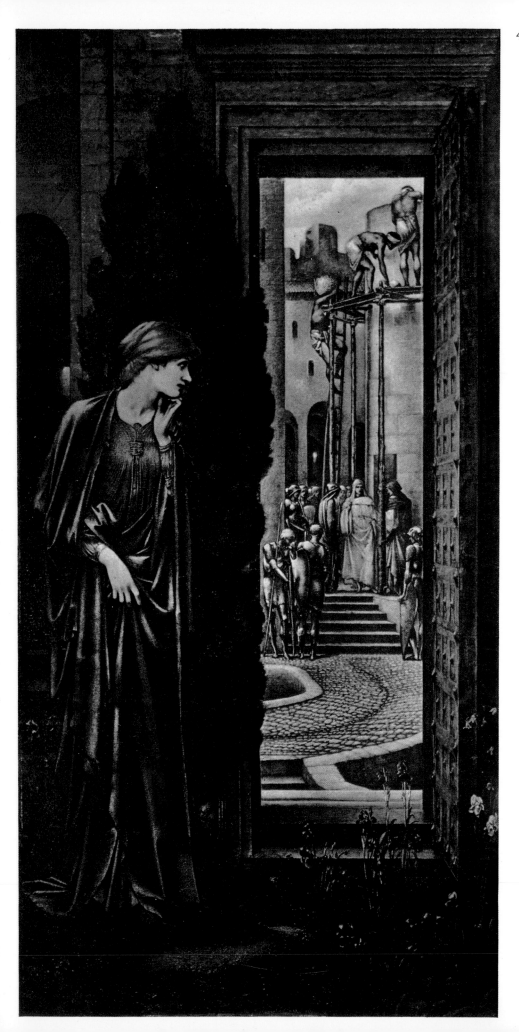

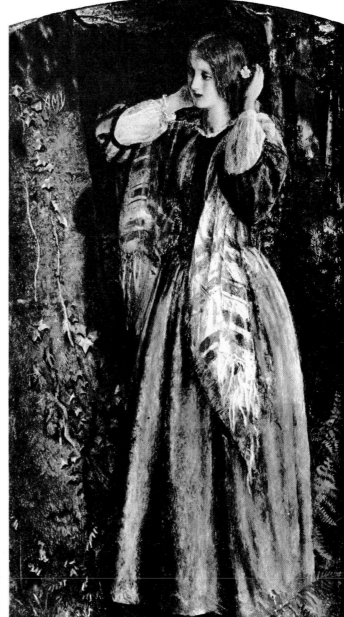

47 Anthony Frederick Augustus Sandys:
Morgan-le-Fay

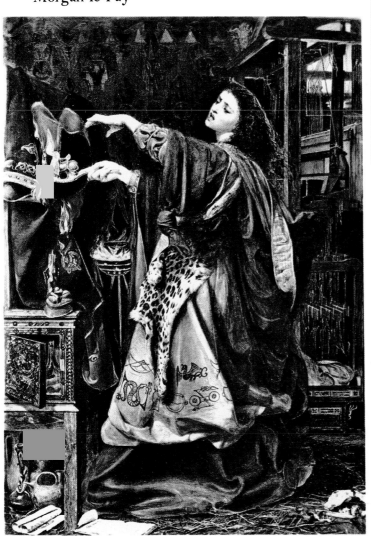

48 Arthur Hughes: 'Amy'

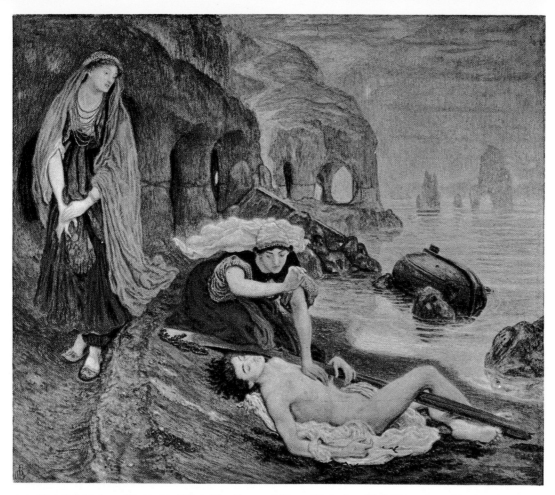

49 Ford Madox Brown: The Finding of Don Juan by Haidée

50 Henry Wallis: The Stonebreaker

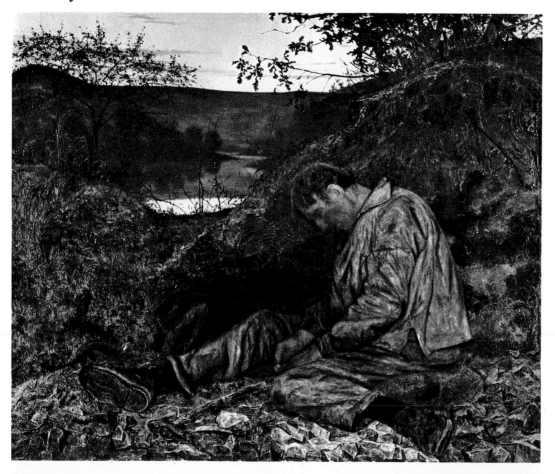

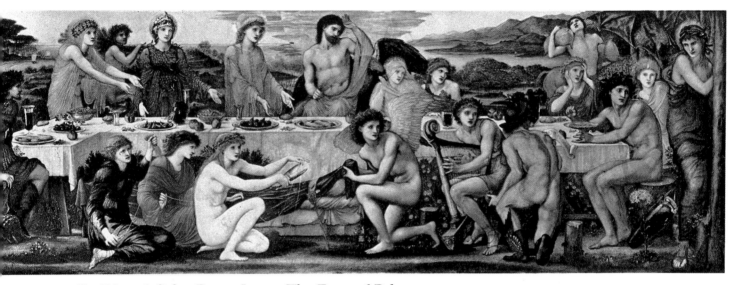

51 Sir Edward Coley Burne-Jones: The Feast of Peleus

52 Sir Edward Coley Burne-Jones: The Backgammon Players

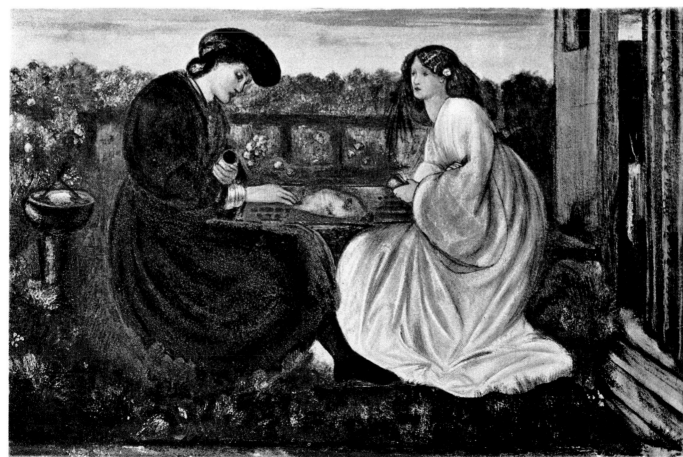

53 Arthur Hughes: Home from Sea

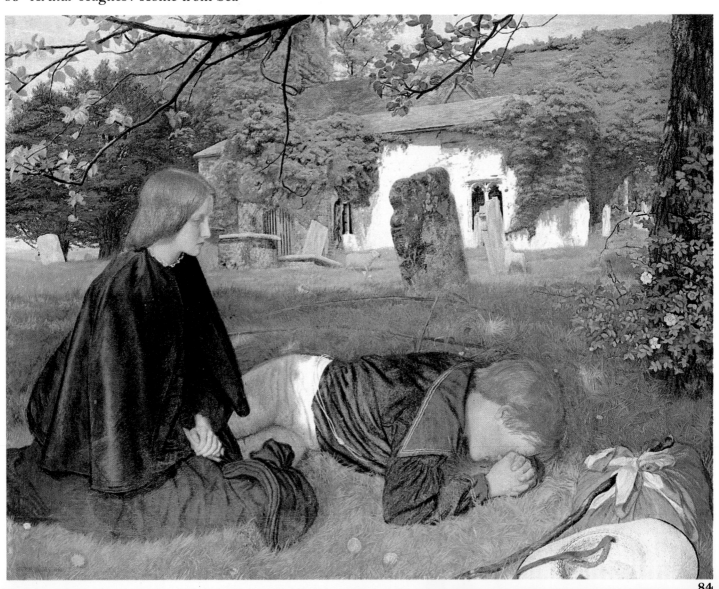

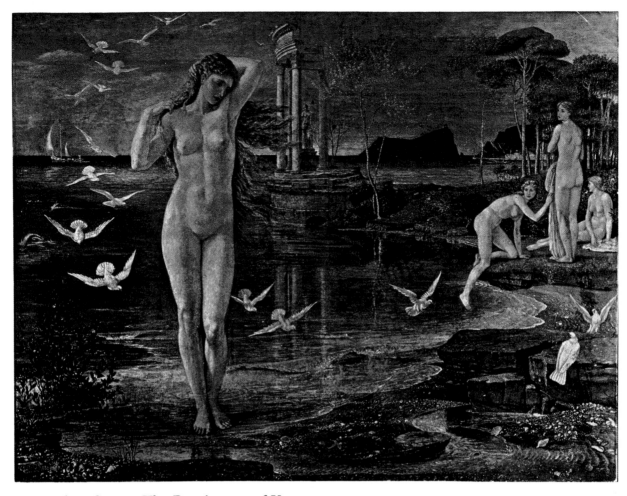

54 Walter Crane: The Renaissance of Venus

55 Henry Holiday: Dante and Beatrice

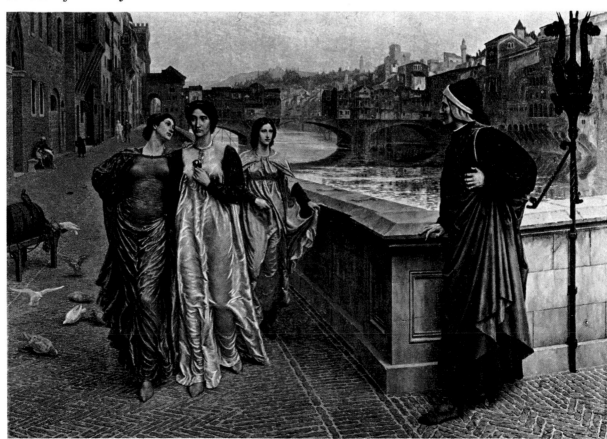

56 John William Waterhouse: Hylas and the Nymphs

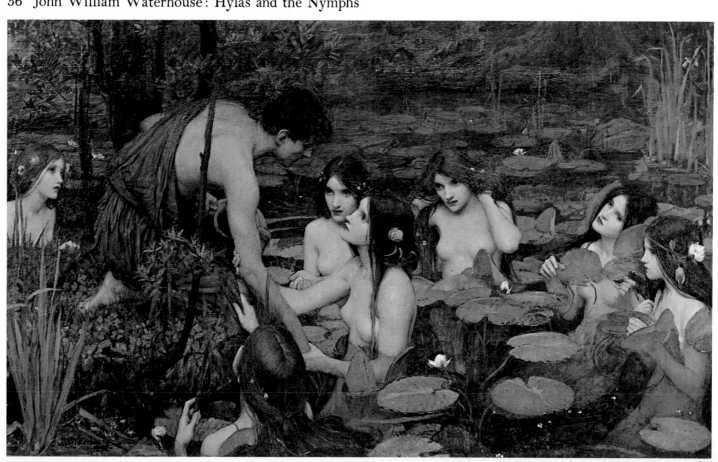

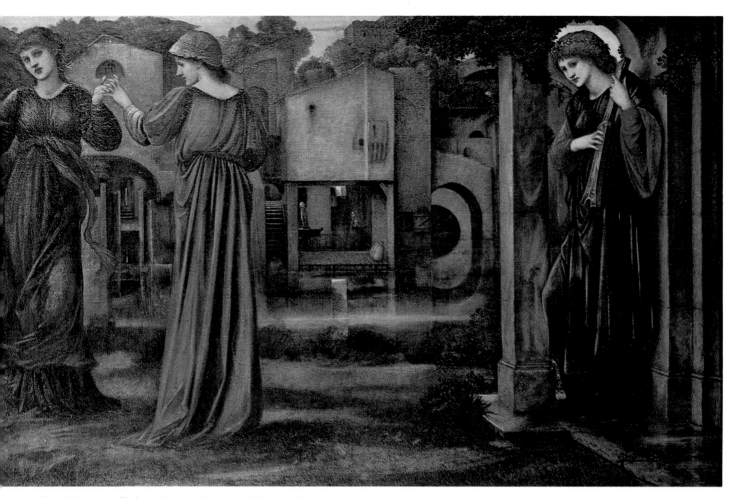

57 Sir Edward Coley Burne-Jones: The Mill

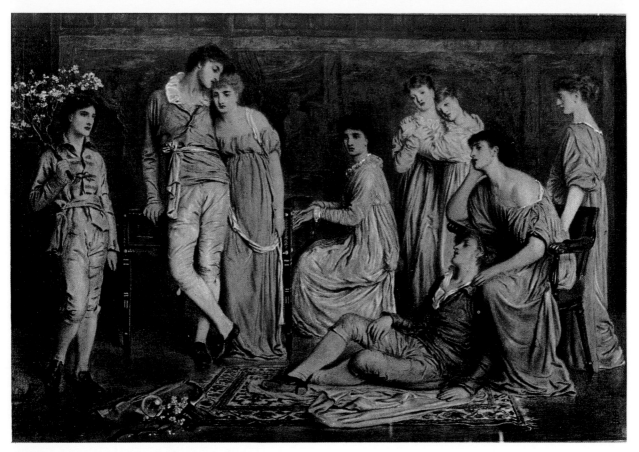

58 Simeon Solomon: A Prelude by Bach

59 Sir Frank Dicksee: A Reverie

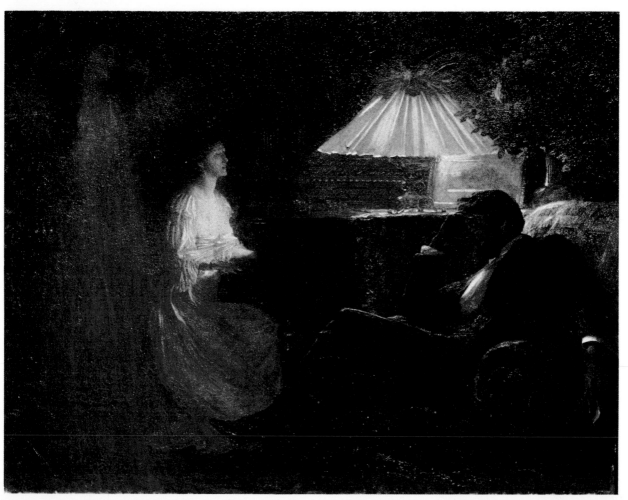

38　Dante Gabriel Rossetti
　　The Bower Meadow
　　$33\frac{1}{2} \times 26\frac{1}{2}$ inches　Signed and dated 1872
　　City Art Gallery, Manchester

Rossetti painted the background from nature in Knole Park in 1850—the landscape by Hunt in Plate 39 being made in his company. The figures were added around 1871/72, when the picture received its present title.

39　William Holman Hunt, OM (1827–1910)
　　Valentine rescuing Sylvia from Proteus
　　$38\frac{3}{4} \times 52\frac{1}{2}$ inches　Signed and dated 1851
　　City Museum and Art Gallery, Birmingham

Exhibited at the Royal Academy, 1851. This painting, with Millais's pictures, was much condemned when exhibited at the Royal Academy; the attack led Ruskin to write to *The Times* in defence of the Pre-Raphaelites. When shown at the Liverpool Academy later in the year, it received a prize of £50. It illustrates the climax of *The Two Gentlemen of Verona*, a play which also supplied the subject for Egg's picture (Pl. 27). The background was painted from nature in Knole Park. The fourth figure is Julia, in boy's clothes. In view of his later critical attitude toward the Pre-Raphaelites it is interesting to note that W. P. Frith lent Hunt the suit of armour worn by Valentine.

40　Sir John Everett Millais, PRA (1829–1896)
　　The Return of the Dove to the Ark
　　$34\frac{1}{2} \times 21\frac{1}{2}$ inches　Signed and dated 1851
　　Ashmolean Museum, Oxford

Exhibited at the Royal Academy in 1851. This was the first Pre-Raphaelite picture to be seen by Morris and Burne-Jones, in a shop window in Oxford.

41　W. Holman Hunt, OM
　　The Importunate Neighbour
　　14 × 20 inches　Dated 1895
　　National Gallery of Victoria, Melbourne

This illustrates the parable of the friend at midnight who knocks up his neighbour for food for an unexpected guest (*St Luke*, chapter 11, 5–8).

42　Sir John Everett Millais, PRA
　　The Woodman's Daughter
　　$35 \times 25\frac{1}{2}$ inches　Signed and dated 1851
　　Guildhall Art Gallery, Corporation of London

Exhibited at the Royal Academy, 1851, this picture was painted as an illustration to the poem 'The Tale of Poor Maud', by Coventry Patmore. This tells

how Maud, the daughter of Gerald the woodman, used to accompany her father as he worked in the 'ancient manor park', to be watched in her turn by the rich Squire's son:—

> He sometimes, in a sullen tone,
> Would offer fruits, and she
> Always received his gifts with an air
> So unreserved and free,
> That half-feign'd distance soon became
> Familiarity.

The four strawberries were bought in Covent Garden in March for the large sum of five-and-sixpence. Also in the interests of realism, Millais commissioned his patron, Mr. Combe, to procure the old walking-boots of a little country girl named Esther who lived in a cottage in Lord Abingdon's park at Botley, near the one in which Millais himself stayed while he was painting the background.

43 James Collinson (1825–1881)
 Childhood
 Panel, $17\frac{3}{4}$ inches in diameter Signed and dated 1855
 The National Gallery of Canada, Ottawa

44 William Lindsay Windus (1822–1907)
 The Interview of the Apostate Shaxton, Bishop of Salisbury, with Anne Askew, in Prison
 $34 \times 43\frac{3}{4}$ inches
 Walker Art Gallery, Liverpool

Exhibited Liverpool Academy, 1849. Painted seven years before the artist demonstrated his conversion to Pre-Raphaelite principles in 'Burd Helen', the incident represented occurred shortly before Anne Askew's execution for heresy in 1546. Shaxton, who had been arraigned with her but saved his life by recanting, was sent to persuade her to do likewise. She replied that it would have been better for him never to have been born.

45 William Lindsay Windus
 Morton before Claverhouse at Tillietudlem
 $43 \times 55\frac{1}{2}$ inches
 Williamson Art Gallery, Birkenhead

Exhibited Liverpool Academy, 1847. The painting illustrates the episode in Scott's *Old Mortality* in which Henry Morton is accused of a capital crime before Claverhouse in the home of Edith Bellenden, who loves him. He gains his life through the intercession of his rival, Lord Evandale. There is an oil sketch for the painting in the Walker Art Gallery, Liverpool.

46 Sir Edward Coley Burne-Jones (1833–1898)
 Danae; or the Tower of Brass
 91 × 44½ inches
 City Art Gallery, Glasgow

The painting illustrates the passage:
'King Acrisius having dreamed that he should be slain by the son of his daughter, Danae, built a brazen tower in which to imprison her as long as she lived, thinking so to escape his fate.'

47 Anthony Frederick Augustus Sandys (1832–1904)
 Morgan-le-Fay
 Panel, 24¾ × 17½ inches
 City Museum and Art Gallery, Birmingham

Exhibited at the Royal Academy, 1864. Morgan-le-Fay is seen weaving the enchanted mantle through which she plans to consume by fire the body of her half-brother, King Arthur, whom she detests for his goodness.

48 Arthur Hughes (1832–1915)
 'Amy'
 Panel, 12⅝ × 7¼ inches
 City Museum and Art Gallery, Birmingham

The picture bears a close relationship to the larger work, 'The Long Engagement', in the same collection.

49 Ford Madox Brown (1821–1893)
 The Finding of Don Juan by Haidée
 Watercolour, 19 × 23 inches
 National Gallery of Victoria, Melbourne

This is the original watercolour version of a subject repeated by Brown on a number of occasions. The design was first made in 1869, as one of a series of illustrations for Moxon's edition of Byron, and shows the discovery of the inanimate Don Juan by Haidée described in the second canto of *Don Juan*. There is a large version in oils, dated 1873, in the City Museum, Birmingham, and a watercolour version, dated 1878, in the Museum of Modern Art, Paris.

50 Henry Wallis (1830–1916)
 The Stonebreaker
 Panel 25¾ × 31 inches Signed and dated 1857–8
 City Museum and Art Gallery, Birmingham

When exhibited at the Royal Academy in 1858, the catalogue contained the following quotation from Carlyle's *Sartor Resartus* (Book III, chapter IV):
'Hardly entreated brother! For us was thy back so bent, for us were thy

straight limbs and fingers so deformed; thou wert our conscript, on whom the lot fell, and fighting our battles wert so marred. For in thee too lay a God-created form, but it was not to be unfolded; encrusted must it stand with the thick adhesions and defacements of labour; and thy body, like thy soul, was not to know freedom.'

Under the Poor Law paupers were frequently employed in breaking stones for the repair of roads. In his entirely original criticism of the system Wallis has shown one who has died at this work.

51 Sir Edward Coley Burne-Jones
 The Feast of Peleus
 $14\frac{3}{4} \times 43$ inches Signed
 City Museum and Art Gallery, Birmingham

The artist planned a vast composition showing the story of Troy designed as an altarpiece with a predella, of which this was the central panel. This version was begun in 1872 and completed in 1881. An unfinished variant of the whole design, mainly carried out by assistants, is in the same collection.

52 Sir Edward Coley Burne-Jones
 The Backgammon Players
 Watercolour, $8\frac{3}{4} \times 14$ inches Painted in 1862
 City Museum and Art Gallery, Birmingham

53 Arthur Hughes
 Home from Sea
 Panel, $20 \times 25\frac{3}{4}$ inches Signed and dated 1862
 Ashmolean Museum, Oxford

Exhibited in its present form at the Royal Academy in 1863. The scene is set in the old churchyard at Chingford. It seems that the painting was first exhibited in 1857 under the title 'A Mother's Grave', but then only contained the single figure of the bereaved boy. The added figure of his sister was painted from the artist's wife.

54 Walter Crane (1845–1915)
 The Renaissance of Venus
 Tempera, $54\frac{1}{2} \times 72\frac{1}{2}$ inches Signed and dated 1877
 The Tate Gallery, London

G. F. Watts owned this painting and gave it to the nation. The model for Venus was Alessandro di Marco, a well-known Italian model (see p. 71).

55 Henry Holiday (1839–1927)
 Dante and Beatrice
 $55 \times 78\frac{1}{2}$ inches
 Walker Art Gallery, Liverpool

Exhibited at the Grosvenor Gallery, 1883. The picture illustrates an incident described in *La Vita Nuova*, in which Dante records that Beatrice, having heard some injurious gossip about him, 'denies him her most sweet salutation'. The artist visited Florence in 1882 to make sketches for the background and accessories. Dante is shown standing on the Ponte Trinita. The pigeons were painted by J. T. Nettleship (1841–1902).

56 John William Waterhouse, RA (1849–1917)
 Hylas and the Nymphs
 38 × 63 inches
 City Art Gallery, Manchester

Exhibited at the Royal Academy in 1897.
The painting illustrates the episode in *The Odyssey* where Hylas, the friend of Ulysses, goes to draw fresh water and is carried away by the nymphs who have fallen in love with his beauty. The nymphs wear waterlilies in their hair in allusion to the botanical name for the plant, *nymphœa*.

57 Sir Edward Coley Burne-Jones
 The Mill
 $35\frac{3}{4}$ × $77\frac{3}{4}$ inches Signed and dated 1870
 Victoria and Albert Museum, London (Ionides Bequest)

Although dated 1870, the artist worked further on it before it was exhibited at the Grosvenor Gallery in 1882.

58 Simeon Solomon (1840–1905)
 A Prelude by Bach
 Watercolour, $16\frac{3}{4}$ × 25 inches
 Private Collection

Swinburne wrote of the people in Simeon Solomon's paintings: 'Always . . . the air and carriage of their beauty has something in it of strange; hardly a figure but has some touch . . . either of eagerness or weariness . . . an expression is there which is not pure Greek.'

59 Sir Frank Dicksee, PRA (1852–1928)
 A Reverie
 $40\frac{1}{2}$ × 54 inches Signed
 Walker Art Gallery, Liverpool

When exhibited at the Royal Academy in 1895, the artist included in the catalogue entry the quotation:

> In the years fled,
> Lips that are dead
> Sang me that song.

4 · The predominance of genre

In 1855 a great international exhibition, which included a large section of paintings, was held in Paris. The English contribution to the galleries was the largest and most important manifestation of our native art outside its own shores yet to be held; it was also the first opportunity for the Parisians to judge its different qualities since Lawrence, Constable and Copley Fielding had had so much effect at the Salon of 1824. The jury of selection had done their job impartially, and made a balanced choice between established and still controversial work. It is accordingly a salutary exercise in historical perspective to find that Baudelaire, writing of the English section, accords his enthusiasm equally to C. R. Leslie (who showed 'Uncle Toby and the Widow Wadman' and a subject from *Don Quixote*) and J. R. Millais (who showed 'Ophelia', 'The Return of the Dove to the Ark' and 'The Order of Release'); and that he writes impartially of 'the two Hunts', that is, W. H. 'Bird's Nest' Hunt and Holman Hunt (who showed 'The Light of the World', 'Strayed Sheep' and 'Claudio and Isabella'). The internal differences separating the generations and exacerbating the heated battles between the Pre-Raphaelites and the other painters were unimportant to Baudelaire in the light of the common national characteristics he could discern. To him, Maclise, J. J. Chalon, Hook, Paton, Sir Francis Grant, Cattermole and the virtually unknown architect Kendall were severally the component 'representatives of the imagination and the precious powers of the soul'.

As well as looking in British art for fantasy, for exotic colour and theatrical gesture, Baudelaire also specified amongst its salient characteristics its 'intimate glimpses of home'. This observation by the most perceptive French critic of his day reinforced the contemporary comment made by Richard Redgrave about the contrasts observed between Continental and English paintings at the 1855 Exhibition: 'To pass from the grand salons appropriated in the Palais des Beaux Arts to French and Continental works, into the long gallery of British pictures, was to pass at once from the midst of warfare and its incidents, from passion, strife and bloodshed, from martyrdoms and suffering, to the peaceful scenes of home.'

It was in the 1850s and 1860s that the impulse to paint calm domestic scenes reached its peak, and it is in this field that the greatest number of rediscovered reputations has been found and others await the finding. At a time when official favour was still directed to the historical, the literary or the exotic, many artists of widely differing attainment and fame felt impelled to paint at least one scene of contemporary life. Just as Samuel Butler was described as *Homo unius libri*, many of these artists are men of one picture. H. A. Bowler

would scarcely be remembered now did not his painting 'The Doubt' represent him in the Tate Gallery with a perfectly phrased interpretation of up-to-date agnosticism in a country churchyard.

The impetus to paint modern life had of course a long history, going for its roots at least as far back as Hogarth. The first nineteenth-century manifestation of contemporary *genre*, in Wilkie's paintings, was rather devoted to the life of the peasant than to the cosier urban milieu which grew in favour in the middle of the century. The Cranbrook school—Webster, Hardy, A. E. Mulready—had at the beginning been concerned with the humours of children; and though, among the members of The Clique, Frith had declared his intentions of being a painter of the modern scene, it was, as has been explained, not till the 1850s that he really felt free to do so.

Richard Redgrave, whose views on the Paris Exhibition have just been quoted, was himself one of the earliest to make the transition and he did so with a strong element of social purpose. Even so his earlier attempts had been halting, and to comment on so contemporary a theme as 'The Reduced Gentleman's Daughter' in 1840, he had to make his painting a literary illustration of an article in *The Rambler*, clothing his characters in eighteenth-century dress. His efforts met with a good deal of criticism, and though he painted 'The Poor Teacher' in contemporary dress in 1843, he continued to paint other political tracts in period costume.

Like many other characteristics of the painting of the 1850s—its lighter key of colour, its abandonment of broad handling—the explosion of modern *genre* coincided with the advent of the Pre-Raphaelites. It may indeed have been fostered by their theory which, as has been seen, favoured taking subjects from daily life. Though such themes make only a modest showing amongst Holman Hunt's mediaeval, oriental and religious subjects, and Rossetti laboured for thirty years to complete his one contemporary subject, 'Found', Millais made an early start with 'The Woodman's Daughter' of 1851 and 'The Rescue' of 1855. Meanwhile James Collinson had preceded him with 'Answering the Emigrant's Letter' in 1850 and other hardly remembered but faithful views of daily life. The vogue once established, critical resistance began to crumble, and the more prudent, like Frith with 'Ramsgate Sands' and Egg with 'Past and Present', could indulge their desire to explore the scene around them.

One aspect of that scene which especially attracted the attention of artists was prostitution and adulterous love. This is the subject-matter of Egg's 'Past and Present', Hunt's 'The Awakening Conscience', and Elmore's 'On the Brink'. But however justified they were in dwelling on this subject, in the light of the high incidence of prostitution in London, this did not provide the predominant theme for the artist drawn to social realism and political comment. As much attention was given to the dominant economic theme of poverty leading to emigration, as in Collinson's 'Answering the Emigrant's Letter' and F. M. Brown's 'The Last of England'. But besides these more serious themes, there are simpler explorations of holiday life, of the seaside and of the joys and sorrows of childhood. Then, as the decade progresses, the separation of homes through the Crimean War contributed a number of subjects for the 1855 Academy Exhibition. This upsurge of domesticity

coincides with the height of influence of the Victorian novel, as well as with the researches of Mayhew into the life of the London Poor; with journalism and photography it makes the mid-century an accessible one for exploration and understanding.

There is a conspicuous homogeneity of treatment amongst the painters of these subjects. Probably this is to be attributed to the success of the plans for national art education laid by Dyce and fostered by Redgrave. Many of the artists who have come to the surface as the period is investigated were themselves involved in the system. Bowler, for instance, the author of 'The Doubt', was headmaster of a provincial art school for five years, then an art inspector, before ending his career as Professor of Perspective at the Royal Academy. To their general grounding in first principles can be attributed the painterly qualities of 'No Walk To-day' by Sophie Anderson and 'The Bird's Nest' by T. F. Marshall, though neither artist made a great reputation.

The records of William Maw Egley, preserved in the Victoria and Albert Museum, throw an interesting light upon the incidence of taste for contemporary subjects. Egley was the son of a successful painter of portrait miniatures, and, having been born in 1826, began his career in the hey-day of the historical picture. He made, for a competition organized by the Art Union in 1844, a cartoon on the subject of 'Wulstan, Bishop of Worcester, preaching against the practice of the early Anglo-Saxons selling their children as slaves to the Irish'; this was sadly marked as 'Sold with old lumber, 1878'.

Egley is a dull enough dog, who never achieved consistent success in his own age and the major part of whose work hardly deserves consideration now. He was a painfully slow worker, and disposed of many of his pictures in bulk to dealers such as Henry Wallis and Arthur Tooth. Yet his diaries show him a constant practitioner of mesmerism in the home circle at the height of the fashion for this experience, and in the wake of Dr Elliotson. And his choice of subjects for painting shows an equally attentive ear for the passing vogue. To begin with, he painted the customary literary illustrations to the texts of *The Vicar of Wakefield*, *Don Juan*, plays of Shakespeare and Molière. Towards the end of his career he painted eighteenth-century subject pieces in the manner of Meissonier mediated through Marcus Stone. Accordingly, it is no surprise to find that when subjects from contemporary life became generally popular he began to paint them. It was not without effect that he was a friend of W. P. Frith and painted backgrounds in several of Frith's pictures. With Egley the painting of modern costume begins in 1855, and from then on, for some years, there are descriptions of the dress in his paintings such as 'Snow white trousers with two frills of lace reaching the feet' and frequent references to 'glittering patent leather sandalled shoes' and the like.

Furthermore, it is from these excursions into modern life that Egley is now remembered. 'The Talking Oak', an illustration to Tennyson of 1856, 'Omnibus Life in London' of 1859 and 'Hullo Largess' of 1862 have all come to the surface again in recent years and preserve, in spite of the hardness and metallic quality which his contemporary critics deplored, an actuality denied to his interpretations of *Tartuffe* or 'The Latest Acquisition' (a collector, dressed in eighteenth-century costume).

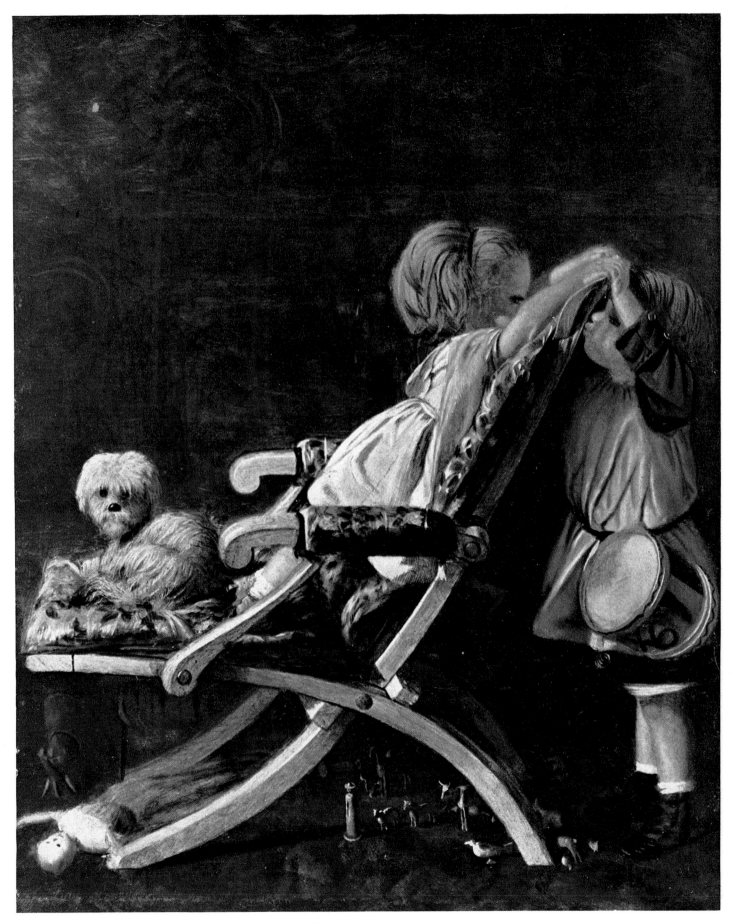

60 Arthur Boyd Houghton: Interior with Children at Play

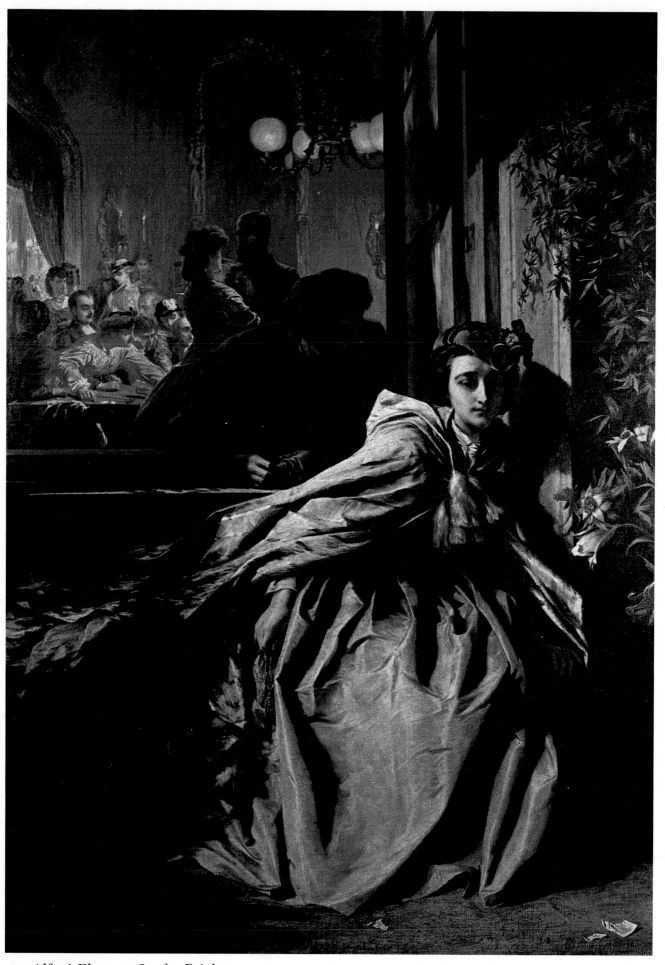

61 Alfred Elmore: On the Brink

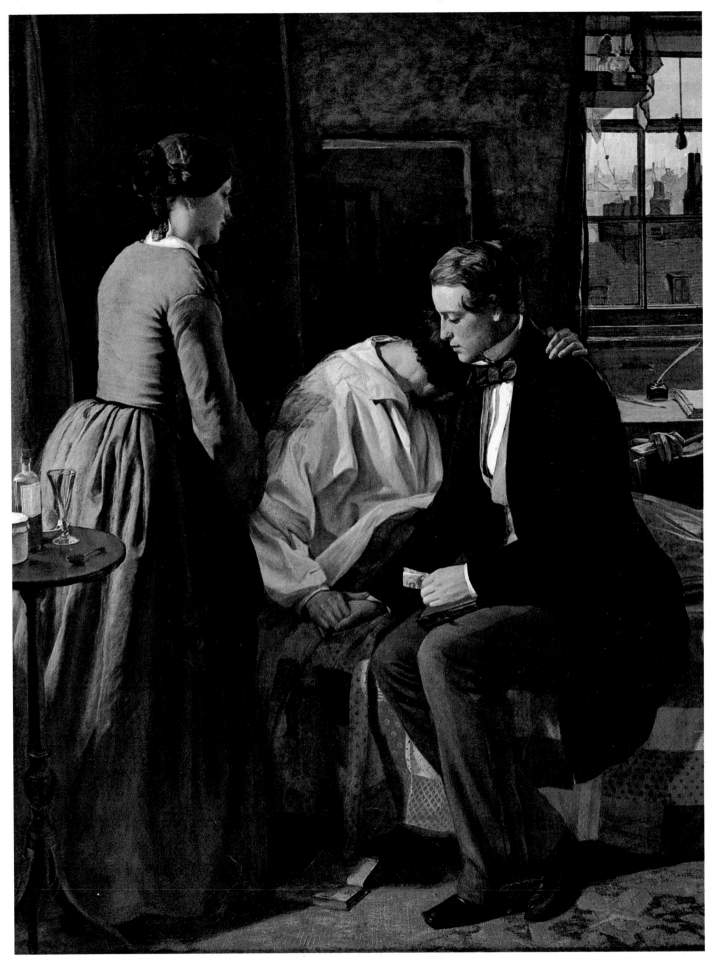

62 Alfred Rankley: Old Schoolfellows

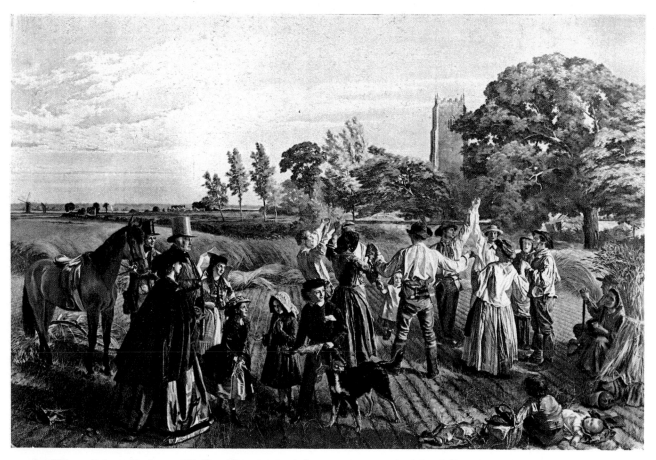

63 William Maw Egley: 'Hallo, Largess'. A harvest scene in Norfolk

64 Arthur Boyd Houghton: Holborn in 1861

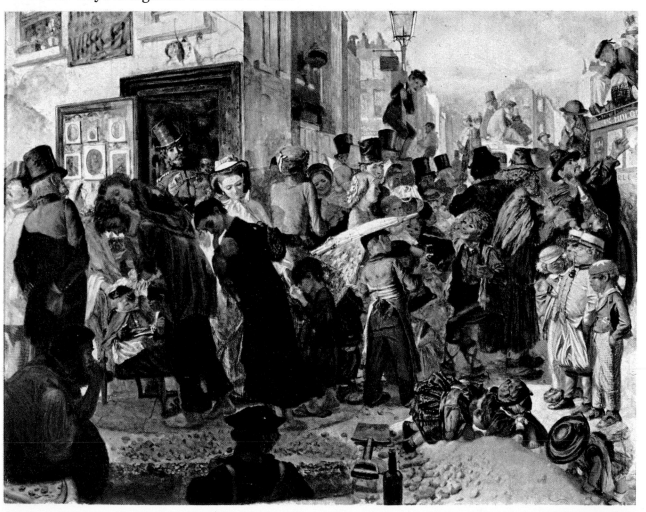

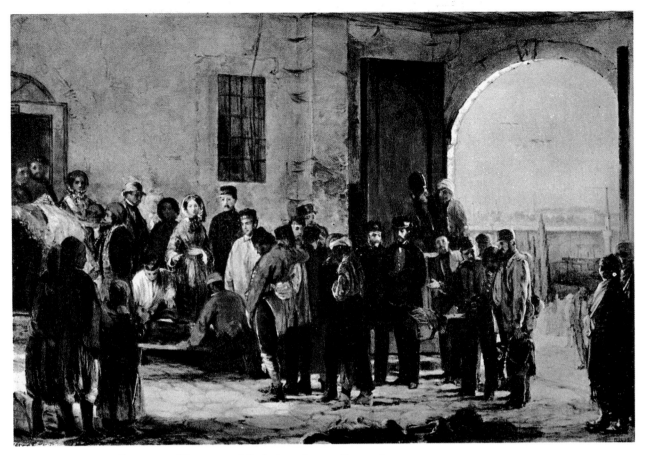

65 Jerry Barrett: Florence Nightingale at Scutari

66 Abraham Solomon: Waiting for the Verdict

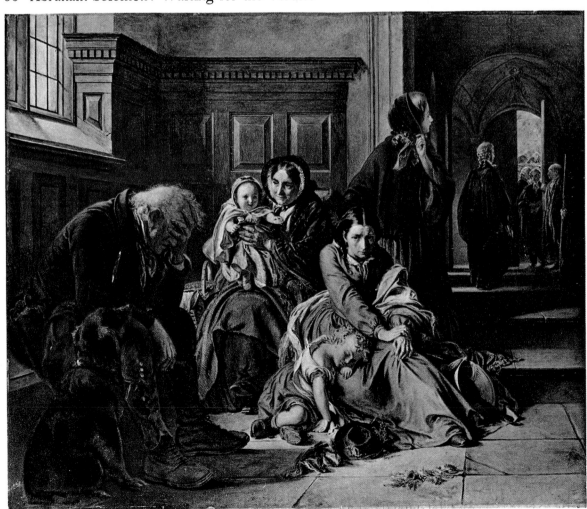

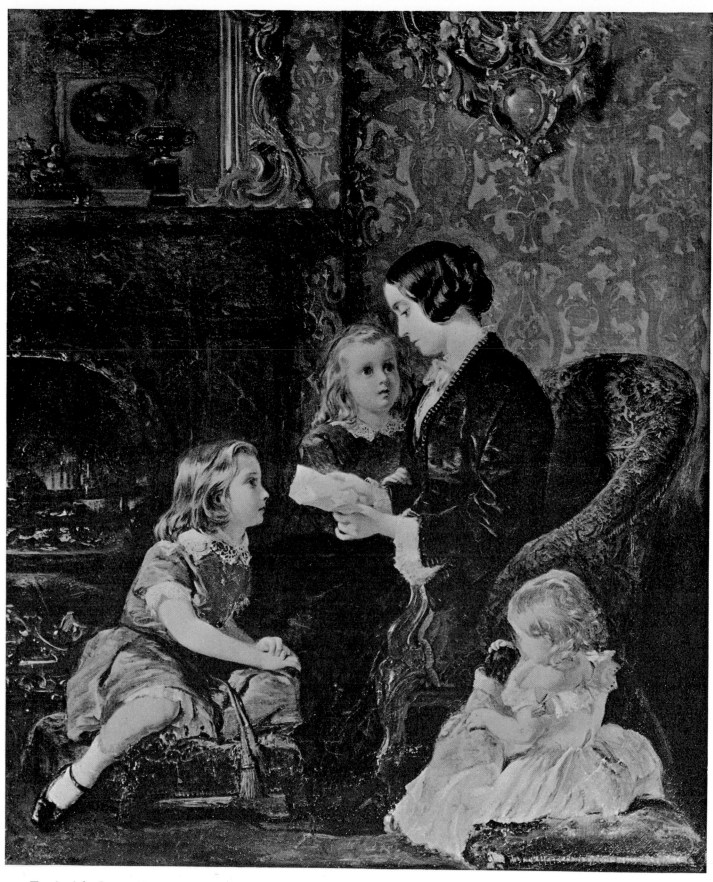

67 Frederick Goodall: A Letter from Papa

68 Alexander Farmer: An Anxious Hour

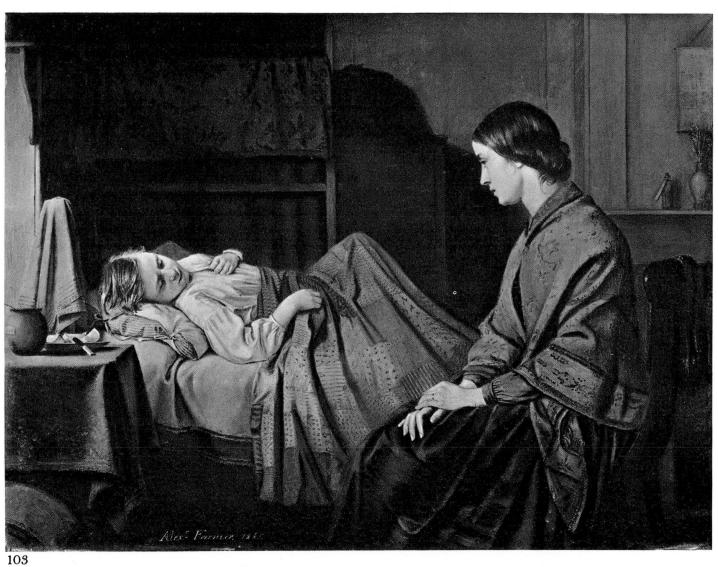

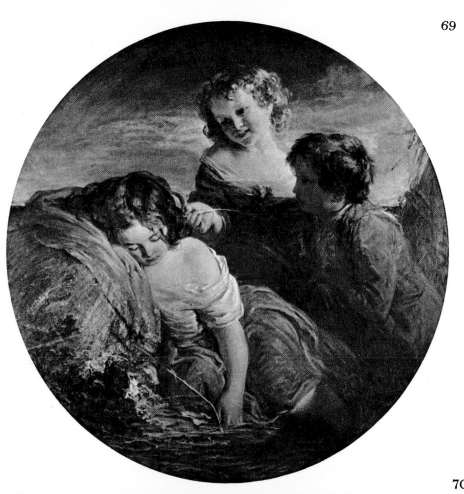

70 Thomas Faed: The Mitherless Bairn

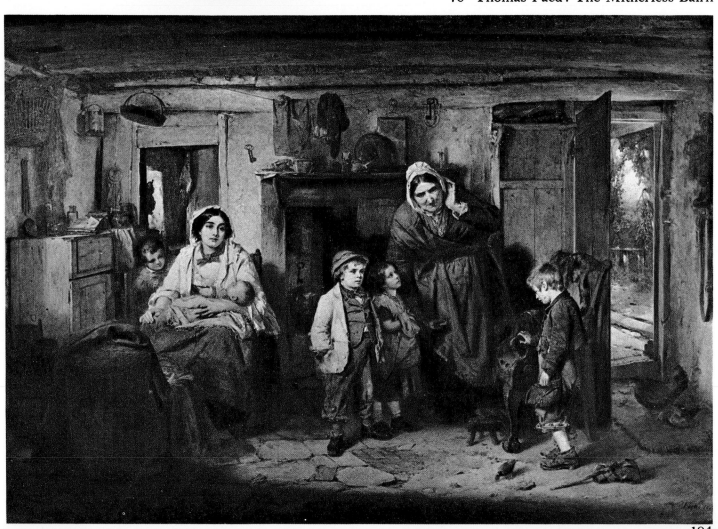

71 Frederick Walker: Old Letters

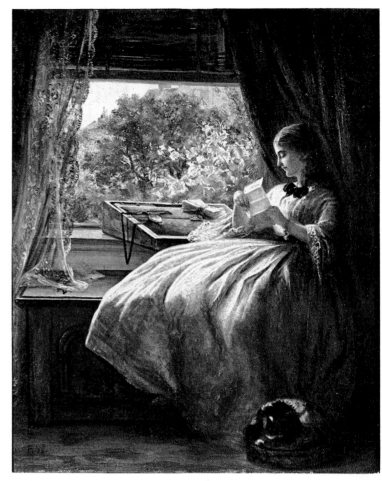

72 Eyre Crowe: The Bench by the Sea

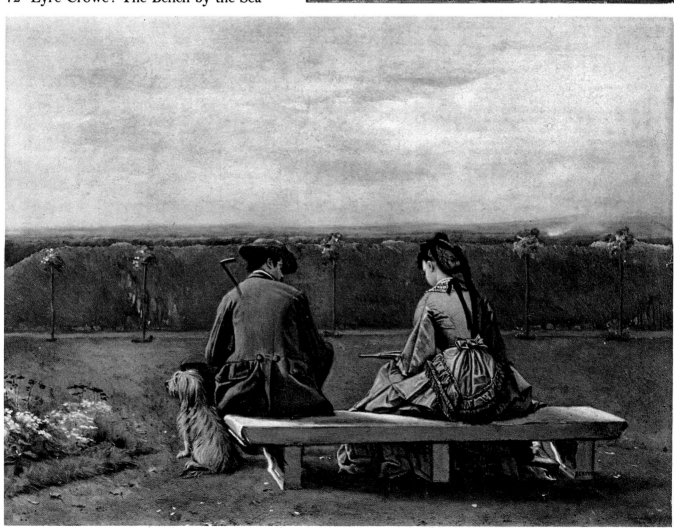

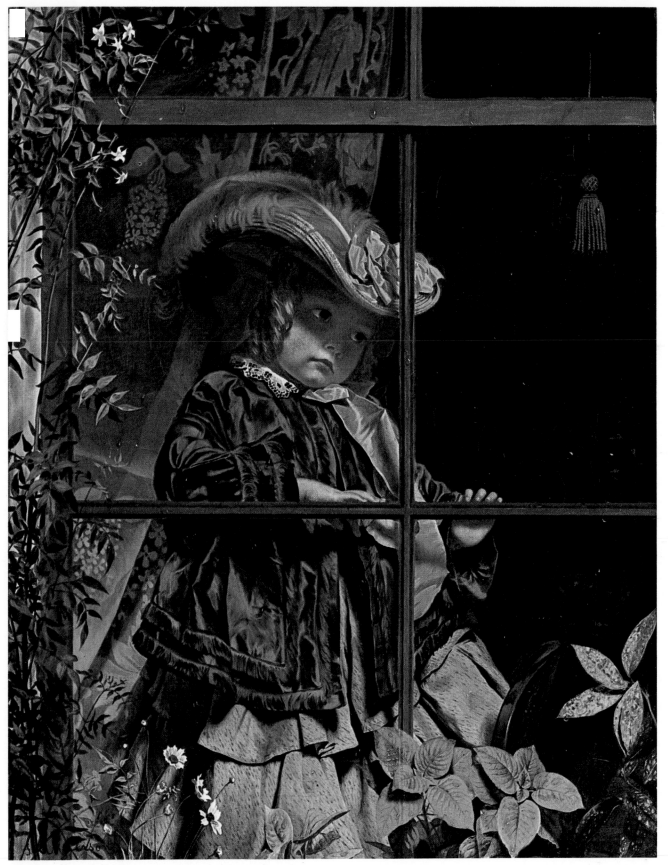

73 Mrs Sophie Anderson: No Walk To-day

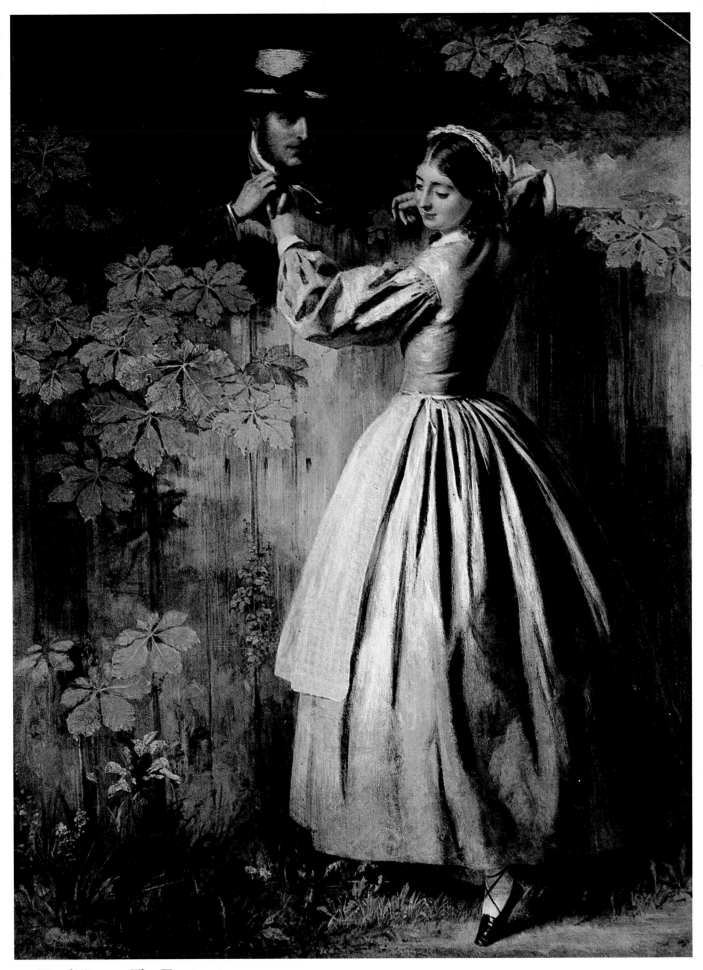

74 Frank Stone: The Tryst

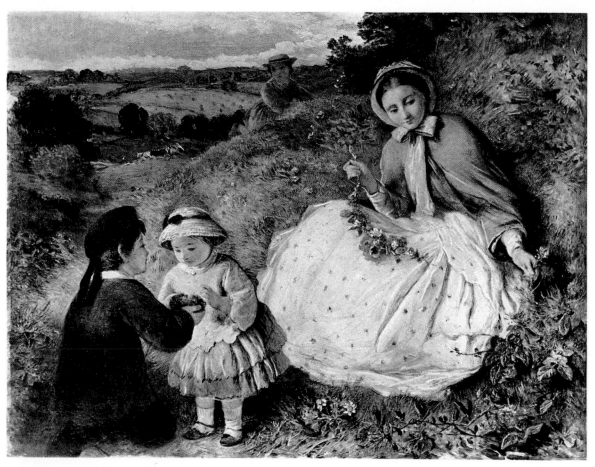

75 Thomas Falcon Marshall: The Bird's Nest

76 Charles Hunt: In the Museum

77 R. W. Chapman: Posting the Letter

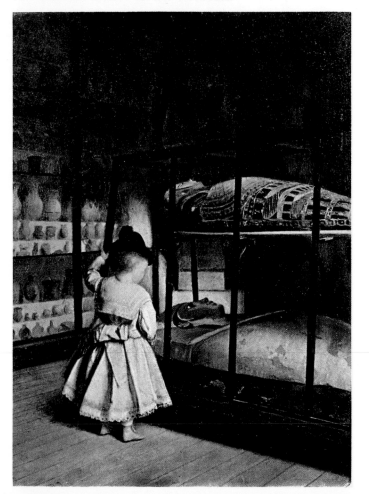

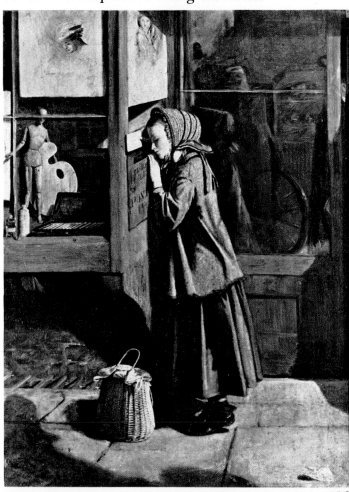

The artist compiled a detailed catalogue of over 1,000 paintings which he made between 1840 and 1910; in this he gave an especially full account of the construction and reception of 'Omnibus Life in London' and 'Hullo Largess'. For the former, now in the Tate Gallery, he used many of his relatives and friends as models for the fourteen figures sitting in the bus. He records that though the bus was studied from a vehicle in the yard of an omnibus builder in Paddington, he made a 'rude structure of boxes, and planks etc.' in his garden to study the effect of light and shade on the figures. When exhibited, it was recognized as a true statement of a salient feature of contemporary life, and even so potentially severe a critic as F. G. Stephens, the Pre-Raphaelite, wrote columns of descriptive praise, mentioning every detail down to the advertisement for Samuels 17s 6d trousers pasted on the carriage wall.

'Hullo Largess' was commissioned. It illustrates an old-time harvest custom known only in the eastern counties of England, and described by Richard Cobbold in his regional novel *Margaret Catchpole*. It was a form of acknowledging the presents customarily made by visitors who watched the harvest, rather in the form of a college cry: 'They then collect in a circle, and "Hullo, Lar-r-r-ge-ess" is given as loud and as long as their lungs will allow, at the same time elevating their hands as high as they can, and still keeping hold. This is done three times, and immediately followed by three successive whoops.' Egley saw this happening when staying at Reedham Old Hall, Norfolk, in 1860 and the owner, John Rose, asked him to paint the picture, which he only delivered two years later after showing it at the Royal Academy.

In other excursions into the contemporary scene Egley chose to take his subjects from poems such as Tennyson's *The Princess* and Elizabeth Barrett Browning's *Aurora Leigh*. This was a rather timid half-measure in which a certain element of distance came between the artist and his subject. It does not make for those 'intimate glimpses of home' of which Baudelaire wrote. Yet there was a keen interest, at length realized, in just these subjects, treated with as little melodrama as possible. J. L. Tupper, the aesthetic theorist who wrote a programme for art in the short-lived Pre-Raphaelite magazine *The Germ*, had asked, in a general plea for modern subject-matter, why artists should invite their public 'to love a Ladie in bower and not a wife's fireside'.

One of the artists who most successfully made this his subject was Arthur Boyd Houghton. He was outstanding as a book illustrator even amongst his brilliant contemporaries of the 1860s, his most conspicuous successes being set in the East (*The Arabian Nights*, published 1863–65) or in Renaissance Spain (*Don Quixote*, published in 1866). His oil paintings are generally on a small scale, but they reveal a refreshingly undoctrinaire approach to the everyday scenes of home life, and give a much less tragic view of Victorian domesticity than might be gleaned solely from the evidence of Hunt's 'The Awakening Conscience' or Egg's 'Past and Present'. They have the intimacy of conviction and enjoyment. And when he observed the outside world, as in his 'Holborn in 1861', he was content to present its actual appearance without overloading the scene with the social significance which had appealed to Ford Madox Brown when he painted 'Work'. He adopts the ugly types of Pre-Raphaelite children, but with comic or satiric effect. Nor was there any lack of astringency

about Houghton's vision when he chose to display it. He was sent to travel in America to provide illustrations for the newly founded *Graphic*. The sketches he made of Shaker customs are of compelling interest, but he was conscious of ugliness in much of what he saw, and conveyed his sense of it in his drawings.

Frith had recognized that the only chance of acquiring a fame which would outlast his lifetime depended on his paintings of modern life; it was for this reason that he deliberated carefully before starting his series of big canvases with 'Ramsgate Sands', and took great trouble matching his subject-matter to the bent of his genius. That he was right in this assessment of the relative merits of his historical and his contemporary paintings is shown not only by the current view of his own work but also by the attention paid to many other artists who pursued a somewhat similar career. Alfred Elmore, who was twenty-two when Victoria succeeded to the throne, and Alfred Rankley, who was four years younger, are two cases in point. Both these artists were caught up in the early Victorian craze for ambitious historical pieces. Elmore composed in the 1840s 'The Martyrdom of Thomas à Becket' and 'Rienzi in the Forum'. Rankley was one of many artists who, rummaging in pre-Norman history for suitable episodes in the early history of Britain, chose 'Edith finding the Body of Harold' as a vehicle for dramatic effect. If these works, praised in their day, have survived, no one has shown any diligent concern to seek them out; but when a scene from modern life by either of them has appeared, such as Elmore's 'On the Brink' and Rankley's 'Old Schoolfellows', they have promptly renewed interest in the artists. So far as the work of these painters can be judged from the titles of exhibited works, which, with a few engravings or unsatisfactory wood-cuts, is often all the enquirer has to guide him, they were timid in adopting such themes and only did so sporadically. Rankley indeed, the younger man, began to do so early in his career. Even so, his exhibit of 1849 called 'Innocence and Guilt', which, with its prefixed verses

> To woman's heart, when fair and free
> Her sins seem great and manifold.
> When sunk in crime and misery,
> No crime can then her soul behold,

suggests that its theme was the endemic one of the fallen woman, was in fact a reading of the Litany set in a country church in eighteenth-century costume. In the following year, however, his 'Contentment' showed a young college graduate seated somewhat incongruously in cap and gown in a country cottage, an exploration in modern dress of the effects of education on social status. The careful technical training required for the execution of his earlier historical works is apparent in his 'Old Schoolfellows' of 1854; with its quotation from Proverbs xvii, 'A friend loveth at all times and a brother is born for adversity', it has, in its theme of the prosperous friend alleviating the poor scholar in his illness, that clarity of anecdote and simplicity of moral appeal which was the strength as well as the limitation of mid-Victorian subject painting.

Elmore seems not to have ventured into the field of modern *genre* till it was even more firmly established; but when he did so with his 'On the Brink' in 1865, he was successful both with his own public and in creating a composition

of lasting effect. As a tragedy of the gambling rooms at Homburg, it precedes Frith's 'The Salon d'Or' of 1871 and tells its dramatic tale less diffusely. Elmore has attempted a visual effect of some subtlety in contrasting the glow of the warmly lighted room with the moonlight on the woman's face. And he has nicely left it to the onlooker to consider whether the brink she stands on involves not only suicide but a fate worse than death in the company of the would-be seducer leaning from the window to speak to her.

In the same year, Alexander Farmer showed in 'An Anxious Hour' a Victorian theme which all recognize as typical: the illness of a child watched by his worried mother. Yet his treatment of the subject has none of the over-burdened sensibility of the death of Dickens's children; as with Fildes's more famous picture 'The Doctor', there is sentiment but not sentimentality about it.

G. E. Hicks, who showed large paintings of 'The Dividend Day at the Bank' (1859), 'The General Post Office: one Minute to Six' (1860) and 'Billingsgate' (1861) in successive years, was one of the few artists to emulate Frith by a systematic series of journalistic explorations of the London scene. But many others did as Egley, Rankley and Elmore, and interposed modern *genre* into a predominantly more backward looking *oeuvre*. Frederick Goodall, for example, built up his successful career—a success which enabled him to commission Norman Shaw to build his house—partly on pictures of historical incidents, such as 'Happy Days of Charles I', partly on old-fashioned *genre* such as his 'Village Post-Office' of 1849, set in eighteenth-century costume, and partly on Eastern subjects based on his travels in Egypt. Yet at the time of the Crimean War he was sufficiently stirred by the impact of its actuality to paint the *intimiste* 'A letter from Papa', which gives a comment on war without recourse to harrowing detail and vividly preserves the effect of a Victorian drawing-room interior, with its riot of rococo ornament, its wealth of rich pattern and its warm comfort.

The Victorians emancipated themselves in this way from a groove into which their painting had fallen. To all but the most accomplished painters, a picture of the discovery of the printing press would provide little difference in the way of visual stimulus from one of the landing of William the Conqueror on British soil. These historical subjects were not felt sufficiently for the artists to enter into them. But they could enter with a sense of participation into those aspects of the world around them which attracted most attention: the growth of transport, railway stations and railway carriages, the seaside resorts to which the railways led, the wider growth of leisure, symbolized by the opera-goer (not the stage spectacle or operatic star), by billiards, archery, gardening.

The stylistic differences normally to be expected between the generations are also lessened in the painting of contemporary *genre*. Frank Stone was born in 1800, and was therefore of an older generation than Frith, Millais or Hicks. He was none the less one of the circle of artists with whom Dickens surrounded himself, which has already been seen to include Maclise and Egg. In 'The Tryst' he produced a picture of over-the-fence courtship which was fully in the modern manner when it was painted, presumably in the 1850s. Calderon's 'Broken Vows' of 1856 might have been painted as a pendant to it, yet it is the work of a man thirty-three years his junior. And in this piece Stone was far

more up to date than his son, Marcus, with his dreary patterns of love set in Regency costume. In its breadth of treatment, of course, it is the antithesis of a Pre-Raphaelite version of the scene, and the juxtaposition of the Stone and the Calderon show what the enemies of the new movement were unable to accept, and why they would, faced with any attempt at sharp focus, use the label Pre-Raphaelite in a pejorative sense.

This was not the full extent of the stylistic contrast to be found even within the simple sub-section of modern-life painting. Thomas Faed kept alive the spirit of Scottish regional painting so triumphantly established by Wilkie. It was his 'The Mitherless Bairn' which made his reputation in London when he showed it in 1855, and he followed this with a succession of similar works in which he explored the problems of poverty in a matter-of-fact but sympathetic way.

Henry Le Jeune's studies of children playing were of a far more idyllic nature. He was of Flemish origin and his brushwork shows a flickering sensitivity alien to the hard metallic quality of the 1850s and 1860s, a fact which perhaps explains why, after becoming curator of painting in the Royal Academy schools in 1848, he did not become ARA, the apex of his official career, till 1863.

Frederick Walker, the son of a Cockney jeweller, entered the art world through making drawings for a wood-engraver, and developed from black-and-white line to highly stippled, gouache-dense watercolours and a small number of oils. He died young, aged thirty-five, and in consequence received a higher meed of praise then, and since, than his actual achievement warrants; he was as 'Old Letters' shows, typical but in no sense outstanding.

Eyre Crowe had precisely the opposite fate; he outlived any possibility of fame. But he had started with innumerable advantages—scion of Anglo-Indian sahibs, cousin of the Thackerays, the Prinseps and other nabobs. His younger brother was the well-known art-historian who worked with Cavalcaselle; he himself became secretary to Thackeray and went with him on a lecture tour to America in 1852. This provided him with the subject of his painting of 'The Sale of Slaves at Richmond, Virginia', a timely foretaste of the Civil War. But he survived till 1910, and his biographer in the *Dictionary of National Biography* sadly records: 'Outliving his contemporaries and spending his last years in much seclusion, he was long an habitué of the Reform Club which he joined in 1866.' Like Hughes, like Dicksee, like Windus, he had outlived his age. Yet in his own time he was capable of such idyllic observations as 'The Bench by the Sea'.

Others, though few in number, were conscious that history was being made in their own time. Haydon, with politically engaged sympathies, had painted 'The Reform Banquet'. With similar intention, and with more executive charm, Jerry Barrett had found a suitable subject in 'Florence Nightingale receiving the wounded at Scutari'. Subsequently he turned to reconstructions of similar events in the earlier part of the century—reproductions of his 'Elizabeth Fry reading to the Prisoners at Newgate', for instance, became popular.

The possibility of reproduction was a factor of the greatest importance to the mid-nineteenth-century artist. Copyright had, thanks to Hogarth, been placed on a satisfactory basis, reproductive engraving was at its highest level,

and the sale of engraving rights could be a high part of a picture's yield. Second only to Frith in popular demand, measured by this means, was Abraham Solomon. A member of a gifted family—his sister, Rebecca, achieved a noteworthy success and the deplorable Simeon was his brother—he began his own artistic career in the customary way by painting illustrations to Scott and Goldsmith. But in 1854 he showed two scenes of modern life: 'First Class—The Meeting . . . and at first meeting loved' and with it 'Second Class—The Parting. Thus part we rich in sorrow, parting poor.' They are a straightforward pair of parables, fearless in their recognition of the advantages of wealth: in the first class carriage the handsome young officer meets and fascinates an attractive girl; whilst the second class carriage witnesses the sad parting of a mother and her son, who is emigrating. But the reception given by public and critics alike to the former scene shows how thin was the dividing line between the permissible and the indelicate, so far as relations between the sexes were concerned. Solomon had originally placed the girl in a seat near the young officer; her father was beyond her in her corner, fast asleep. Such lack of care and tender innocence, this failure to chaperon, was unacceptable, and when Solomon painted replicas he rearranged these characters: the girl is now in the corner, simpering across a larger distance at the young man, and her father is almost aggressively awake and conversing brightly. No such misgivings attended the exhibition of 'Waiting for the Verdict' in 1857. This was engraved in mezzotint by W. H. Simmons and achieved a vast sale. And such was the pressure towards the painting of modern life in this decade that such scenes by almost unknown artists—Charles Hunt, R. W. Chapman, Sophie Anderson, T. F. Marshall—attain a standard of achievement which ensures their continuing interest.

Notes on the plates 60 - 77

60 Arthur Boyd Houghton (1836–1875)
 Interior with Children at Play
 $9\frac{3}{4} \times 8$ inches
 Ashmolean Museum, Oxford

This was painted in reverse, with modifications, from the illustration 'Kiss Me' engraved by Dalziel and published in *Good Words* 1863.

61 Alfred Elmore, RA (1815–1881)
 On the Brink
 45 × 32¾ inches
 Fitzwilliam Museum, Cambridge

Exhibited at the Royal Academy, 1865. The scene is set outside the gaming rooms at Homburg, an interior of which is seen in Plate 25.

62 Alfred Rankley (1819–1872)
 Old Schoolfellows
 36¾ × 28 inches Signed and dated 1854
 Collection of Sir David Scott, KCMG, OBE

When shown at the Royal Academy in 1855, the catalogue entry included the quotation from the *Book of Proverbs*, chapter 17: 'A friend loveth at all times, and a brother is born for adversity.'

63 William Maw Egley (1826–1916)
 'Hallo Largess' A harvest scene in Norfolk
 48 × 72 inches
 Private Collection

Exhibited at the Royal Academy, 1862. The picture was painted for John Rose of Reedham Old Hall, Norfolk; the artist witnessed the scene when visiting him in 1860. For a description of the subject see above, p. 109. Mr Rose is seen standing beside his favourite horse, and the tower of Reedham Church is in the distance.
The artist calculated that he spent 92 days painting the picture, for which he received £200. Since the artist gives the measurements as 54 × 72 inches, it may have been cut down.

64 Arthur Boyd Houghton
 Holborn in 1861
 12 × 16 inches Signed
 Private Collection

65 Jerry Barrett (*c.* 1814–1906)
 Florence Nightingale receiving the Wounded at Scutari in 1856
 16 × 24 inches Signed
 National Portrait Gallery, London

This is Barrett's original sketch for the group entitled 'The Mission of Mercy', of which Thomas Agnew published a key. M. Soyer, the cook, and Mrs Bracebridge are immediately to the left of Florence Nightingale.

66 Abraham Solomon (1824–1862)
 Waiting for the Verdict
 24 × 30 inches Signed and dated 1859
 Private Collection

Abraham Solomon exhibited a version of this composition at the Royal Academy in 1857. A small version dated 1857 is in Tunbridge Wells Museum (Ashton Bequest), with its pendant, 'The Acquittal', a subject which was shown at the Royal Academy in 1859.

67 Frederick Goodall, RA (1822–1904)
 A Letter from Papa
 16 × 14 inches Signed and dated 1855
 Tunbridge Wells Museum (Ashton Bequest)

Papa is evidently serving in the Crimean War.

68 Alexander Farmer (d. 1869)
 An Anxious Hour
 Panel, 12 × 16 inches Signed and dated 1865
 Victoria and Albert Museum, London

Exhibited at the Royal Academy, 1865.

69 Henry Le Jeune, ARA (1819–1904)
 Tickled with a Straw
 Diameter 33 inches
 Private Collection

Exhibited at the Royal Academy, 1868. The title is derived from Pope's *Essay on Man*, Epistle II:

> Behold the child, by nature's kindly law
> Pleased with a rattle, tickled with a straw.

70 Thomas Faed, RA (1826–1900)
 The Mitherless Bairn
 Panel, 25 × 36 inches Signed and dated 1855
 National Gallery of Victoria, Melbourne

Exhibited at the Royal Academy in 1855 with the quotation from William Thom: 'Her spirit, that pass'd in yon hour o' his birth . . . ' It was the exhibition of this work in London which established the artist's reputation as a painter of Scottish *genre*.

71 Frederick Walker, ARA (1840–1875)
 Old Letters
 $11\frac{3}{4} \times 9\frac{1}{2}$ inches Signed
 Walker Art Gallery, Liverpool

72 Eyre Crowe, ARA (1824–1910)
 The Bench by the Sea
 $8\frac{3}{4} \times 12$ inches Signed
 Private Collection

73 Sophie Anderson, née Gengembre (1823–1903)
 No Walk To-day
 $19\frac{3}{4} \times 15\frac{3}{4}$ inches
 Collection of Sir David Scott, KCMG, OBE

74 Frank Stone (1800–1859)
 The Tryst
 $30 \times 23\frac{5}{8}$ inches
 Private Collection

75 Thomas Falcon Marshall (1818–1878)
 The Bird's Nest
 Panel, $12\frac{1}{2} \times 16\frac{1}{2}$ inches Signed and dated 1862
 Collection of the Lady Margaret Douglas-Home

 ────────────────────────────────

 T. F. Marshall was a member of the Liverpool Academy. Having won a
 painting of Dolly Varden by Frith in an Art Union lottery, he is said to have
 modelled his style upon it.

76 Charles Hunt (1803–1877)
 In the Museum
 Panel, 20×16 inches Signed and dated 1870
 Private Collection

 ────────────────────────────────

 This artist specialized in humorous portrayals of children at play. This
 rather more solemn scene is set in the Egyptian Gallery at the British
 Museum.

77 R. W. Chapman (Exhibited 1855–1861)
 Posting the Letter
 24×18 inches Signed and dated 1857
 Collection of Sir David Scott, KCMG, OBE

 The post-box is set in a shop for artists' materials. The girl posting the
 letter is accompanied by a man whose shadow is seen in the foreground, and
 whose bicycle is reflected in a window pane.

5 · The return to Greece and Rome

Many of the artists who have been discussed in the last chapter made no great pretence of rising above the common level of their kind. But, besides enjoying a general adequacy of training which gives a certain uniformity to their work, they were, in the paintings chosen to represent them, concerned with the actual facts of the daily life around them. These might have a quasi-fictional or illustrative source, just as when Egg constructed a novel in three volumes for his 'Past and Present' (in the Tate Gallery), and Hughes made his painting to illustrate Elizabeth Barrett Browning's *Aurora Leigh*; but even in such cases their eyes were firmly fixed on the things they saw around them, the buildings, walls, furnishings and costume of the 1850s or 1860s, as it might be.

Quite a different course was adopted by the artists whose work we now have to consider, though it took its rise and gathered strength at about the same time as the climax of contemporary *genre*. The neo-classicists, who went back to Ancient Greece and Rome for their subjects, were planning a complete escape from the appearances of the actual world around them. Of course classical subjects had been the theme of a preponderant amount of painting since the Renaissance, and neo-classicism had superseded the Rococo in the eighteenth century with the rise of increased archaeological curiosity, a movement underlined in England by Flaxman's illustrations to Homer. But the neo-classicism of the late nineteenth century in England seems more remote from the natural interests of its time, a deliberate turning away into the Age of Gold. The attempt at archaeological correctness becomes even more pronounced, the sense that life in these legendary days was of quite a different order from that in the nineteenth century more complete.

One of the aspects of English painting in the nineteenth century which makes the task of unravelling its various skeins such a complex one is the fact that so many discordant tendencies were powerful at the same moment. While the Pre-Raphaelites were producing a counterpoise to C. R. Leslie and Frith, the pioneer in England of the high Victorian version of neo-classicism, Frederic Leighton, was beginning his career. In 1855, when Millais' 'The Rescue' was the 'Picture of the Year', Leighton exhibited his enormous 'Cimabue's Celebrated Madonna is carried in Procession through the Streets of Florence'. This is really a pageant picture, in which a number of characters in mediaeval costume do their best to fill out the parts of Giotto, Dante and so forth. In its lifeless formalism it reflects the strict training Leighton had received in Frankfurt from Edward von Steinle, the 'last Nazarene' and one of the most frigid. But the German accent in the work was sufficiently apparent

to Prince Albert to ensure that it was bought for the Royal Collection on the opening day of the Royal Academy's exhibition.

For a number of years after this Leighton's exhibits were largely taken from legends and stories of the Middle Ages, and from Biblical subjects. It was not till the mid-1860s, with 'Orpheus and Eurydice', 'Helen of Troy' and 'Syracusan Bride leading Wild Beasts in Procession to the Temple of Diana' in successive years, that he entered on that real preponderance of paintings from classical themes on which his reputation rests. Even now he still cast about in a wide area for his themes, though with the exception of some portraits, landscapes and Eastern figure subjects, the present-day world does not figure among them. Indeed, his two predominant veins are juxtaposed in the frescoes he painted in lunettes in the Victoria and Albert Museum: 'Industrial Art as applied to Peace' is placed in a Grecian setting, whilst 'Industrial Art as applied to War' is clad in mediaeval costume. But when we think of Leighton we think, not of 'Dante in Exile' or 'A Condottiere', but of 'The Bath of Psyche' or 'Captive Andromache'. And this is right, because the whole bent of Leighton's style is towards the antique. His mediaeval figures are Roman statues dressed in armour or wimples, as the case may be. Still more, the precise discipline of his painting has a classical bent. It was his practice to make a monochrome sketch of his whole composition. Then he made a complete nude study of the whole, nude studies of the individual figures, and then draped studies of the figures. The drawings and oil sketches he made during this laborious stylized process are often of a quality and interest which escape in the final work. But that final canvas was never painted until all the preliminary stages had been followed. It was an attempt to make painting as fool-proof as possible, given an adequate amount of talent. In a sense it is like the more mechanical types of theatrical production. And like them, it is not fool-proof, but extremely variable in its results. So, with Leighton, the 'Helen of Troy' and 'Hero' are cold and unsuccessful, whilst the 'Captive Andromache' and 'Flaming June' are triumphant justifications of his plan. In his own lifetime he was compared with Bouguereau; this confrontation may at first seem a surprising one, but reviewing the whole of Leighton's *oeuvre* it is possible to see how such a comparison can be made.

What redeems Leighton from the sterility and frigidity into which he sometimes fell is his physical sense of the human body. For his preliminary sketches he would sometimes not only make nude and draped drawings, but also small statuettes of the principal figures. This practice lay at the root of his instant success when he turned to sculpture and produced 'An Athlete struggling with a Python'; he had always cherished the sense of corporeal roundness which lies at the heart of sculpture. To that extent Leighton was truly Greek; he valued three-dimensional form above colour, and had a natural instinct for space. It was this capacity and sense of scale which enabled him to succeed in the lunettes at the Victoria and Albert Museum; they are almost the only effective wall decorations of their kind made in England in the nineteenth century. Many of Leighton's contrived pieces seem cold and lifeless; yet at other times he could show passion. 'Flaming June', exhibited in the last year of his life, has a voluptuousness of form and colour hardly expected from the painter of 'The Bath of Psyche'.

In his study of this movement of Victorian taste, *Victorian Olympus*, William Gaunt has found exactly the adjective for Leighton in 'Olympian'. His deliberate, but swift advance to recognition, his command of languages, his predestination to be President of the Royal Academy, his social aplomb, the impeccable performance of his official duties, are all implied. Nor is it possible to overlook his versatility. Besides his alternation between mediaeval and classical painting he became a typical, even outstanding sculptor of the late nineteenth century. And his landscapes, which reflect his widely ranging travels, have at times an emotion of a different kind. In the Irish studies of his last years he produced a stagey romantic effect which gives a foretaste of James Pryde—an effect echoed by his description of the Etruscan tomb of Volumnus Violens: 'of a dignity almost Dantesque'. And, if Henry James suspected that behind the outer façade of that total competence there was emptiness, there were many who spoke gratefully of his genuine and unostentatious kindness to others less fortunate than himself.

Poynter said that he was the very first to receive Leighton's friendly encouragement, and there was a similarity in their minds and sympathies which makes their meeting in Rome in 1853, when Poynter was seventeen and Leighton at the age of twenty-three was working on his 'Cimabue', a significant junction in English art history. This was near the beginning of an educational process which led Poynter ultimately to work three years in the Parisian *atelier* of Gleyre, a purist devoted to transmitting the gospel of Ingres. Here he formed one of that circle of expatriate Englishmen—Du Maurier, Lamont, Armstrong—whose student days are commemorated in *Trilby*. But in spite of the ineffectiveness of Gleyre as a teacher, Poynter respected the French principle of learning early to draw from the life. When in his turn he became Director of Art at South Kensington he said, 'I shall impress but one lesson on the students, that constant study from the life model is the only means they have of arriving at a comprehension of beauty in nature, and of avoiding its ugliness and deformity; which I take to be the whole aim and end of study'. This is a neo-classic manifesto, and Poynter practised what he preached—he was regarded as the best academic draughtsman of his time, though powerless without the model in front of him. In this way he and Leighton reintroduced from abroad that sense of the human, fleshy figure which had been absent from English art since Etty's death.

Poynter carried into the twentieth century the tradition of the practising artist who was also connoisseur, collector and administrator. When Leighton died in 1896, Millais succeeded him for the last few months of his life; then Poynter became President of the Royal Academy. He had been made Director of the National Gallery two years before and held both offices jointly for ten years before resigning the latter. His career had been in a number of ways similar to that of Eastlake, and he is so far the only other instance of one man holding both these offices. But Poynter is of more interest than this recital of exacting offices would suggest; like so many of his contemporaries he was a natural polymath, but his first interest was his painting and in that field he made a notable contribution to the art of his time.

As with Leighton, there is no contact with the modern world outside the

portraits and watercolour landscapes he made. His first great success was the reconstruction of Pharaonic civilization 'Israel in Egypt', exhibited in 1867. He made only one other painting of an Egyptian theme; his important pictures from now on were mainly reconstructions of life in Greece or Rome, with an occasional excursion into Biblical story or mediaeval legend. The elaboration he liked to introduce in his larger pictures, and his attention to detail, suggest that had he been born a little later he would have found his natural bent as a director of historical films in the manner of Cecil B. de Mille. His 'Visit of the Queen of Sheba to King Solomon', which was his most ambitious venture in this *genre*, illustrates both the strength and weakness of his method clearly enough—it was bought for Sydney soon after being painted and hardly became known in England. For each of the figures in that piece there is a drawing, and these carry the impression of an authoritative completeness.

A less complex and cluttered scene was revealed in the painting bought from him for the Chantrey Bequest, 'A Visit to Aesculapius', and in some of the panels he painted for the decoration of Lord Wharncliffe's billiard room, notably 'Atalanta's Race'. But probably the most effective explorations by him of the ancient world are the smaller and less elaborate compositions in which one figure, or only a small number of figures, were present. In 'Psyche', of 1882, he made a study of a model who evidently appealed to him over a number of years, since she appears also as the sole figure in 'Under the Sea Wall' of 1888 and 'On the Terrace (A Greek Girl)' of 1889. These compositions place him in the ranks of the 'marble painters', a group which includes Alma-Tadema and Godward. They led his contemporaries to compare him with the former, but there is usually a profound difference of spirit and temper which over-rides the superficial similarity of their subject-matter.

Poynter impressed a number of people who came into contact with him as a morose, bad-tempered man; but many of his models, after initial rebuffs, came to venerate him. It is distressing therefore to find that he clung too long to his last official post, the Presidency of the Royal Academy. Still in office at eighty, it seems not to have occurred to him that he might resign; though it has to be admitted that there can have been no obvious younger successor, since he was followed by Sir Aston Webb, a seventy-year-old architect, and Sir Frank Dicksee, then seventy-one and equally a monument of the past. The memoirs of Luke Fildes, who had been a candidate when Poynter was elected, record that when eventually, in 1918, Poynter announced his resignation, he spoke bitterly, saying that he was not 'wanted here any more'.

Poynter's versatility was not confined to the variety of appointments he held. He, as Leighton had been, was swept into the network of illustrators of the 1860s through the mechanism of Dalziel's *Illustrated Bible* (an imitation of the Nazarene Bible of Schnorr von Carolsfeld). For this he made a number of designs for the story of Joseph in Egypt, which antedate his 'Israel in Egypt' and helped to direct his mind to that subject. As a decorative artist he took his chance when asked to design tiles for the Grill Room of the Victoria and Albert Museum. He chose as subjects the Four Seasons and the Twelve Months, and his success in rendering them, together with the attraction of the food, made this restaurant a place of pilgrimage for late nineteenth-century London society.

Whilst Poynter was combining a productive artistic career with an exacting succession of official and administrative posts, his near contemporary, Albert Moore, was pursuing an entirely withdrawn life, given entirely to the slow and lonely pursuit of a far more refined and exquisite art. Many stories are told of his unpractical nature, and it was thought to be his unclubableness which kept him from election to the Royal Academy. Pressed to become a teacher, he declined because it would be a distraction. He began to exhibit classical subjects in the mid-1860s. 'The Marble Seat' of 1865 is a work in which, as the title implies, all the ingredients of his simple well-known manner are to be found; and his later work is a continual exploration of this statuesque, almost motionless world in which a single Grecian figure, or a small number of them, are grouped to make a perfectly balanced design. Albert Moore was one of the first English artists to ignore the question of subject-matter in his pictures; he was indifferent to their titles and their themes, and this was another barrier between him and his contemporaries, at the moment of the hey-day of the subject picture.

The real originality of Moore lay in his exquisite understanding of colour. With Burne-Jones, though in an entirely different way, he is one of the few nineteenth-century British artists who possessed this natural painterly quality, a genuine feeling for the juxtaposition and interrelation of colour. His London walks would be made exciting to him by the sight of oysters on blue paper, and he could not work without the stimulus of flowers in his studio. But there was nothing effete about this perceptual sybaritism. The staffage of his paintings (for example, two somnolent girls lying on a couch, one, half-awake, holding a fan) are only excuses for exquisite arrangements of colour. The production of these canvases was not in the least slapdash or uncalculated; their unstudied effect is the result of art concealing art. For each one he had made, with slow and intense care, monochrome drawings of the whole composition, then of each figure in the nude, then draped. Colour studies of the draperies on the figures followed. When, untypically, there was action in the paintings, as in a picture of 'Follow-my-Leader', the models had to run backwards and forwards in his studio while he watched for graceful positions and the fall of the drapery.

That his approach was more akin to that of a twentieth-century abstract painter than that of his contemporaries is seen in his method with replicas of his paintings. Of 'A Sofa' he painted two other versions, identical in all but the smallest details of composition, but entirely different in colour and with variant accessories. In the first version of 1875, he introduced, for example, a yellow couch with orange cushions; in 'Apples' there is a green couch with yellow cushions, and in 'Beads' it is greyish cream with blue and orange cushions. The variant accessories—a string of beads under the left-hand girl's arm in 'A Sofa', two apples on the floor by the right-hand girl's foot in 'Apples' —give bright accents of colour. All this, with the deliberate arrangement of horizontal lines in accord with the relaxed postures of the sleeping figures, shows how Moore worked out the construction of his canvas with the care of a suprematist, while the pains he took to relate the folds of his drapery to natural appearances shows the concern of a classical sculptor. Not the least of

his merits is his ability to link the fully three-dimensional quality of his figures with the essentially flat and linear organization of his canvas; the decorative effect is not destroyed by too great an intrusion of reality.

Albert Moore was one of the very few English artists whom Whistler genuinely admired. In one phase in his progression from realism to the quasi-impressionism of his Nocturnes, Whistler himself devised a number of panels and decorations of markedly similar theme based on classical figure subjects. These centre round the 'Six Projects' now in the Freer Gallery, Washington, possibly designed as a connected decorative scheme. Certainly it is at this moment that Whistler's art and that of native England come closest, and since these panels were painted in the 1860s, the question of who was the originator, Whistler or Moore, is an interesting one. It is by no means certain that Whistler, although the better known artist and seven years Moore's senior, can claim the privilege. In fact the matter became of some concern to the painters themselves, and Mr Denys Sutton has found in the Glasgow papers a judicious summing up by Eden Nesfield, who had been asked to look into the question. Nesfield, an architect whose originality has been overlooked in the attention paid to his partner Norman Shaw, had befriended Moore in his student days, and must have possessed remarkable tact to satisfy Whistler in such a question. What he said was: 'I strongly feel that you have seen and felt Moore's specialité in his female figures' method of clothing and use of coloured muslin; also his hard study of Greek work. Then Moore has thoroughly appreciated and felt your mastery of painting in a light key . . . there is no harm in both painting in a similar way as the effect and treatment are so wide apart.'

A minor facet of the same question concerns the type of signature adopted by these two spiritually akin artists. Albert Moore was using the stylized anthemion motif as his signature in the 1860s (it appears, for instance, on his 'Apricots' of 1866), whereas Whistler is said not to have evolved the butterfly signature from his initials J.A.M.W. till the early 1870s. This has a bearing on the artists' approach, since such a signature became a symbol in a form which could fit unobtrusively into the background as one of the decorative elements of the painting.

Both Moore and Whistler formed part of that drive in the second half of the nineteenth century which attempted to link painting with the decorative arts and was one of the props of the arts and crafts movement. Sofas—hideously uncomfortable ones—like those in 'Beads', together with yellow walls and other schemes of decoration in the colours favoured by Albert Moore, were still endemic in Bloomsbury in the 1920s. But, whatever their vagaries, these two artists had far more ingrained sense of placing colour and arranging decorative effect than the more commercially successful and more publicized William Morris. Whilst Morris was applying cerebral ideas based on his understanding of mediaeval art to the applied arts, Whistler and Moore were using their ingrained, intuitive sense of rightness.

The German critic, Muther, wrote of Albert Moore: 'It might be said that the old figures of Tanagra had received new life, were it not felt at the same time, that these beings must have drunk a good deal of tea.' This is unjust to Moore's intentions and an inadequate description of the ethereal, abstract,

aesthetic style of his arrangements in yellow, gold, white and coral red. The artist whom the description does fit is Alma-Tadema. Few reputations have fluctuated as wildly as his. He was extremely successful for most of his life, but his fame declined to the point when a dealer described him to a would-be collector of the 1960s as the worst painter who ever lived. The collector's dissentient judgment was amply justified by the high prices paid at an auction of 35 works in 1973. A Dutchman trained in Belgium, Alma-Tadema did not settle in England till the 1870s but he had already shown his sensitiveness to the prevailing trend by painting in 1865 his 'Catullus reading to Lesbia', which governed the trend of his style for the next forty years. Even in his own day it was recognized that he frequently failed through lack of variety and that his marble was often more living than his personages. He produced over four hundred paintings—numbered, like a musician's *oeuvre*, Opus CXIX and so forth—and viewed in the mass they are of a dull uniformity in which the attempt to enter into the physical presence of the past has sadly miscarried. But, at his best, he produced such works as the 'Apodyterium' or 'The Pyrrhic Dance', in which his finicky technique and his obsession with the fashionable lineaments of his epoch merge into a genuine comprehension of the past and a certain exquisite preciosity.

The feeling that he, even more than Poynter, was born into the wrong age and should have been the producer of colour films of *The Grandeur that was Greece* and *The Glory that was Rome* is justified by the actual success of the stage designs he prepared for the production of *Coriolanus* put on by Irving in 1901. These, which are of some importance in the history of décor, show a feeling for theatrical effect and spectacular confrontations of space and distance. This quality comes out in such a painting as 'A Coign of Vantage' in which three girls, in classical costume, are looking down from the top of a very high building to the galleys in the water perpendicularly below them, dwarfed in size by the distance. It is not strictly a vertiginous composition, but it has very much the effect sought after and achieved in Hollywood spectaculars. Nor is the impression of his theatrical quality belied by the common-sense way in which he used photographs to compose his works. In this he was following what was by the second half of the nineteenth century a well-established studio practice. But whereas with Alma-Tadema, as with Frith, the photographic origin of his accessories is sometimes visible, in the case of Albert Moore, who latterly made his own photographs of drapery arrangements, it is concealed.

Thomas Armstrong was one of the young students of the early 1850s, who, with Lamont, Poynter, Whistler and du Maurier, formed the 'Paris Gang' described in *Trilby*. Although he was not the direct model for any of the figures in that nostalgic evocation of the past, he endorsed its accuracy in re-creating the atmosphere of his days as a *rapin*. Armstrong's training was a thoroughly eclectic one, for besides studying under Ary Scheffer and working in Barbizon, he also sought training in Antwerp and Düsseldorf. On his return to England around 1860 he received, through his friendship with some of the rising architects such as Aitchison and Nesfield, a number of commissions for decorative panels in houses. The manner in which he carried out these works led him to be compared at the time with Albert Moore and Whistler. It is

clear from 'The Hay Field', which was exhibited at the Royal Academy in 1869, that he belongs to the same movement in English painting, in which emphasis is laid in the decorative elements, on statuesque poses, and subtlety of colour. The costumes, referable to a rather vague past, at the same time anticipate the looser shifts which were to come into fashion with the Aesthetic Movement.

Armstrong succeeded his friend Poynter as Director of Art at South Kensington, a post which involved making acquisitions for the Museum and directing the course of studies in the College of Art. He took up the position in 1881, but he was less successful than Poynter in combining with it the continuation of his career as a painter, and this date virtually marks the end of his production. When he died thirty years later his art had been largely forgotten, and he was remembered mainly as the friend of du Maurier, who could testify to the truth of the heartiness, the singing, the athleticism of the Paris days half a century earlier.

G. F. Watts was born two years before Queen Victoria, and died three years after her. From one point of view he dominates the painting of the entire Victorian age in his precocity, his remarkable development and his unique technical gifts. Yet he was for much of his life an isolated figure; living in an artificial isolation produced round him by friends who idolized and, to some extent, tamed him. Watts was of course an eclectic in technique and independent of the current movements in the art world, so it would be unjustifiable to classify him specifically as a Neo-classicist, or with any other limiting label. But his introduction to the Elgin Marbles by the sculptor Behnes when he was ten years old was a decisive moment of his precocious early life, and the formal content of his figure studies is largely a development of that enthusiasm through a specifically Venetian style of painting.

He touched the art of his time at so many points—fresco painting, landscape, portraiture, in which he excelled, and the later, allegorical figure subjects—that he escapes classification on this score as well. His career was one of the few to be positively helped by the Houses of Parliament competition of 1843. In that exhibition his cartoon 'Caractacus led in Triumph through the Streets of Rome' was awarded one of the first prizes of £300, which he in his turn used to take himself to Rome. Haydon, the disappointed supplicant, might, had he had foreknowledge of Watts's later career, have regarded him as the man destined to fulfil his programme for an English historical painter. But though Watts had material luck in being sheltered from the harsh economic facts of life, which Haydon could never attract, the final outcome of the heroic phase of his style is nearly as disappointing. In planning a cosmic scheme of decoration for an imagined 'House of Life', Watts was anticipating similar adventures by Gauguin and Munch. Relative outcasts though they were, they succeeded more nearly in giving body to the plan they had imagined. Watts's vision split up into a succession of canvases, some badly painted, some grotesquely misconceived. His approach was sometimes through the misty, indefinite veils of theosophical painting, sometimes that of the political cartoonist. Yet, when out of the scores of allegorical canvases the successful ones are sorted out, they are seen to have a unique power.

124

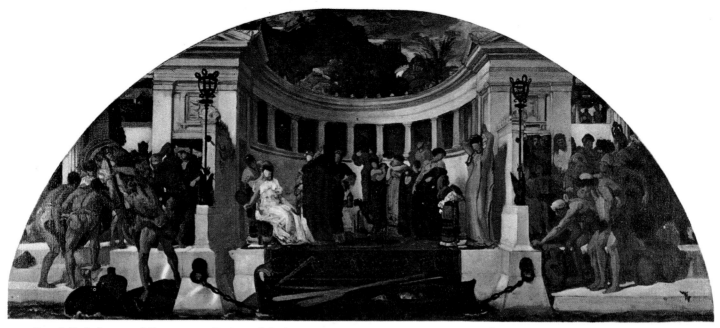

78 Lord Leighton of Stretton: Industrial Art as applied to Peace

79 Lord Leighton of Stretton: Captive Andromache

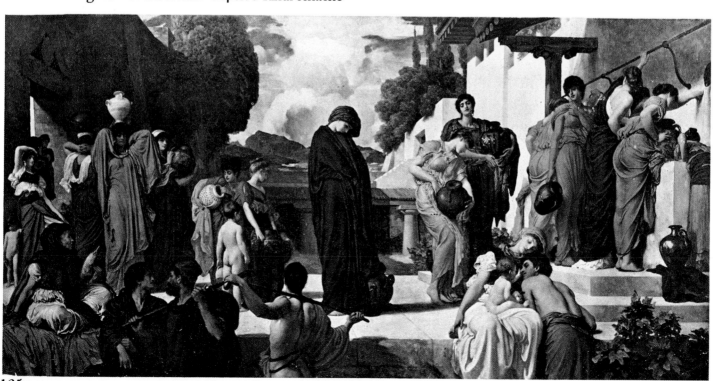

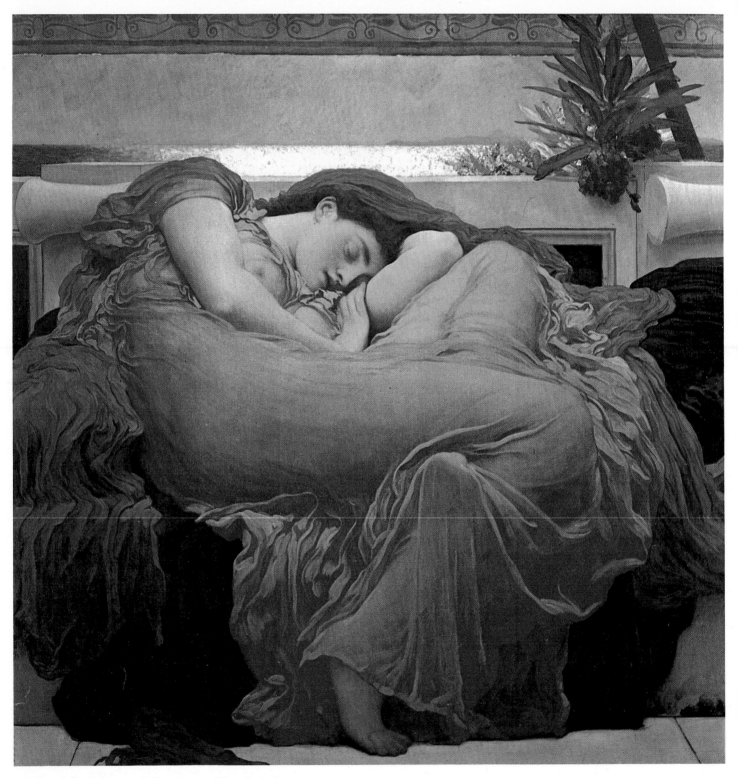

80 Lord Leighton of Stretton: Flaming June

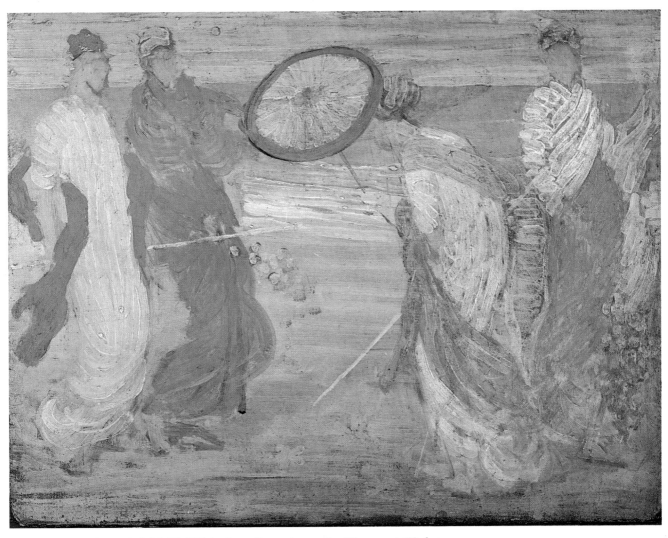

81 James Abbott McNeill Whistler: Symphony in Blue and Pink

82 Albert Joseph Moore: Beads

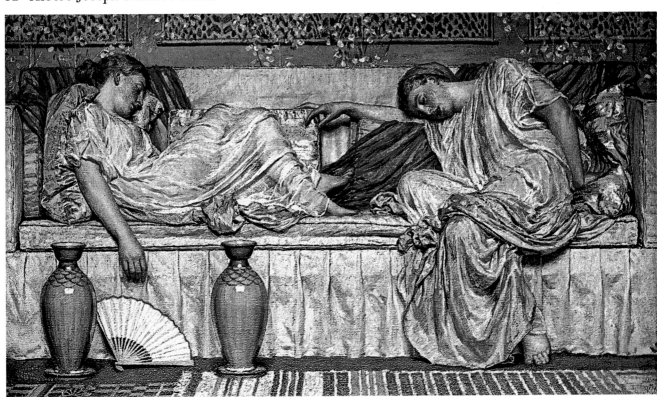

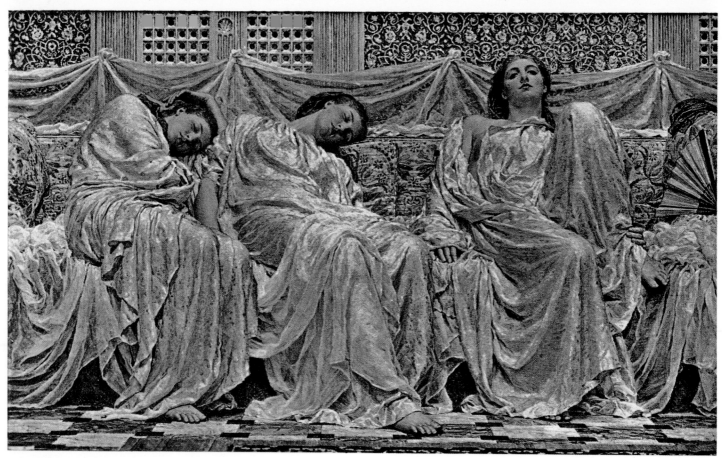

83 Albert Joseph Moore: Dreamers

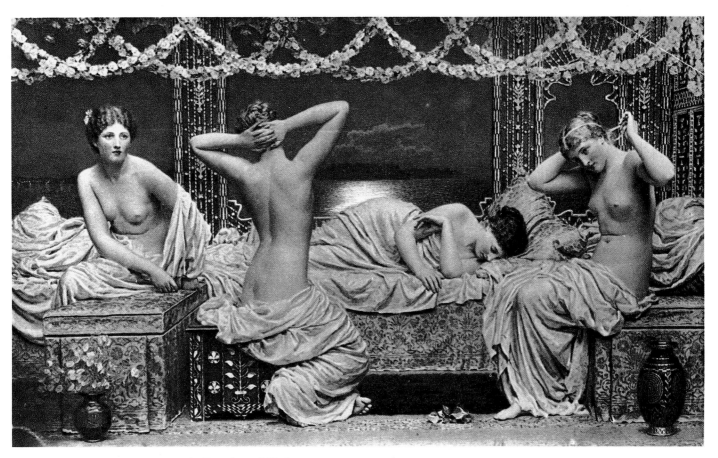

84 Albert Joseph Moore: A Summer Night

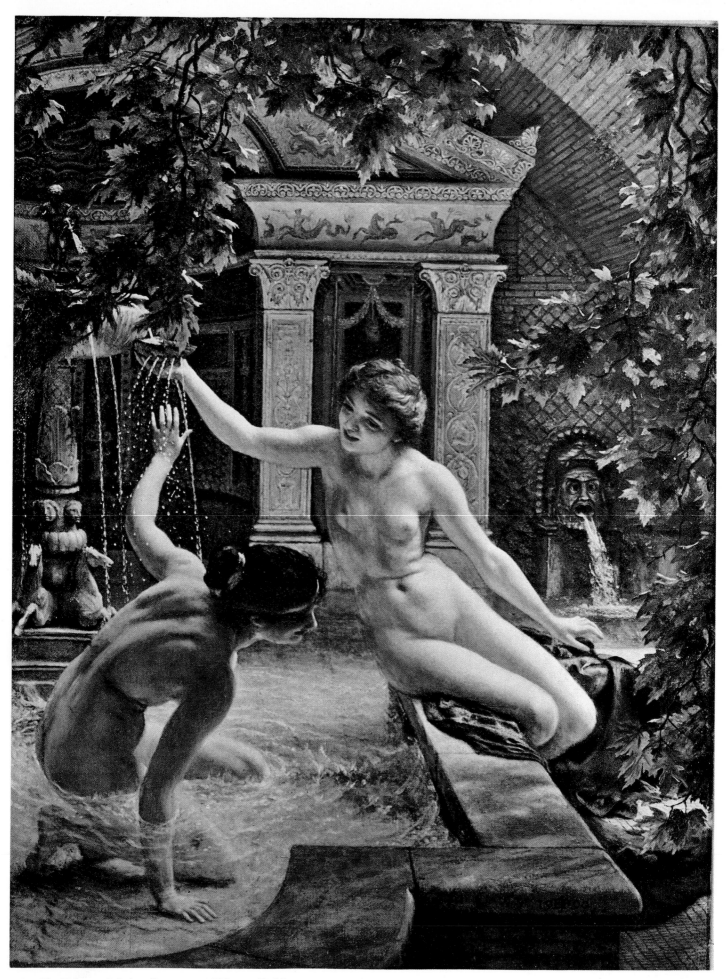

85 Sir Edward John Poynter: Water Babies

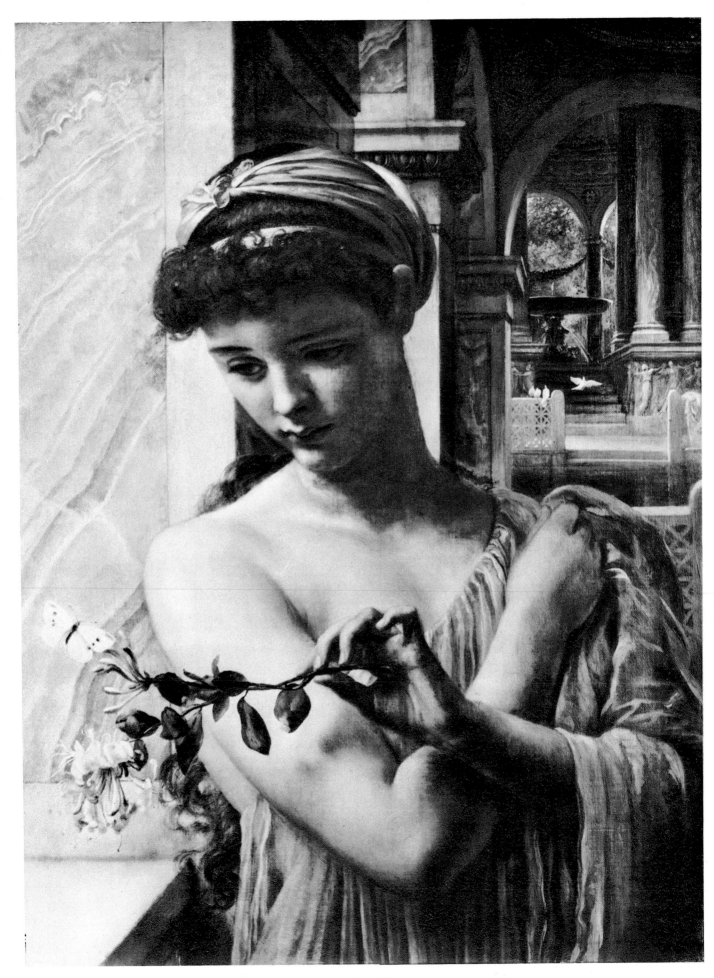

86 Sir Edward John Poynter: Psyche in the Temple of Love

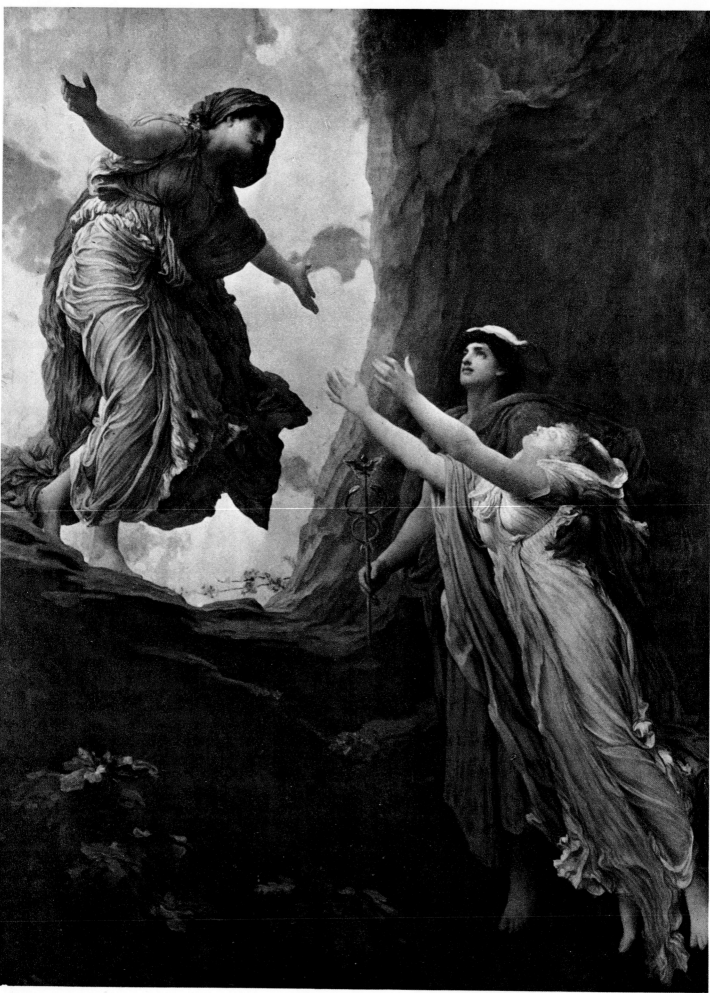

87 Lord Leighton of Stretton: The Return of Persephone

88 Sir Edward John Poynter: The Visit of the Queen of Sheba to King Solomon

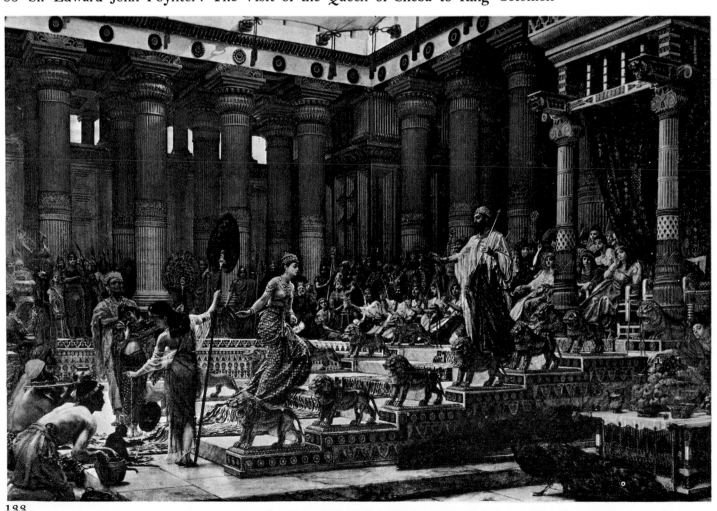

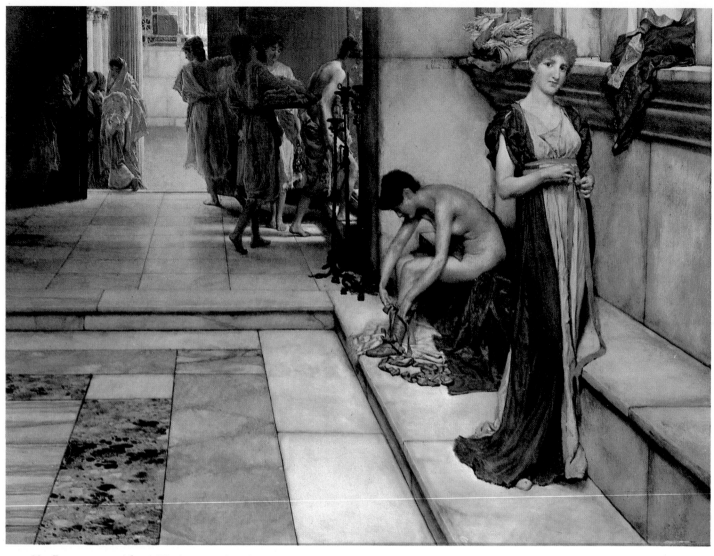

89 Sir Lawrence Alma-Tadema: An Apodyterium

90 Sir Lawrence Alma-Tadema: The Pyrrhic Dance

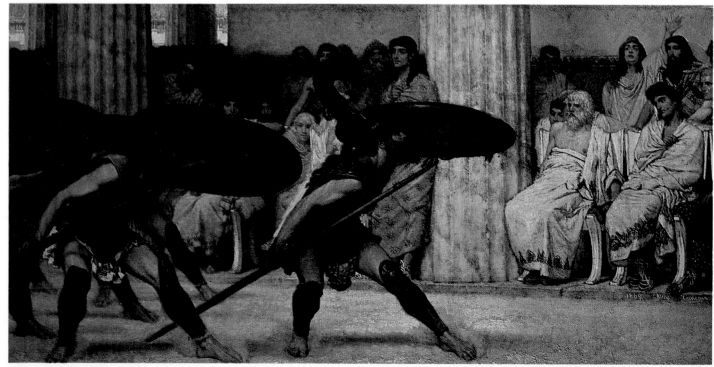

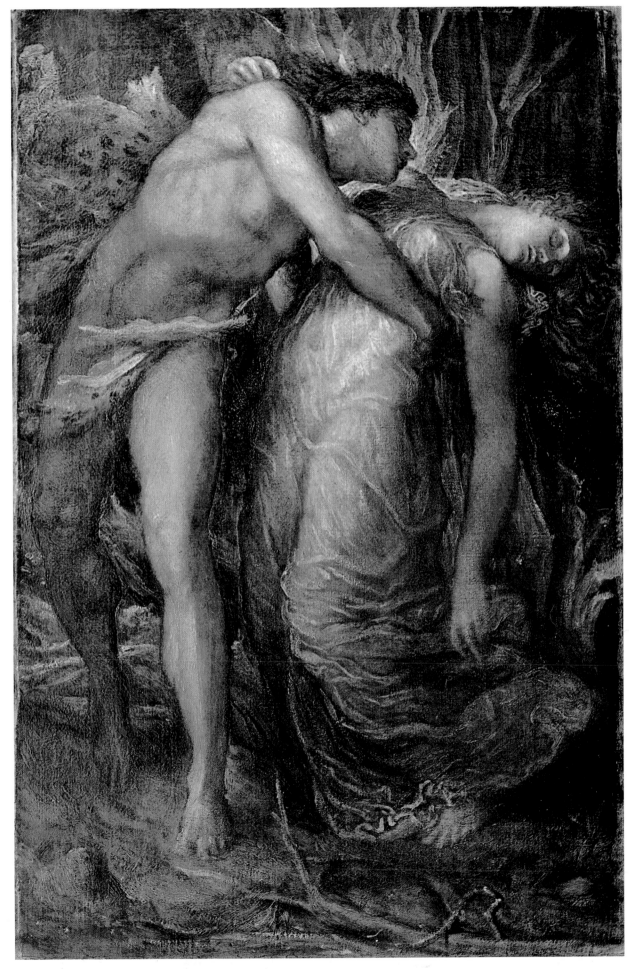

91 George Frederick Watts: Orpheus and Eurydice

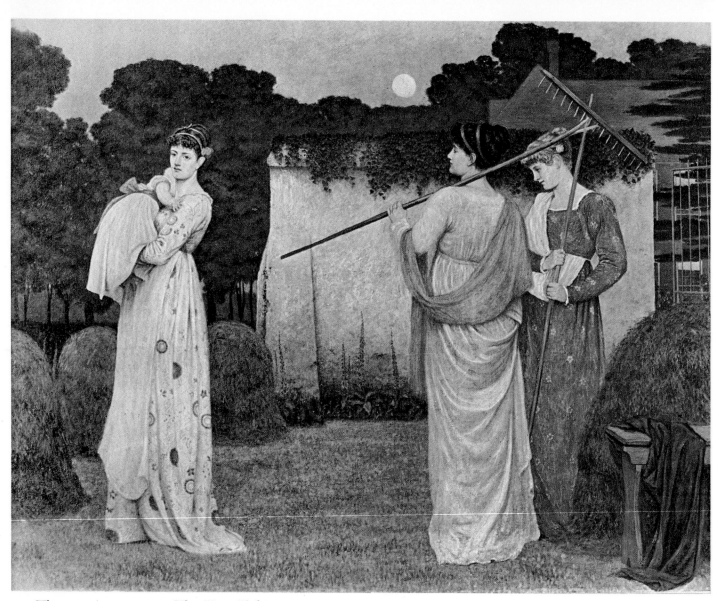

92 Thomas Armstrong: The Hay Field

The failures result partly from the collapse of the tradition, partly from Watts's own intellectual shortcomings. The tradition of allegory and personification was still vigorous in the eighteenth-century baroque tradition. Though it had barely taken root in England, Thornhill did not scruple to decorate his own house with allegorical figures symbolical of his heroic virtues. But this thin native growth was killed by Romanticism and Neo-classicism. Just as personification in poetry became grotesque, so allegory became a dead language. In attempting to resurrect it by inventing his own symbols, Watts clearly took on a task beyond his powers. And unlike Moore, Leighton and Poynter, he was shy of the human form; his reticence about the facts of the naked figure are a pictorial embodiment of Victorian prudery.

Yet he was a painter of an individuality and stature beyond that of most of his contemporaries. As Mr Loshak has said, he rose to the challenge of painting the portraits of eminent men; the greater the sitter, the better his portrait. And in his rare successes with figure subjects, when the tight composition and the flicker of a Venetian palette work in unison, he produced some of the most unforgettable Victorian paintings. 'Mammon', 'Fata Morgana', 'The Temptation of Eve' all fall into this category: and in 'Orpheus and Eurydice' a greater tension is given to the composition because he is reinterpreting a classical legend.

Notes on the plates 78 – 92

78 Lord Leighton of Stretton, PRA (1830–1896)
 Industrial Art as applied to Peace
 16 × 36 inches
 Victoria and Albert Museum, London

This is an oil sketch for one of the two large frescoes painted by Leighton in lunettes in the Victoria and Albert Museum. Its pendant, 'Industrial Art as applied to War', is set in mediaeval times. The latter was the first to be commissioned and completed. It had originally been intended that Watts should make the second design, but in the end Leighton undertook both commissions, beginning his sketch for the first in 1870 and finishing work on the second in 1886.

79 Lord Leighton of Stretton, PRA
 Captive Andromache
 77 × 160 inches
 City Art Gallery, Manchester

When this picture was exhibited at the Royal Academy in 1888, the catalogue

entry contained the following quotation from Elizabeth Barrett Browning's translation of *The Iliad*, Book VI:

> 'Some standing by,
> Marking thy tears fall, shall say, "This is she
> The wife of that same Hector that fought best
> Of all the Trojans, when all fought for Troy." '

After the fall of Troy, Andromache became the slave of Neoptolemus. The painting shows a moment at which her attention has been drawn by the happy group of husband, wife and child in the foreground, reminding her of the death of Hector and her son Astyanax.

The model for Andromache was Dorothy Dene, who was the inspiration for Leighton's work from the mid 1880s.

80 Lord Leighton of Stretton, PRA
 Flaming June
 47½ × 47½ inches
 Museo de Arte de Ponce, Puerto Rico

Exhibited at the Royal Academy in 1895, the year before his death. The model was again Dorothy Dene.

81 James Abbott McNeill Whistler (1834–1903)
 Symphony in Blue and Pink
 Board, 18⅜ × 24⅜ inches Painted about 1868
 Smithsonian Institution, Freer Gallery of Art, Washington, D.C.

This one of the 'Six Projects' designed as sketches for a decorative scheme for Leyland which was not carried out. They were produced at the time when Whistler's art was at its closest to the style of Albert Moore. The composition is related to the woodcut 'Cool of the Evening by the Sumida River' by Kiyonaga.

82 Albert Joseph Moore (1841–1893)
 Beads
 11¼ × 19¾ inches
 Signed with anthemion and dated (18)75
 The National Gallery of Scotland, Edinburgh

Moore made three versions of this subject almost identical in composition but with different arrangements of colour in each. The first was called 'A Sofa'; the present version, 'Beads', was exhibited at the Royal Academy in 1876. The third version, 'Apples', was lent by Mr W. E. Kendrick to the exhibition 'Victorian Painting' held at Messrs Agnew in 1961.

83 Albert Joseph Moore
 Dreamers
 27 × 47 inches
 City Museum and Art Gallery, Birmingham

Exhibited at the Royal Academy in 1882. Moore made several studies of each of the three figures in this composition and exhibited them under such titles as 'Jasmine' and 'Acacias'.

84 Albert Joseph Moore
 A Summer Night
 51 × 88½ inches
 Walker Art Gallery, Liverpool

Exhibited at the Royal Academy in 1890.

85 Sir Edward John Poynter, PRA (1836–1919)
 Water Babies
 22 × 17 inches Signed and dated 1900
 Messrs M. Newman Ltd

Exhibited in the Royal Academy in 1900.

86 Sir Edward John Poynter, PRA
 Psyche in the Temple of Love
 26 × 20 inches Signed and dated 1882
 Walker Art Gallery, Liverpool

Exhibited at the Royal Academy in 1883.

87 Lord Leighton of Stretton, PRA
 The Return of Persephone
 80 × 60 inches
 City of Leeds Art Gallery

Exhibited at the Royal Academy in 1891. The colour sketch is reproduced, in colour, in Mrs Barrington's monograph on Leighton, Vol. I f.p. 221.

88 Sir Edward John Poynter, PRA
 The Visit of the Queen of Sheba to King Solomon
 91 × 138 inches Signed and dated 1890
 Art Gallery of New South Wales, Sydney

Having exhibited this picture in 1890 at the gallery of T. McLean, who published an engraving of it, the artist showed the finished design for it in the Royal Academy of 1891.

89 Sir Lawrence Alma-Tadema, OM, RA (1836–1912)
 An Apodyterium
 Panel, 17½ × 23¼ inches Signed and numbered: Opus No. CCLXXIV
 Collection of Charles Jerdein, Esq

Exhibited at the Royal Academy, 1886. This is one of a number of subjects set by Alma-Tadema in the Roman baths, e.g. 'In the Tepidarium' of 1881. The apodyterium is the undressing room at the entrance to the baths themselves.

90 Sir Lawrence Alma-Tadema, OM, RA
 The Pyrrhic Dance
 Panel, 16 × 32 inches
 Guildhall Art Gallery, London

The success of this painting at the Royal Academy in 1869—it was the first year he showed there—encouraged the artist, who was born in Holland, to settle in England. Writing of it later, Ruskin said that 'the general effect was exactly like a microscopic view of a small detachment of black-beetles in search of a dead rat'.

91 George Frederick Watts, OM, RA (1817–1904)
 Orpheus and Eurydice
 27½ × 18 inches
 The Art Gallery and Regional Museum, Aberdeen

Watts depicts the moment in which, having rescued Eurydice from the underworld by the power of his music, Orpheus breaks the condition that he must not look back at her, and she is lost to him for ever. He treated the subject many times.

92 Thomas Armstrong (1832–1911)
 The Hay Field
 50 × 62 inches Signed
 Victoria and Albert Museum, London

Exhibited at the Royal Academy in 1869.

6 · The Victorian exotics

Since non-conformity is endemic to the British character, it is not unexpected to find in every generation some painters who are anxious to go their own way regardless of the consequences so far as popularity or criticism is concerned. Although the chief aim of art is to communicate with other people, some artists have been willing to forgo the prospect of making this type of contact in their own time, in order to pursue their immediate purposes. If success came, well and good; if not, they continued to paint without it. This attitude is a refreshing one if set beside the sturdy materialism which is a more constant feature of Victorian art: the deliberate pursuit of financial success by Frith, Millais and Fildes, to name only a few obvious instances.

Blake is the most complete example of the solitary visionary who escaped from his age by his seclusion and self-absorption. While few of the Victorians can be equated with his heroic example, there are some artists who took unorthodox paths at the expense of their material prosperity. Some have already been encountered in other contexts in this book. Richard Dadd is one, though the circumstance that his message was for the twentieth rather than the nineteenth century was an accidental consequence of his madness. Samuel Palmer is another, though his arcane works were completed before the Victorian age began, and were kept by him in his 'Curiosity Portfolio', to be only occasionally shown to sympathetic viewers.

Calvert, another adherent of the circle which grew up round Blake's admirers and disciples, pursued a different course. He had been a member of the Shoreham Group, and embraced part of their excited vision in his remarkable wood-engravings, such as 'The Cyder Feast' and 'The Chamber Idyll'. With the last of these, produced in 1831, a career was virtually closed. From then on he painted mainly to please himself, destroying a great deal, leaving much unfinished. There is nothing of the tension which makes the early woodcuts, and one or two small watercolours he made at the same time, seem like visions received in a trance from Blake's own imagination. Yet, woolly though such a painting as 'Pan and Pithys' is in comparison with his own early work, it embodies an Arcadian vision, a sympathy with pagan forms and a different and subtler kind of classicism than that found in Leighton or Poynter. In its sense of affinity with the irrational elements in nature which the Greeks personalized as nymphs and dryads it shows that order of identification which alarmed Palmer and Calvert's other Christian friends with fears for his salvation. It is the paganism of Swinburne, possibly of Böcklin, that Calvert embodies. If some of his criticism of contemporary life was wilful, such as counting Paddington as one of the four beautiful cities, his attitude to finish was one which found an

echo even in his own time. A would-be purchaser of one of his oils, on being told it was unfinished, replied, 'Yes, sir, and I am glad it is not finished. The great modern pictures, sir, are too finished—no room to get a thought in edgeways. It's wretched work, sir; they never know when to stop!'

Another solitary figure, James Smetham, came by different ways to a somewhat similar formal approach to painting and achieved an equally distinct withdrawal from the world. A devout Wesleyan and an associate of the Pre-Raphaelites, he made one of the most effective revaluations of Blake, and the community of imagination he shared with him and Palmer was recognized by his friends. Rossetti, who saw his merits and encouraged him, also told him, 'What you lack is simply ambition'. But like other men equipped with great imaginative resources and unable to find full expression for them, the weakness was deeper than that, and Smetham became incurably insane for the last twelve years of his life.

In the case of Paul Falconer Poole, a certain withdrawal from the centre of artistic life was not entirely due to the poetic imagination he undoubtedly possessed. When only twenty, though already of declared talent, he became involved in a scandal in which Frances Danby was also concerned. The details are still not entirely clear, and are generally told from the point of view of Danby, whose art has attracted more attention than Poole's. But it seems that Poole probably lived with Danby's wife in about 1830, and that Danby eloped to Geneva with a mistress, taking with him a family of ten children, seven legitimate and three illegitimate. Danby was never sufficiently forgiven to become a member of the Royal Academy. Poole, who ultimately married Danby's widow after her husband's death in 1861, was able to expiate his fault in that institution's eyes, becoming an ARA in 1846 and an RA in 1861, the year of his second marriage. He is said to have been a good hater and to have had much of the savage in him. This fierce quality does not emerge in a number of his routine pieces, smiling country girls with their children posed against the rocky streams of the West Country. But he was a slow worker, and needed to accumulate reserves of concentration and feeling to produce his most impressive canvases. When he did so, as in the 'Solomon Eagle exhorting the People to Repentance during the Plague of London', shown in 1843, 'The Vision of Ezekiel', painted over thirty years later, and 'The Last Scene in Lear', of 1858, his power is impressive. In these canvases the savagery which had been discerned in his character is apparent enough. At a glance the figure subjects might seem ordinary enough extensions of the school of history painting typified by Egg and Maclise, and in fact Poole was yet another of the artists to become involved in the Houses of Parliament project, receiving a prize of £300 in 1847 for a painting of 'Edward III's Generosity to the People of Calais'.

But what distinguishes Poole from his fellow history or landscape painters are his technique and his uniquely personal colour sense. The indefinite, merging quality of his outlines he probably owed to his escape from any formal artistic training. His power of conveying mood through his choice of colour is an entirely personal one, akin to those of Albert Moore and Burne-Jones, but quite distinct from them in detailed content. He was characterized as painting

to an overall 'tawny gold tone', and the description, while it does not convey the whole richness of his colour, is right as an analysis of its dominant key. The 'Last Scene in Lear' shows the death of Cordelia witnessed by the half-comprehending anguish of the old king. The scene is that wild British camp near the coast defined by the stage directions. Poole's composition is un-doubtedly based upon the design Barry made for Boydell's *Shakespeare*. But he has made of the characters and their expressions universal and not particular statements, and above all has flooded the scene with his own individual sense of tone. The action takes place by moonlight, and in some magical way Poole has fused the broad local areas of colour in his scene into a harmony which reflects the impact of Shakespeare's verse. The white of Cordelia's robe has turned yellow under the moon, Lear's robe is indeed a tawny gold, and the grey-blue and green of the other characters enter completely into the scheme. Furthermore, the expressions on the faces, that aspect in which the Victorians frequently failed, particularly in illustrative art or representations of theatrical settings, are human, unforced and tragic. Here is something barbaric, which corresponds to the elemental in Shakespeare's most moving and absolute tragedy.

For one decade John Frederick Lewis also isolated himself from the artistic world of which he had already become a part. His travels in the 1830s had earned him the name of 'Spanish' Lewis; the most important product of those years had been two volumes of lithographed scenes of life in Spain. In 1840 he went farther afield, and from 1842 to 1850 lived indolently in Cairo. He was not the first artist of his day to feel the pull of the East—in fact it was one of the great aims of the Romantic Movement to escape in space as well as time. But when the French went to North Africa they brought back, in the paintings of Delacroix, Chassériau and Fromentin, great, broadly painted vibrant canvases, full of contraposto and with a marked emphasis on violence.

To Lewis the Orient was an entirely different thing; an uncomplicated idyll of pure delight to the sense of vision. Thackeray came across him in Cairo in 1844 and, in the midst of a careful, almost envious description of the state in which Lewis lived and the extent to which he had adopted native customs and costume, said of his life: 'It was an indulgence of laziness such as Europeans, Englishmen at least, don't know how to enjoy. Here he lives like a languid Lotus-eater—a dreamy, hazy, lazy, tobaccoed life. He was away from evening parties, he said; he needn't wear white kid-gloves or starched neck-cloths, or read a newspaper.' Even so, he sought still less socially constricting life in the desert under the tents. In so doing Lewis showed himself akin with those Englishmen who have instinctive affinity with the nomad Arab life, an affinity shared by Doughty, Wilfrid Scawen Blunt, and T. E. Lawrence, and commemorated in later fiction by Robert Hitchins and Marmaduke Pickthall.

But the extraordinary thing about the temperament of Lewis was not that he succumbed to this indolent safari, but that he returned from it to do twenty years of his most creative and advanced work. When, after a long absence from its exhibitions, he sent 'The Hhareem' to the 1850 display of the Old Water Colour Society, he created a sensation. It contained all the ingredients of his later work, the microscopic stippling, the use of gouache accents, and though

he had never seen a work by Millais or Holman Hunt, or conversed with these men who were so much his juniors, this approach was automatically labelled 'Pre-Raphaelite'.

Lewis's attitude to the rival media of oil and watercolour was a utilitarian one. Having been trained in oil, he first took to watercolour because it was so much easier to handle. The first triumphs of his return from Cairo, in rendering the brilliance of colours seen in diffused light, and the beauty of the girls, and the gazelles, around him, were in water and body colour. They led to his appointment in 1855 as President of the Old Water Colour Society. But he found the medium to which the Society was committed too cumbersome: 'I felt that work was destroying me. And for what?—to get by water colour art £500 a year and this, too, when I knew I could get my thousand (by oil).' So he resigned his office and concentrated with no loss of power on the other medium.

Lewis revelled in the exotic side of Oriental life, and the subject of his first ambitious Eastern watercolour, the harem, is one which occurs again and again in his later work. Throughout the period of gestation in Cairo he was evidently feeding his memory on graceful attitudes, striking effects of colour and the specific qualities of Eastern light. It was to render the colour and tone, dazzling in its intensity, that he evolved his system of closely divided tones. Vibrant with light his pictures form a unique feature in nineteenth-century English art, their originality being due to the closeness of his observation.

Their merit is the more apparent when they are compared with the work which Frederick Goodall produced as a result of his travels in Egypt. We have already encountered his exceptional incursion into *genre* at the time of the Crimean War. Three years later, in 1858, he paid the first of a number of visits to Egypt. His motives, entirely different from those of Lewis but akin to those of Holman Hunt, were to find scriptural subjects. The account he gives of his visits leaves no doubt of the visual excitement he received from the scene in Cairo, and he was indefatigable in sketching, a task requiring courage since he had to be protected from the stone-throwing of the Moslem believers. But little of this excitement was transferred to such canvases as 'A New Light in the Harem', and we have only to compare it with Lewis's 'Hhareem' to see that this is one case where indolence bred the power of proper observation. Whilst the light in Goodall's picture is that of an English drawing-room, that in Lewis's is the real sun of an Eastern sky.

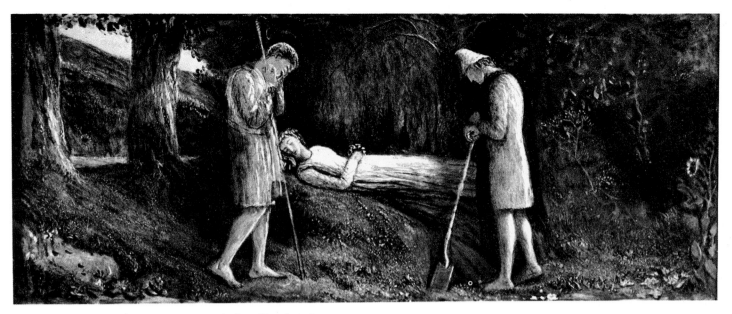

93 James Smetham: Imogen and the Shepherds

94 Edward Calvert: Pan and Pithys

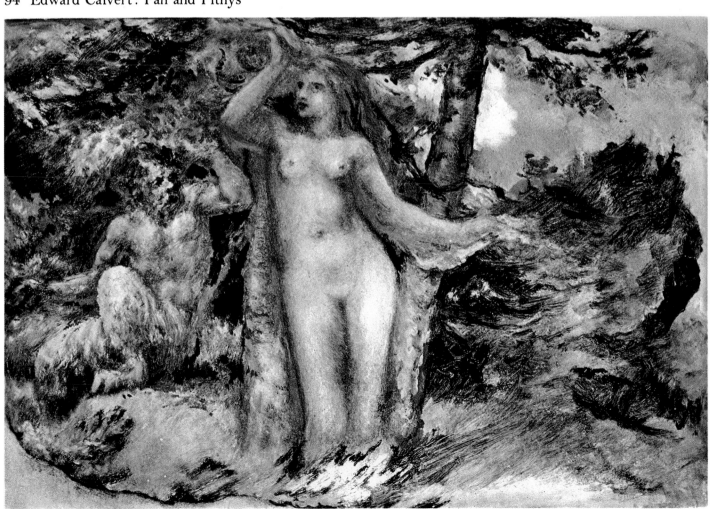

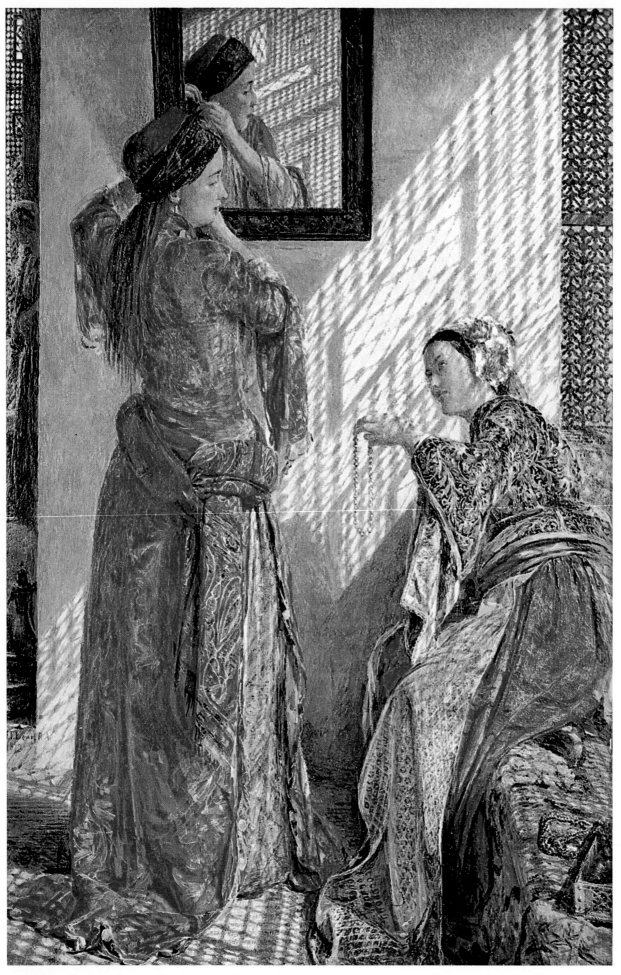

95 John Frederick Lewis: Indoor Gossip, Cairo

96 Paul Falconer Poole: The Last Scene in Lear

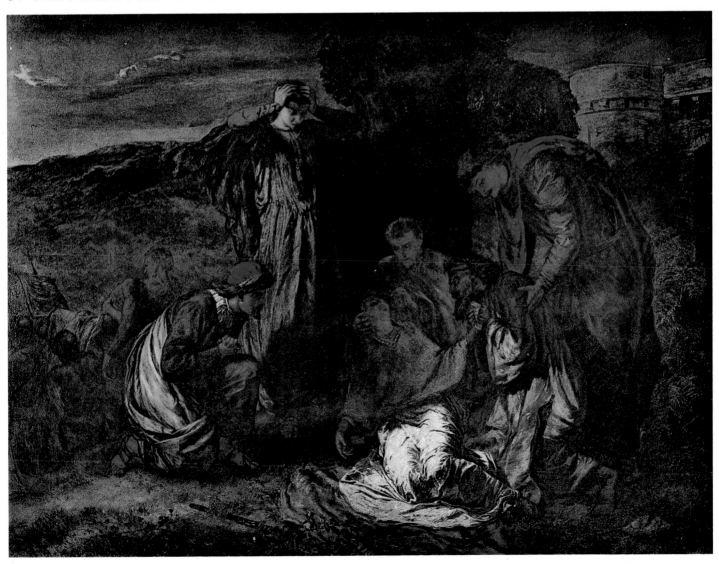

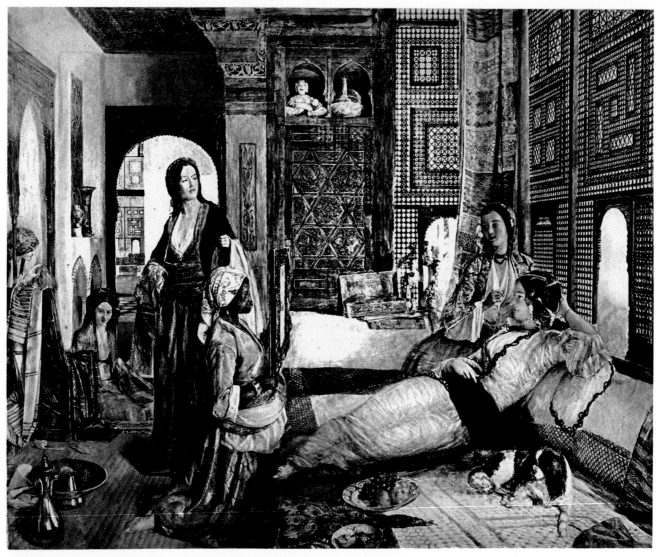

97 John Frederick Lewis: The Harem
98 Frederick Goodall: A New Light in the Harem

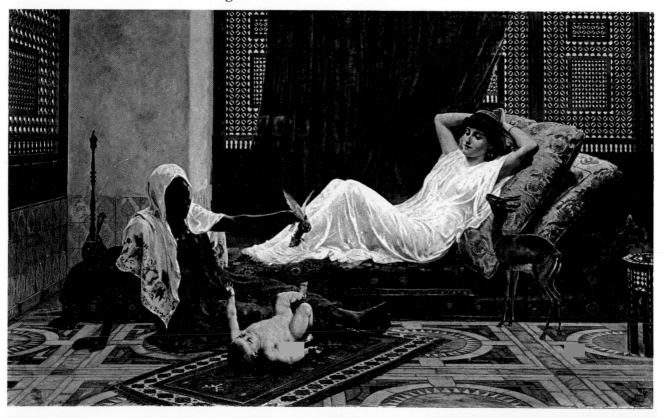

Notes on the plates 93 – 98

93 James Smetham (1821–1889)
 Imogen and the Shepherds
 10 × 24½ inches Signed
 City Museum and Art Gallery, Birmingham

The painting illustrates the episode in Shakespeare's *Cymbeline*, Act IV, when the shepherds find Imogen dressed as a boy and overcome by a drug, and believe her to be dead. They lay her in the grave to the song 'Fear no more the heat o' the sun'.

94 Edward Calvert (1799–1883)
 Pan and Pithys
 Millboard, 10¼ × 15 inches
 City Museum and Art Gallery, Birmingham

The legend which the painting illustrates is that of Pithys, who was beloved of Pan. When she accepted his rival, Boreas, he dashed her against a rock, and she changed into a pine tree.

95 John Frederick Lewis, RA (1805–1876)
 Indoor Gossip, Cairo
 12 × 8 inches Signed and dated 187(3)
 Whitworth Institute, Manchester

96 Paul Falconer Poole, RA (1807–1879)
 The Last Scene in Lear
 56 × 73 inches Signed and dated 1858
 Victoria and Albert Museum, London

Exhibited at the Royal Academy, 1858. The subject is the closing scene of Shakespeare's *King Lear*, set in the British Camp near Dover, at the point where the King speaks the lines:

> 'This feather stirs; she lives! If it be so
> It is a chance which does redeem all sorrows
> That ever I have felt.'

The composition shows that Poole knew the engraving after James Barry in Boydell's *Shakespeare*, 1792; the painting by Barry is now in the Tate Gallery, London.

97 John Frederick Lewis, RA
 The Harem
 35 × 44 inches
 City Museum and Art Gallery, Birmingham

98 Frederick Goodall, RA
 A New Light in the Harem
 48 × 84 inches
 Walker Art Gallery, Liverpool

Exhibited at the Royal Academy, 1884. The picture was painted in 1884. The gazelle was lent to the artist for several days from the Zoological Gardens. His studio, which was hung with Egyptian sketches, incorporated some Musharabea lattice work of the kind shown here.

7 · Later landscape painting; portraiture; still life

It is incontestable that Victorian landscape painting did not continue at the pitch set by Constable and Turner; equally certain that the next great manifestations of the art were to come from France, although she had learned so much from England in the 1820s. If the Barbizon School is roughly parallel in quality to much that is discussed here, the Impressionists far outstripped their English contemporaries, and the salutary effect of their influence had to be reimported, rather than being of indigenous growth.

None the less, there is a considerable body of mid- and even late-nineteenth-century British landscapes which is interesting and enjoyable, even if it bears with it a sense of limitation. Much of it was produced by artists who were not wholehearted or full-time landscape painters, though specialists still accounted for some of the more striking examples of the *genre*.

Richard Redgrave, though fully trained before Victoria's accession, deserves consideration in this connection. He is another of the monotonously long list of artists—Dyce, Eastlake, Poynter, Leighton and Armstrong have already been discussed—who were called on to devote a good deal of their time and energy to official duties. Nothing can more vividly illustrate the seriousness with which the Victorians regarded their art institutions, and the desire they had to spread education in the most efficient way, than the extent to which they recruited established or prominent painters to undertake the administrative duties of these bodies. Richard Redgrave was one of the main officials of the present Victoria and Albert Museum; he was for a number of years responsible, in succession to Dyce, for the national system of art education and, as if this were not enough even for the energies of a dedicated public servant, he accepted the post of Inspector of the Queen's Pictures which entailed his making the first systematic catalogue of that great collection. If all his paintings were completely forgotten, he would still have had a great and abiding influence in public taste by his choice of paintings for the South Kensington collections. Like so many of the polymaths of the time, he designed pottery and glass, and gave much thought to the relation between art and industry.

The effect of an exacting round of official duties upon his art was of a different nature from that of his similarly burdened contemporaries. Whilst this deprived Eastlake and Armstrong of any real power to continue as painters, but made little difference to Poynter's output, Redgrave's course was diverted. He was famous at the time of his first official appointment, in 1847, almost solely as a *genre* painter; his efforts at social realism in that field have been referred to in the fourth chapter. From then onwards, as he could only

paint in the summer, he concentrated upon landscape painting, and his genuine bent for this branch of art enabled him to produce a number of successful pictures. He was an early instance of an artist-commuter, taking a cottage at Abinger and using it as the base for his sketching and landscape painting. He painted 'An Old English Homestead' at Sutton in 1854 on one of these visits, on which he made the comment: 'It was one of the clearest, sunniest summers I have known for many years. We had weeks of uninterrupted sunshine, and the country was thoroughly enjoyable. Hook and his wife were staying in Abinger . . . The pleasant hours passed in painting out of doors, with the wife reading a good novel in the intervals of her own sketching, a few minutes chat with a passing farmer or labourer, the sweet scents of clover and beans as the evening closes in, a luncheon of hard boiled eggs in the open air . . . make altogether a charming time to look back upon when hard at work in the weary writing and official world.' Although so prosaically expressed, the sense of relaxation apparent in his account reflects itself in this clear, well-organized and typically rural scene.

Thomas Creswick, on the other hand, painted nothing but landscape and, with a due sense of his own limitations, only a narrow range of scenery. His art was so far identified with the presence of streams, or at least of water, that it was thought worth mentioning, in the Memorial Exhibition held after his death, that one specific canvas had no river in it. In an age in which painters were becoming more and more concerned with their material welfare, it is refreshing to find that he set only a modest value on his art, and charged relatively low prices accordingly. More a continuer of the traditions of Glover than of Constable, he liked to maintain an overall brown tone in his landscape, and his handling is rather thin and dry. None the less his work stands out in a collection of Victorian landscape by its integrity and power of construction. He diversifies the generally thin painting of his canvases in a restrained yet homogeneous tone, with moss-like patches of impasto which, in the context, have the same quality as the relief on Samuel Palmer's early watercolours.

The biographers of Creswick are at pains to emphasize the uneventful nature of his serene, successful career. Yet there is one question they have not answered: did he go as a visitor to the United States of America? There is a view by him in the Jones Collection, Victoria and Albert Museum, of Mount Tom, Massachusetts, and the Memorial Exhibition included a view of the Hudson. Did he make these paintings from nature, or was he supplied with sketches of the subjects (a frequent custom in those days, followed by Turner and Cotman) by another hand? Stillman, who might, as an American, have been expected to comment on this issue, says nothing. What he does record is his disapproval of Creswick's facility of manner. 'I remember his showing me the way in which he produced detail in a pebbly brookside, by making the surface of his canvas tacky and then dragging over it a brush loaded with pigment which caught only on the prominences and did in a moment the work of an hour of faithful painting.' But the method he describes is what gives animation to the surface of Creswick's pictures.

Burchett represents in a minor key the same sort of career as that of Redgrave. After a distinguished start when a student, he became known mainly as

a history painter. He was early appointed to a post in the Government School of Design and became Headmaster in charge of the training of teachers in 1853. It seems he was somewhat of a rebel, and that an insurrection led by him caused the dismissal of the Director, Charles Heath Wilson. Also, in that spiritually tormented age, he became a convert to Catholicism. He is said to have used Manning, shortly after his conversion, as the model for St Oswald in his painting of 'The Death of St Oswald, Archbishop of York, anno 992'; one is reminded of Mr Casaubon in *Middlemarch* being painted by Naumann, the late Nazarene, as St Thomas Aquinas—and to have miraculously anticipated his appearance in old age. Surprisingly, even in a less specialized world, he tried to farm on a large scale, a course which led to financial disaster. The landscape he painted of the Isle of Wight seems to be his only known treatment of a natural scene, yet it is one of the out-of-the-way, entirely unexpected masterworks which frequently reward the follower of minor Victorian fortunes.

When Redgrave recorded in his diary from Abinger the name of his neighbour, Hook, he was referring to the painter J. C. Hook. This once well-known and influential artist was one of those singled out by Baudelaire for praise in the English contribution to the 1855 Exhibition in Paris. But at that group show, and indeed for many years before, Hook had shown historical scenes, set in Venice. Indeed, we read with a sense of familiarity amounting to despair that he, too, painted a canvas of 'Finding the Body of Harold' and received the gold medal of the Royal Academy for it in 1844.

But when he took a house in Abinger in 1853 he, like Redgrave but with greater single-mindedness, devoted himself to the painting of nature. His forte, for which he may still be appreciated, lies in his painting of the sea; he has a rich Venetian tone, no doubt appropriated from his historical paintings, and a surface which is in agreeable contrast to the linoleum-like finish of some of his contemporaries. Hook, who had been encouraged by Constable while in his teens, lived into the twentieth century. But he is yet another example of the open-mindedness of the supposedly rigid and old-fashioned; he spoke highly in praise of the Pre-Raphaelites and, though his work had no affinity with theirs was, as a sort of uncovenanted reward, himself praised by Ruskin. To have been praised both by Baudelaire and Ruskin is no common achievement, and Hook's work will some day emerge from the obscurity in which it temporarily rests. He has sometimes too strong a penchant for the rosy-cheeked bucolic fishermen; but the merit of his later style rests in its clear understanding of the sea, his ability to link human action with coastal scenery, and the genuinely attractive character of his brushwork.

Henry Moore, the elder brother of Albert Moore, was once described as a parasite of Hook's. But although they were close friends at one period, there is a wide gulf between the two artists' aims, even when they are both painting the sea. Hook generally took his viewpoint from dry land and introduced a note of *genre* on the cliffs or shores. From the mid-1870s Henry Moore devoted himself to studies and paintings of the mid-ocean, contrived with real knowledge and with a refreshing breadth of brushwork. To his contemporaries his work was almost as wild and unacceptable as that of the Impressionists, but the comparison these outraged Academicians were drawing is as difficult to defend

as such parallels generally are. His nearest affinity within the British Isles is with the Scottish painter, M'Taggart.

It is strange now to recall that in his own day the sea painter who rivalled Henry Moore in popularity was John Brett, for this artist is now remembered only for the Pre-Raphaelite phase in which he painted 'The Stonebreaker' and the 'Val d'Aosta'. Ruskin is generally criticized for having insisted on the arid photographic naturalism of these Swiss landscapes, painted to satisfy his own demand for geological exactness. Yet Brett himself was lost without the one critic who had praised him, and spoke bitterly of all others: 'It is a well-established practice that if you cannot dig and to beg you are ashamed, you go into business as an art critic!'

The Pre-Raphaelite attitude toward landscape was indeed a reversal of the method perfected by Wilson, Gainsborough, Turner and Constable. That there was a contradiction in their attitude to the *genre* can be seen in the way whereby Millais, for instance, would paint a specimen of landscape and seek for figures to put in it, to make for narrative interest. Furthermore, their microscopic examination, point by point, of the field of vision destroyed the possibility of an overall *coup d'oeil*, and entailed a reversion to that method of piecemeal composition criticized in French painters by Constable. Most singular of all, in painters whose main material was to be found in the English countryside, their method destroyed the aerial perspective which was so often the chief charm of what they were painting.

But if these trends told against the possibility of any really effective English landscape painting on Pre-Raphaelite principles, they did not to the same extent hamper those who travelled to the East. For this reason the intense harshness of Seddon's 'Jerusalem' is a legitimate interpretation of the scene in front of him. Seddon painted this on his first visit to Palestine, travelling with Holman Hunt in a spirit of imperfect sympathy. While there he met Edward Lear, who was engaged in one of those extensive hunts for material which took him to adventurous and inaccessible places—Southern Calabria, Corsica, India.

From many aspects Lear qualifies to be considered as an exotic artist. Though he did not carry the dichotomy between the two sides of his nature as far as Lewis Carroll, who adopted that pseudonym when publishing his children's books, Lear regarded his landscape painting as a more important activity than the nonsense verse for which he is now most remembered. His landscape art was in essentials a linear one, well adapted to expressing the precipitous transitions which he especially sought in scenery. At the time of his visit to Palestine his oil painting had fallen under the spell of Holman Hunt, though this influence had abated by the time he made his large canvas of 'Bethlehem' in 1861 from the sketches he had taken about eight years before. Efforts on this scale were, however, a burden to him; he wrote to a friend in the very year he painted 'Bethlehem', 'I certainly do hate the act of painting; and although day after day I go steadily on, it is like grinding my nose off.'

A more congenial application of Pre-Raphaelite principles to mountainous landscape was made by J. W. Inchbold. He too felt the doubtful blessing of Ruskin's interest; but the critic was undoubtedly kind to him, and not only singled out his work for attention, but acted as his host in Switzerland. Of this

visit Ruskin recorded: 'It was a delicate and difficult matter to make him gradually realise his faults . . . At last I think I succeeded in making him entirely uncomfortable and ashamed of himself.' Ruskin practised the same kind of—in the words of the editor of the Library Edition of his works—'helpful friendship' with Brett: 'I think he looks more miserable every day, and have a good hope of making him completely wretched in a day or two—and then I shall send him back to his castle.' Ruskin judged that Brett was 'much tougher and stronger than Inchbold'; but in fact Inchbold preserved his own personality far more intact from this persuasive and influential voice. His 'The Lake of Lucerne' is a landmark in the painting of the 1850s, whereas Brett's 'Val d'Aosta', to which Ruskin refers when he talks of 'sending him back to his castle', was not unfairly described by Millais as 'a wretched work like a photograph of some place in Switzerland'.

B. W. Leader developed in a different way. His father had known and admired Constable—had indeed painted a faithful copy of 'Gillingham Mill'—but Leader's work does not bear any trace of these high origins. Born in time to be influenced in his first pictures by the Pre-Raphaelites, he exhibited three paintings at the Royal Academy in 1922, at the age of ninety-one. The 'February Fill-Dyke' of 1881 marks the entrance into his established manner, and despite its literalness and the obviousness of its vision it has captured a mood of the English landscape rarely attempted. Its vast popularity is therefore not entirely unjustified; it is the equivalent in landscape of 'The Light of the World' in religious painting. There is also some originality in the tonality of Leader's less ambitious sketches, a use of paint resembling brown and green sealing wax, but not without pictorial quality. The motif of leafless trees patterned against the sky was caught and extended by Atkinson Grimshaw.

The early death of F. L. Bridell seems to have robbed mid-nineteenth-century English landscape painting of an individual note. His large 'Coliseum by Moonlight', composed in deep tones of blue and grey, is in a sense the last flare-up of the eighteenth-century romanticism established by J. R. Cozens. Its appearance at this date reminds us how far the emotional interpretation of ruined monuments had already been superseded by topographical descriptions or by pastoral homeland scenes.

Cecil Lawson achieved a greater fame, and was believed to have the seeds of development in him when he, too, died young—at the age of thirty. His memoir, written by Edmund Gosse, had in it an etching by Whistler from his last, unfinished picture, 'The Swan and the Iris'. That these tributes were not misplaced is shown by the solid matter-of-fact success of his 'Minister's Garden'. This painting, shown at the Grosvenor Gallery in 1878 when that gallery had replaced the Royal Academy as the fashion, made the artist's fame. He himself described it as a tribute to Oliver Goldsmith, in a passage which shows his literary culture. 'The materials for the composition I found in and about the little hillside that crowns the village of Sandhurst. The garden was an old-fashioned one with hollyhocks and roses, marigolds and cloves, and "the borage beloved of bees", in comely confusion. Its high position and gently sloping character gave me the opportunity of connecting the whole of the pastoral landscape with the garden itself. The aim of the picture, as far

as it has anything to do with Goldsmith, is suggestive homage and not illustration: it is not meant as a portrait of "Sweet Auburn, loveliest city of the plain", yet might this tangled garden be the home of one who

"passing rich on twenty pounds a year,
Allures to brighter worlds and leads the way."'

During the second half of the nineteenth century, landscape ceased to occupy its former position amongst the work of the watercolour painters. The watercolourists had perhaps contributed to this result by engaging in direct rivalry with the oil painters. As soon as they began to exhibit separately the question arose, 'Are watercolour paintings as good, as valuable, as serious as oil paintings?' Anticipating, or receiving, a negative answer, they began to paint pictures with a degree of elaboration and attention to detail which enabled them to be exhibited in heavy gilt frames and compete on the walls of a house with its oil pictures. A distinction grew up between the 'finished' watercolour, heavily framed in gold, and the 'sketch' in a white mount. There is a great gulf between, for instance, the watercolours which De Wint left in a deliberately sketchy state and the works he elaborated for exhibition. This process was accelerated by the growing use of gouache or opaque pigment, in place of the transparent washes which are the source of light in the freest works of Cozens, Girtin, Turner and Cox.

Furthermore, gouache was being used with a stippling technique, unlike the broader areas which had been washed by Sandby and other eighteenth-century practitioners of the gouache style. So the whole trend was against breadth and towards fragmentation. This was summed up by J. F. Lewis when he emerged from his Cairo seclusion in 1850 with the spectacular 'Hhareem'. He once said that 'when he left off for the day he had the satisfaction of knowing that he had finished a camel's eye'.

A version of the 'Hhareem' belonged at one time to Birket Foster. In view of the evident affinity between the style of these two artists, it is tempting to speculate whether it was from Lewis's work that the younger master learned his personal technique; but since the first sale of the drawing was for £1,000, it must be supposed that Birket Foster could only acquire it after he was himself famous.

Virtually self-taught, Birket Foster began his career as a designer of cuts for the *Illustrated London News*, and later specialized in book illustration. His rough designs at this stage, as indeed his sketches for his watercolours, have a breadth and calligraphic freedom which come as a surprise to those who only know his finished work. 'The Milkmaid', painted in 1860, stands at the start of the new career he undertook when nearing the age of thirty-five, when he resolved to devote his time to painting in watercolour. A favourable example of his style before much repetition had made it careless, it was painted from the fields round Hampstead, with the artist's niece as a model for the figure. The way in which he caught the effect of prettiness in a summer landscape soon became phenomenally popular. This led to the further spread of his images by chromolithographs, the excellence of one of which deceived the artist into going into a shop to enquire the price at which they were offering his drawing.

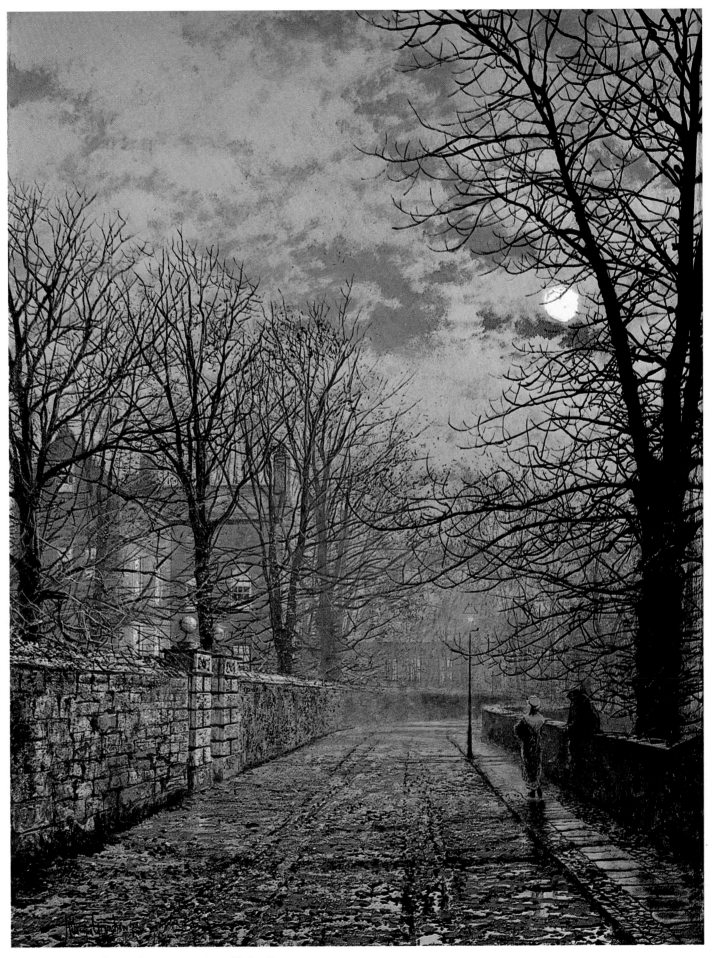

99 Atkinson Grimshaw: A Moonlight Scene

100 Richard Redgrave: An Old English Homestead

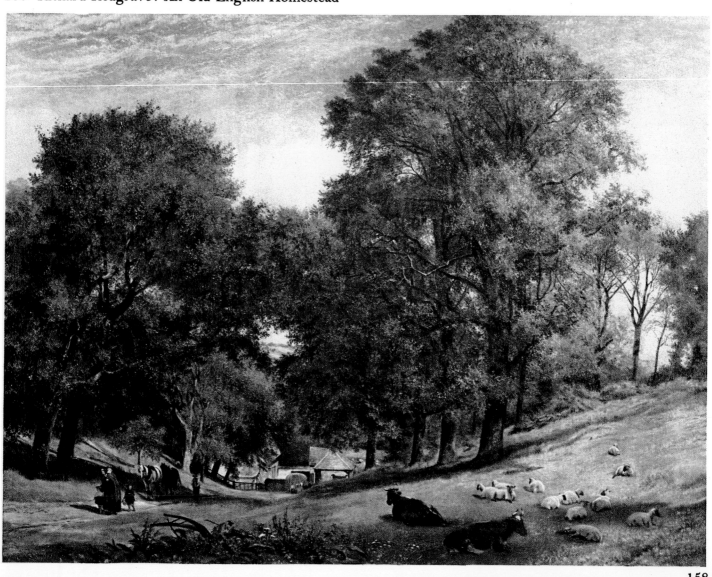

101 Thomas Creswick: Land's End, Cornwall

102 Richard Redgrave: 'The Valleys also stand thick with Corn'

103 Richard Burchett: A Scene in the Isle of Wight

104 Henry Moore: Arran

105 James Clarke Hook: The Mushroom Gatherers

106 Edward Lear: The Plains of Lombardy from Monte Generoso

107 Edward Lear: Bethlehem

108 Thomas Seddon: Jerusalem and the Valley of Jehoshaphet from the Hill of Evil Counsel

109 John William Inchbold: The Lake of Lucerne

110 Cecil Gordon Lawson: The Minister's Garden

111 Frederick Lee Bridell: The Coliseum by Moonlight

112 Benjamin Williams Leader: February Fill—Dyke

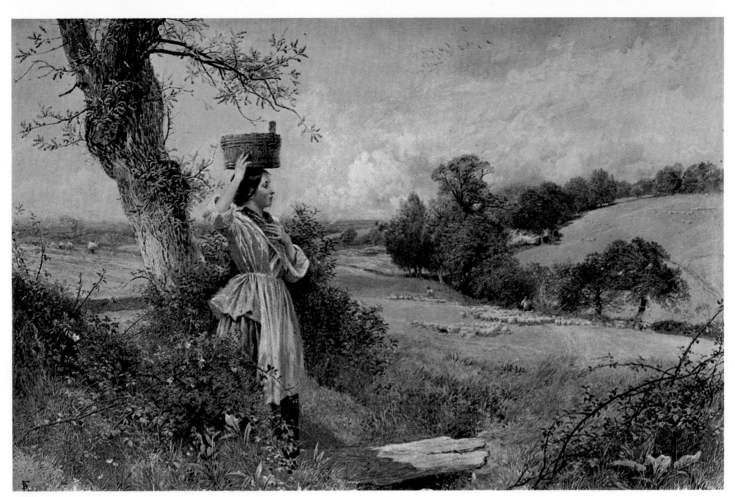

113 Myles Birket Foster: The Milkmaid

114 Albert Goodwin: 'A Pleasant Land'

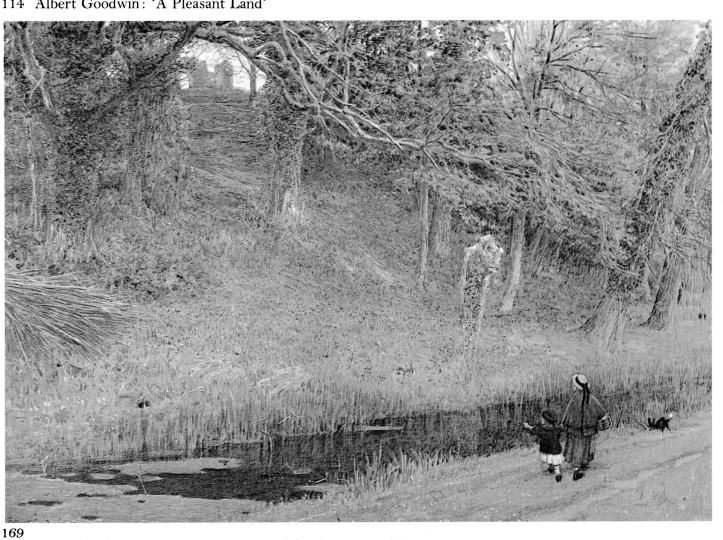

115 Sir William Charles Ross:
Louis Philippe, King of France

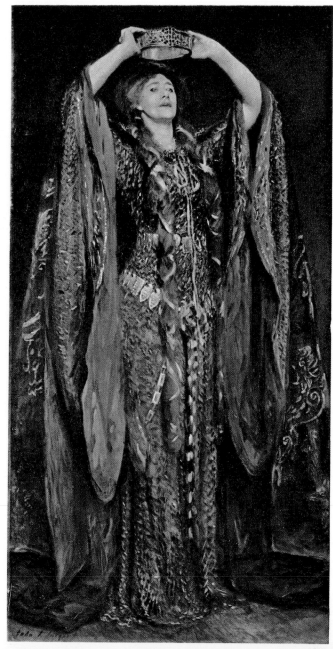

116 John Singer Sargent: Ellen Terry as Lady Macbeth

118 George Frederick Watts:
Lord Lawrence

117 Sir Francis Grant:
Henry, Lord Montague of Boughton

119 George Lance:
Still Life with Fruit

120 William Henry Hunt:
Primrose
and Birds' Nests

So many enquiries were made from him about the genuineness of paintings attributed to him that he felt obliged to charge a fee of a guinea for authenticating his own works.

Albert Goodwin painted in a comparable stippling manner, but reached a higher plane of poetry, even a hint of mystery, in his 'A Pleasant Land'. To this he prefixed the quotation, 'And they saw on the other side a pleasant land full of flowers and winding paths and did hear the song of the singing birds.'

Although Etty and De Wint made some exceptional incursions into the field, the revival of still-life painting, as an artist's main preoccupation, was effected almost single-handed by George Lance, who has the distinction of being one of the few pupils of Haydon's who prospered. His idea of form and arrangement may closely follow the seventeenth-century Dutch masters in this field, but Lance's work is executed with complete conviction and much subtlety. Part of the work of W. H. Hunt in watercolour is of cognate interest —close studies of the hedgerow which earned him the name of 'Bird's Nest' Hunt. In fact the artist's talents range over a far wider area; he began as a topographical draughtsman in the late eighteenth-century style, placing his emphasis upon line. Then he made a number of charming *genre* drawings, including many of a boy model who was a favourite with him; these are humorous without being mawkish. His later manner is a complex amalgam of stippling, rubbing-out and body-colour, used with a keen eye for texture and colour. It is small wonder that he was admired by Birket Foster, who bought a number of his drawings. But his popularity was general; Ruskin devoted a monograph to him, and his arrangements of nests and blossoms gave the cue for the composition of many Victorian photographs.

Portraiture, like landscape, pursued an uneven course in the Victorian era. That overpowering emphasis on the character of the sitter which ran through the Romantic portraiture dominated by Lawrence diminished after his death. The portrait painters of the great age, Reynolds, Gainsborough, Romney, however much they may have complained, virtually specialized in that one field. The product of later Victorian times suggests that their dedication was a wise one. Of the specialist portrait painters only a few—Grant, Winterhalter, Watson Gordon, Holl—rise above mediocrity, though the prolific contributions of Ballantyne and Lowes Dickinson have a respectable competence. But many painters distinguished in other ways painted portraits occasionally. In this, as in so many other directions, Watts is an exception; possibly the typical Victorian painter of portraits and, as has been seen, at his best with distinguished sitters. Amongst the others who dabbled in portraiture are Landseer, Leighton, Frith, Orchardson, Tissot, Poynter. Some of their works —Landseer's 'John Gibson', Tissot's 'Captain Burnaby'—are among the successes of high Victorian art. But it was not till the advent of Sargent, Lavery, Sickert and Tonks towards the end of the century that freedom of paint and sympathetic interpretation of character again became a common feature of British portraiture.

To some extent the craft had been bedevilled by the invention of photography. In no section of art was this felt more strongly than in miniature painting. A robust, almost an indispensable, feature of social life, it withered

away in a generation after the mechanical difficulties of the daguerreotype had been smoothed away.)Though Miss Annie Dixon kept working till the 90s, Thorburn forsook miniature painting for oils around 1860. Others combined the practice of pure miniature painting *ad vivum* with the tinting of small photographs; H. C. Heath did this. The last untroubled exponent, and one who sums up the tradition of three centuries in this art, was Sir William Ross. Although his ambition was to be an historical painter—he too competed in the Houses of Parliament competition and won a prize in 1843 for his cartoon of 'The Angel Raphael discoursing with Adam and Eve'—he concentrated his professional career upon miniatures and owed his success to the patronage of the Royal Family. It was his especial gift to catch his sitters at their most genial and agreeable, and his miniatures of Prince Albert, Melbourne and Louis Philippe rank among the most attractive and effective portraits of their epoch.

Notes on the plates 99 - 120

99 Atkinson Grimshaw (1836–1893)
 A Moonlight Scene
 Board, 18 × 14 inches Signed and dated 1881
 Private Collection

This is a characteristic example of Atkinson Grimshaw's preoccupation with night scenes in suburban streets, and the silhouettes of wintry trees.

100 Richard Redgrave, RA (1804–1888)
 An Old English Homestead
 $40\frac{3}{4}$ × 54 inches Signed and dated 1854
 Victoria and Albert Museum, London

Exhibited at the Royal Academy, 1854. Painted when the artist was staying at Sutton near Abinger, busily engaged in painting landscapes.

101 Thomas Creswick, RA (1811–1869)
 Land's End, Cornwall
 $36\frac{1}{4}$ × $51\frac{1}{4}$ inches Signed and dated 1842
 Victoria and Albert Museum, London

Exhibited at the British Institution, 1843. In the year in which he painted this picture, Creswick was awarded a premium of 50 gns by the British Institution, and also elected ARA.

102 Richard Redgrave, RA
 'The Valleys also stand thick with Corn'
 28 × 38 inches Signed and dated 1865
 City Museum and Art Gallery, Birmingham

Exhibited at the Royal Academy, 1865. The title is taken from Psalm lxv. It refers here to the good harvest of 1864.

103 Richard Burchett (1815–1875)
 A Scene in the Isle of Wight
 $13\frac{1}{2}$ × $22\frac{1}{2}$ inches
 Victoria and Albert Museum, London

The view is taken from along Shanklin Down looking across Sandown Bay; the Culver cliffs are in the distance.

104 Henry Moore (1831–1895)
 Arran
 $11\frac{1}{2} \times 21$ inches
 City Art Gallery, Manchester

105 James Clarke Hook, RA (1819–1907)
 The Mushroom Gatherers
 Panel, $7 \times 9\frac{1}{2}$ inches
 The Art Gallery and Regional Museum, Aberdeen

106 Edward Lear (1812–1888)
 The Plains of Lombardy from Monte Generoso
 $9\frac{3}{4} \times 18\frac{1}{2}$ inches Signed
 Ashmolean Museum, Oxford

Painted in 1880–81.

107 Edward Lear
 Bethlehem
 $37\frac{3}{8} \times 45$ inches Signed
 Walker Art Gallery, Liverpool

Seddon, the painter of Plate 108, met Lear in Egypt and consulted him about Sinai. He recorded his sketching costume in the East: 'a straw hat with a brim as large as a cart-wheel with a white calico cover. He was called up the Nile . . . the father of the white turban like a table.'

108 Thomas Seddon (1821–1856)
 Jerusalem and the Valley of Jehoshaphet from the Hill of Evil Counsel
 25×32 inches
 The Tate Gallery, London

Seddon first went to the East, with Holman Hunt, in 1853; this painting took him five months to complete in the following year. He wrote of his first view of Jerusalem: 'I never was so affected in my life at the sight of any place, and could hardly help bursting into tears'. Seddon died in Cairo on his second visit, three years later.

109 John William Inchbold (1830–1888)
 The Lake of Lucerne
 Millboard, 14¼ × 18½ inches Signed and dated 1857
 Victoria and Albert Museum, London

The painting has as sub-title, 'Mount Pilatus in the distance'. The artist spent some time with Ruskin in Switzerland in the year in which he painted this view.

110 Cecil Gordon Lawson (1851–1882)
 The Minister's Garden
 71 × 107 inches
 City Art Gallery, Manchester

111 Frederick Lee Bridell (1831–1863)
 The Coliseum by Moonlight
 60 × 90½ inches
 Southampton Art Gallery

112 Benjamin Williams Leader, RA (1831–1923)
 February Fill-Dyke
 47 × 71½ inches Signed and dated 1881
 City Museum and Art Gallery, Birmingham

Exhibited at the Royal Academy, 1881. The title refers to the saying 'February fill the dyke/With the black or with the white'. However, the artist described the scene as 'A November evening after rain'.

113 Myles Birket Foster (1825–1899)
 The Milkmaid
 Watercolour, 11¾ × 17½ inches Signed and dated 1860
 Victoria and Albert Museum, London

114 Albert Goodwin (1845–1932)
 'A Pleasant Land'
 Watercolour, 9⅞ × 14⅛ inches Signed and dated 1875
 Victoria and Albert Museum, London

115 Sir William Charles Ross, RA (1794–1860)
 Louis Philippe, King of France
 Miniature on ivory, 5⅛ × 4⅛ inches Painted in 1841
 Reproduced by Gracious Permission of H.M. The Queen

116 John Singer Sargent, RA (1856–1925)
 Ellen Terry as Lady Macbeth
 87 × 45 inches Signed
 The Tate Gallery, London

Exhibited at the New Gallery, 1889.
Sargent was present at the first performance of Irving's new production of *Macbeth* at the Lyceum Theatre on 29 December 1888, and was greatly impressed by Ellen Terry's appearance as Lady Macbeth. He suggested that she should sit for him in costume, and invented the action of placing on her head the Royal Crown of Duncan, which was not in the production. The portrait was the sensation of 1889.

117 Sir Frances Grant, PRA (1803–1878)
 Henry, Lord Montagu of Boughton
 43½ × 25 inches Painted in 1842
 Collection of the Duke of Buccleuch

118 George Frederick Watts, OM, RA
 Lord Lawrence
 Panel, 23½ × 19½ inches Signed and dated 1862
 National Portrait Gallery, London

John Laird Mair Lawrence, first Baron Lawrence (1811–1879), distinguished himself in the Indian Mutiny and became Governor-General of India.

119 George Lance (1802–1864)
 Still Life with Fruit
 14 × 17 inches Signed and dated 1842
 Victoria and Albert Museum, London

Exhibited at the British Institution, 1843.

120 William Henry Hunt (1790–1867)
 Primrose and Birds' Nests
 Watercolour, 13½ × 13⅞ inches Signed
 Victoria and Albert Museum, London

Hunt described his method in later years as 'pure colour over pure colour'. This is an example of the technique of hatching and stippling applied to the subjects which gained him the nickname of 'Bird's Nest' Hunt.

8 · Genre painting and the later Victorian era

Side by side with developments which were in retrospect to seem more important, the solid, steady tradition of subject-painting—historical, illustrative and anecdotal—pursued its course till the end of the nineteenth century and beyond. Indeed, the development of chromolithography and photogravure as a means of multiplying the most popular images led to their being known in a wider range of homes than ever before. Mary Clive has written in *The Day of Reckoning* of the impact in the nursery of these best-selling reproductions. And whatever may have been the reputation of Frith's 'Railway Station' or Abraham Solomon's 'Waiting for the Verdict', increased as it was by the number of engravings which were sold, this was undoubtedly eclipsed by the best-selling prints of the last decades of the nineteenth century. 'Friday' by Dendy Sadler, 'For He had spoken Lightly of a Woman's Name' by John Lomax, 'Between Two Fires' by Millet are still titles which evoke sharp visual images in many people's minds, though these may not always be accompanied by feelings of pleasure and approval. Such reproductions occupy in the last years of the Victorian age a position somewhat similar to that of those painters of Keepsake beauties who supplied, on a rather higher level, the popular visual pabulum of its earliest decade.

But popularity was not necessarily synonymous with badness and there were some artists who, while they profited from painting best-sellers, did so by means of adequate pictorial and technical means. W. F. Yeames is an example, although the very title of his 'And when did You Last see Your Father?' has become a joke. That he could make a sympathetic study of a modern predicament is shown by his problem picture 'Defendant and Counsel' in the Bristol Art Gallery. His 'Amy Robsart' in the Tate Gallery, though painstakingly literal, gives a dramatically lighted and effective account of the climax of the story. The large watercolour 'Exorcising by Bell, Book and Candle' is austere in treatment as well as theme, and gains in effect from the sharply angled, cold light coming from the right. Yeames claimed that his short sight enabled him to make good compositions; it helps to explain the emphatic tonal contrasts in these works.

Yeames was one of the members of the second artistic society in the Victorian age to call itself 'The Clique', in this case the 'St John's Wood Clique'. Its leader was P. H. Calderon, whose father was a renegade priest who had left Spain; this Protestant strain persisted, and his portrayal of St Elizabeth of Hungary as a naked figure before the altar gave great offence in Roman Catholic circles. One of the features of The Clique's activities—H. S. Marks, G. D. Leslie, D. W. Wynfield and G. A. Story were other members—was an

addiction to practical jokes of a kind then endemic in British art circles. It is difficult to resist the conclusion that the prosperity which, when it came, came in full measure to the painters of popular subject pictures, accounts for the drop in the quality of temperature and attack which they so frequently show. An almost obligatory feature of an artist's biography at the time was the description and illustration of his well-found home: Norman Shaw was employed to design houses for Frederick Goodall, Kate Greenaway, Frank Holl, Edwin Long, Marcus Stone and Luke Fildes, whilst the splendours of Alma-Tadema's home, altered to his own design, are well known.

In his earliest successful work 'Broken Vows', now in the Tate Gallery, Calderon did achieve under Pre-Raphaelite influence a sense of the drama of betrayal which places it among the best instances of modern *genre* in the 1850s: it shows, over a garden fence, the reverse side of the story from Frank Stone's genial 'Tryst'. Painted almost thirty years later, his biblical illustration 'Ruth and Naomi' preserved something of the tension, but in a form more acceptable to a wider public.

H. S. Marks, another member of the St John's Wood Clique, also grew up when Pre-Raphaelite influence was strong. His 'May Day in the Olden Time', painted as the design for a decoration in the Refreshment Room of the Victoria and Albert Museum, is a rather depressing fancy-dress charade. But it was through his ability to identify himself to some extent with the feelings of birds, to which he was greatly attached, that he produced some paintings worthy of a second look. His high spirits were always evident and earned a rather ponderous shake of the head from Ruskin, who in other respects admired his natural history studies. He wrote to him solemnly about his humour: 'Some very considerable part of the higher painter's gift in you is handicapped by that particular faculty'. But the element of humour present in 'A Select Committee' is not too insistently obtrusive, and the painting has a loving, first-hand understanding of the characteristics and expressions of the birds it represents.

In stark contrast to the escapist trend of these painters is the short-lived school of social realists who made their presence felt about 1870. These artists gathered round the newly founded weekly newspaper *The Graphic*, and their first work was produced in the form of wood-engravings from their drawings, which were greatly admired by Van Gogh. This impetus towards the observation of the daily life of their times, and a bent in their temperament and in the public curiosity towards its seamier side, led to the careers which Frank Holl, Luke Fildes and Hubert Herkomer followed as painters. All three subsequently became first, interpreters of their drawings in oil painting and, secondly, fashionable portrait painters. And although the impetus seems to have been dimmed by success, there is a genuine compassion with the poor and the suffering in Holl's 'Newgate: Committed for Trial' and Fildes's 'Applicant for Admission to a Casual Ward', though interpreted in a low key of colour and without much pictorial imagination.

At almost the same time as the social realists, there was a move to record the glittering appearance of the world of society, rich and ostentatious on a broader scale than it had ever been before. Tissot was the most attractive of the artists who took this world for their subject-matter, and in his case Ruskin

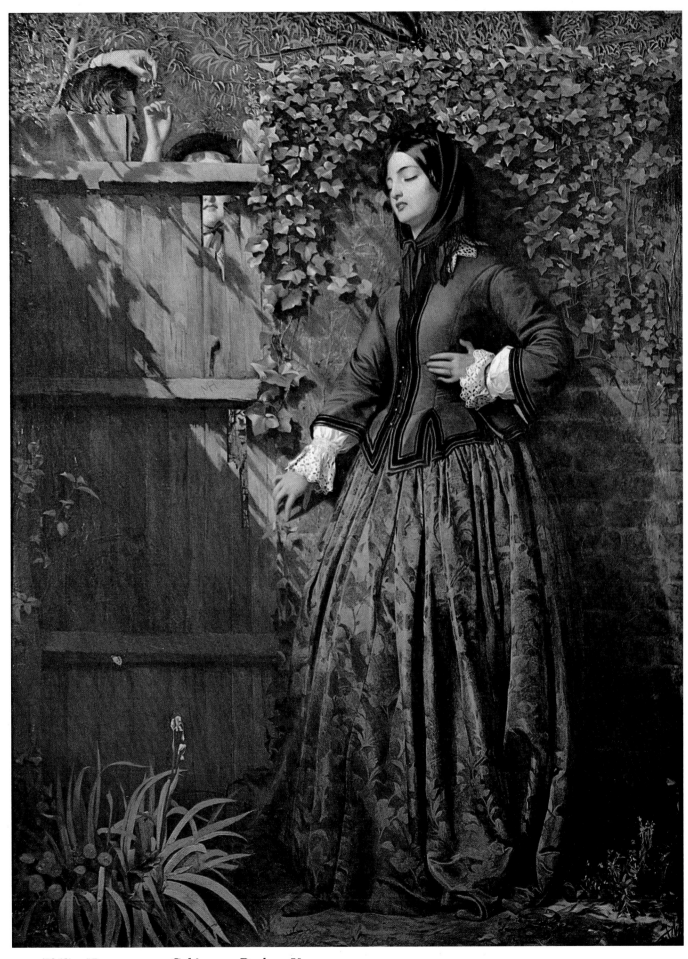

121 Philip Hermogenes Calderon: Broken Vows

122 William Frederick Yeames: Amy Robsart

123 Henry Stacy Marks: A Select Committee

124 William Frederick Yeames: Exorcising by Bell, Book and Candle

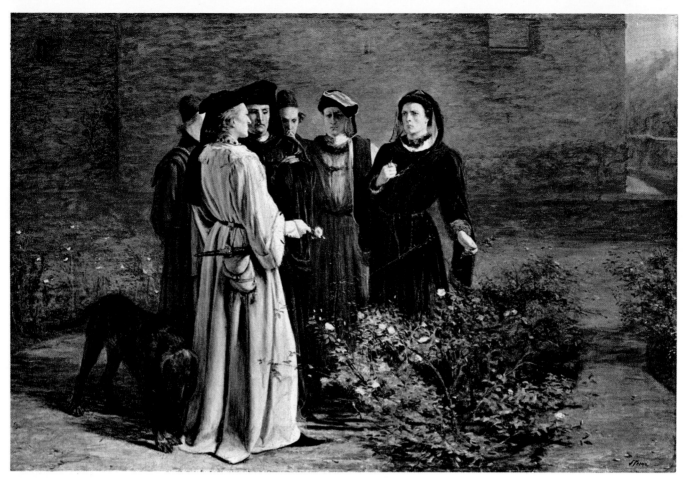

125 John Pettie: Scene in the Temple Garden

126 James (Joseph-Jacques) Tissot: The Ball on Shipboard

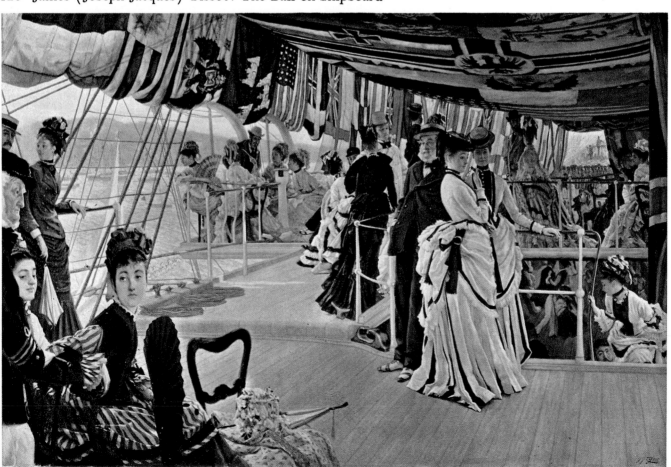

127 Sir William Quiller Orchardson: The Broken Tryst

128 Tom Graham: The Landing Stage

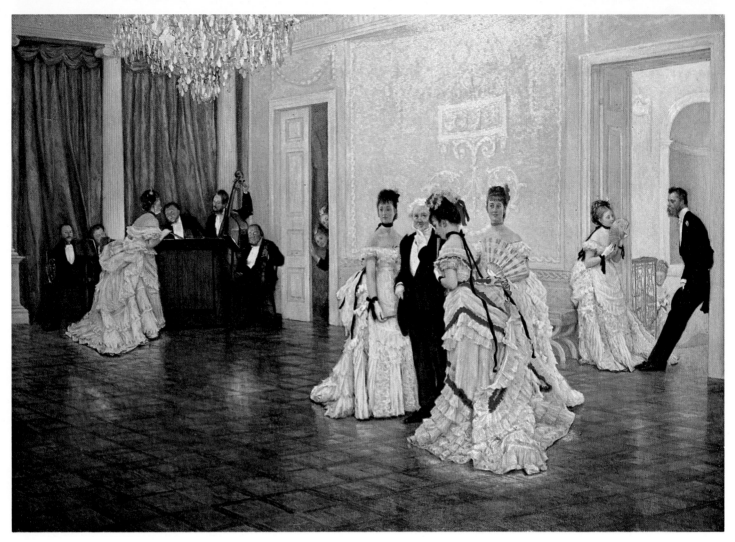

129 James (Joseph-Jacques) Tissot: Too Early

130 Sir William Quiller Orchardson: The First Cloud

131 Frank Bramley: A Hopeless Dawn

132 Haynes King: Jealousy and Flirtation

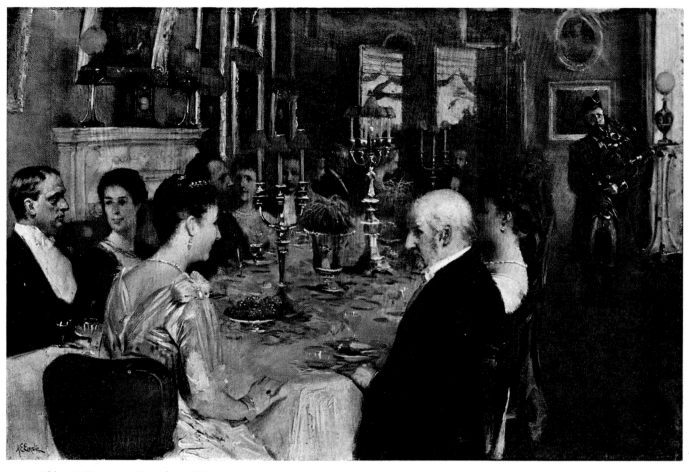

133 Alfred Edward Emslie: Dinner at Haddo House, 1884

134 James Sant: Miss Martineau's Garden

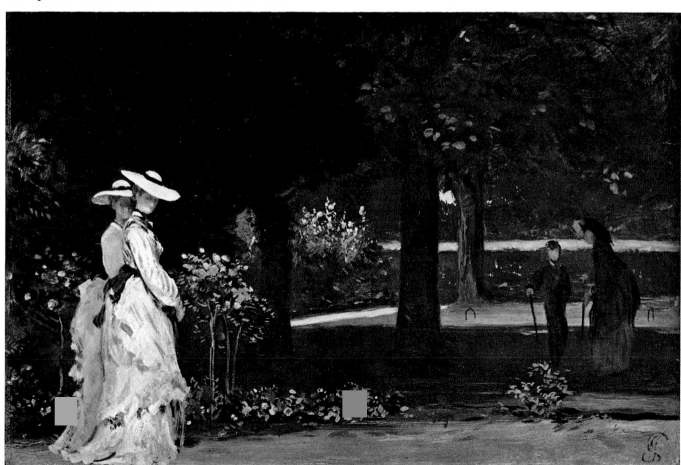

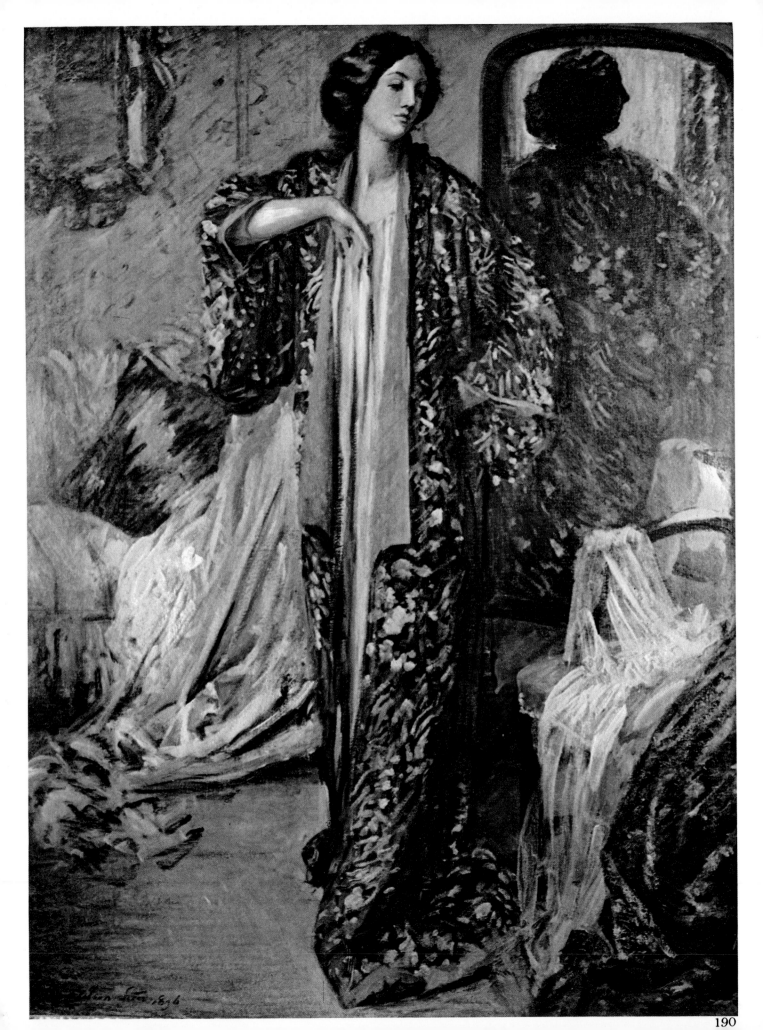

135 Philip Wilson Steer: The Japanese Gown

136 Walter Richard Sickert: Gatti's Hungerford Palace of Varieties, second turn of Katie Lawrence

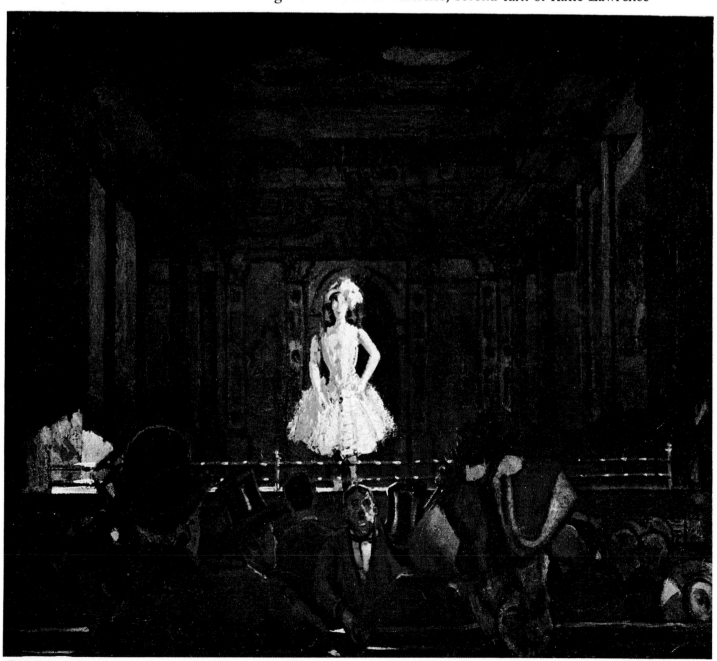

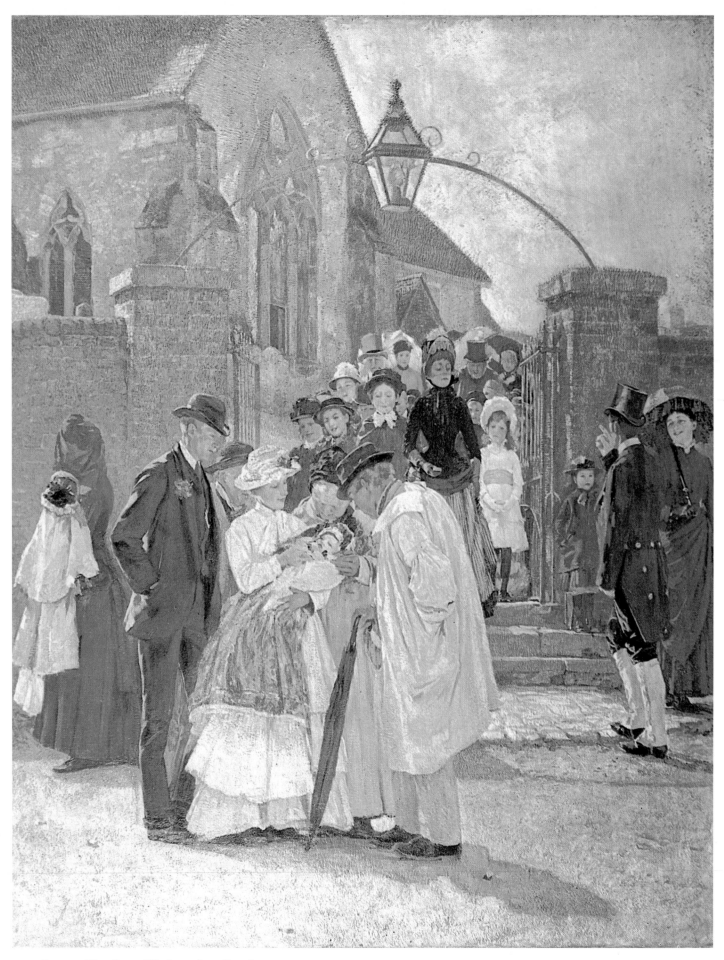

137 James Charles: Christening Sunday

characterized his themes as 'vulgar society'. Vulgar it may well have been; it is difficult to read the accounts of the famous scandals of the time, such as the Tranby Croft case in which the future Edward VII and his set were involved, without being conscious of the force of his criticism. Tissot came to the contemplation of this section of London life with the twin advantages of being an outsider and having a sophisticated training in the company of Whistler and Degas. Perhaps he did not take full advantage of these gifts of fortune; his painting of contemporary life has not the detached integrity of Degas', and he did not use his privileged position as a visitor to suggest a satirical or ironic comment on what he saw. Like any successful portrait painter of the time, he took his men and women at their own valuation. But his cosmopolitan knowledge and his enthusiasm for the arts of Japan lend a style and distinction to his work which is lacking in most contemporary British painting. We may catch a glimpse of the native product at its most appealing in Emslie's 'Dinner at Haddo House'—a high society piece which is both portraiture and contemporary *genre*—or in Sant's 'Miss Martineau's Garden'. The most interesting phase of Tissot's English career comes with his gradual withdrawal from the social world, as a result of his liaison with Mrs Kathleen Newton, a beautiful married woman who lived with him. Mysteriously hidden in the rooms which were subsequently to be remodelled by Alma-Tadema, she became more and more his obsession. As with Rossetti, 'One face looks out from all his canvases'. We see her constantly, under the chestnuts in a hammock in the Grove Lodge garden, reading a letter in the autumn. When she died of consumption at the age of twenty-eight, Tissot's life in England was shattered and his career as a painter of modern life came to an abrupt close. The later paintings of the life of Christ no longer seem potent to arouse the religious fervour they evoked in his own lifetime.

Tissot's place as the interpreter of high life was taken by W. Q. Orchardson. Orchardson was one of another group of closely-associated artists; the link in this case being his Scottish birth and his training at the Trustees' Academy, Edinburgh. He enrolled in this Academy at the age of thirteen; he remained a student for many years, and in the last of them R. Scott Lauder became the principal teacher. His instruction fired Orchardson, and also encouraged a number of other students who achieved success—among them MacWhirter, M'Taggart, Cameron, Pettie and Tom Graham. When in 1862 Orchardson decided to move south to London, he was soon followed by Pettie and, in the following year, by Tom Graham. Of this group, who had lodgings together, Orchardson was the acknowledged leader. He ultimately became the master of a style which was equally applicable to the reconstruction of historical —especially Regency—dramas, or the equivalent happenings in modern life. It is characterized by the thinness of the paint and the overall brown quality of the tone, and was described in his own day as resembling the reverse side of a tapestry. The first application of his mature power to social scenes was in 'A Social Eddy' of 1878, showing, in an absolutely Late Victorian ballroom, an event clad in Regency costume. In the 1880s he started to translate this idiom into modern dress with 'Mariage de Convenance', a confrontation of an elderly rich man and his bored young wife over a dinner table. 'The First Cloud' con-

tinues this series in the pictorial idiom which Orchardson made his own. It is a theatrical presentation, with a backcloth opening on to a dramatically lighted interior with wings at the side, and only two figures—though sometimes he allowed himself crowd scenes—in the rigidly defined picture space. Here, as in so many of his pictures, Orchardson presented the tableau of an effective exit which the spectator expects to be followed by the fall of a curtain.

Tom Graham was the model for the cross husband in 'The First Cloud'. Although of a finer sensibility than his fellow students in Edinburgh, he did not achieve the same official successes. Yet, as 'The Landing Stage' shows, he was capable of combining the observation of human emotion with a purely painterly approach to its physical setting. The third of these Scottish *genre* painters to come south with Orchardson, John Pettie, had a more successful but more obvious approach. The 'Scene in the Temple Garden' is an effective example of his work in its suggestion of the conspiratorial meeting which led to the Wars of the Roses. Yet even here, despite that rich sense of tone which was Pettie's talent, there is a suggestion of economy with models, the feeling that one man has been used over and over again for different figures with little facial change, which is so frequently a weakness with Lomax and Dendy Sadler.

The gulf between English and French art which had been so apparent at the Exposition Universelle of 1855 had become even more absolute in the later years of the nineteenth century. This was not entirely due to lack of contact between the two cultures. As we have seen, the *Trilby* set, Poynter, Armstrong and du Maurier, had been art students in Paris in the 1850s, when Whistler had been their friend. Pettie and Tom Graham spent some time in Paris in 1860. But these visits, and the reciprocal journeys of French artists to England, together with the display of Continental painting in the increasing dealers' colony in Bond Street, served only to reinforce the insularity of British art and its determined progress along its self-appointed lines. The divergence between the two schools became dramatically apparent when the Impressionists began in the 1860s to develop a style of painting which, at least in landscape, might reasonably have looked for support in England. Indeed, had it been possible for such work to have been shown here in the 1830s, it might well have escaped the sense of bewilderment and outrage which it met in the 1870s and 1880s.

Ultimately the sense of divergence between the intentions and the quality of the two traditions became so wide that a new generation of English artists who had studied in Paris decided that it was necessary to escape from official trammels in order to develop a new freedom. This movement led to the formation of the New English Art Club, which held its first exhibition in 1886. Yet that first show contained work by many artists who are not now considered to have been the *avant garde* of their decade. By the side of Sargent and Steer were Arthur Hacker, Greiffenhagen, La Thangue, Stanhope Forbes, Tuke, Bramley and Charles. Even these artists were sufficient to instil a sense of shock into the more conservative amongst the patrons and dealers. It had been intended to hold the first exhibition of the Club under the aegis of an established dealer, but after Mr Colnaghi had seen the paintings, 'particularly one study of nude boys' (evidently by Tuke), he declined to be officially associated with the group.

The unusual constitution of the New English Art Club, without a President or permanent Committee, made it especially responsive to the pressures of the young and active painters, and for some years it did mirror the progressive side of British painting. When Whistler deserted the Royal Society of British Artists in 1888, he took Sickert with him into the New English Art Club: soon the original body of artists reformed into new, loose groupings. The Glasgow School headed by Guthrie, and with Lavery, Cameron and Arthur Melville among its members, was one; another, with similar aims and type of vision, was the Newlyn School of which Bramley, Stanhope Forbes and Tuke were all leading members. Dominance in the N.E.A.C. itself fell to the artists loosely and rather inaccurately known as the London Impressionists—Sickert, Steer and Tonks being the most prominent. The artistic world entered in a new phase of controversy before the bitterness of which the animosity caused by Pre-Raphaelitism appears a mere ripple. This argument, with MacColl playing the role assigned in the earlier fight to Ruskin, lingered on into the 1930s, and helped to shape the course of British art in the present century. But in a retrospect of Victorian painting it is more relevant to point out that there was continuity as well as revolution. There are close affinities between the wild men of the '90s and the illustrative anecdotal painters who preceded them, as well as apparent links with the work of Degas, Whistler and, above all, Bastien Lepage.

The debate was mostly about the importance of 'subject' in painting. This had been canvassed for most of the century. The long line of illustrative painters discussed here—Mulready, Leslie, Frith, Holman Hunt, Solomon, Orchardson—shows to what an extent the possession of anecdotal content had become an accepted fact about Victorian painting. While this is a perfectly natural requirement to make of art, it had become a cause of weakness, and the late-nineteenth-century rebels were attempting to reaffirm the prime importance of those purely pictorial values, together with painterly intelligence, which they thought had been overlooked in the pursuit of literary meanings. None the less, the difference between Sickert's 'Katie Lawrence' and Charles's 'Christening Sunday', or between Steer's 'The Japanese Gown' and T. Graham's 'Landing Stage' is one of degree rather than kind. They have to be judged, as all art is judged, by the evidence they give of the artist's ability and quality, not the warmth of his response to the revolutionary activities on the other side of the Channel.

Notes on the plates 121 - 137

121 Philip Hermogenes Calderon, RA (1833–1898)
Broken Vows
$35\frac{1}{2} \times 26\frac{1}{2}$ inches Signed and dated 1856
The Tate Gallery, London

Exhibited at the Royal Academy, 1857, with the quotation 'More hearts are breaking in this world of ours . . . ' A work in which the Pre-Raphaelite influence is strongly marked, this was the first painting by the artist to achieve success.

122 William Frederick Yeames, RA (1835–1918)
Amy Robsart
$109\frac{1}{2} \times 72$ inches
The Tate Gallery, London

When showing this painting at the Royal Academy in 1877, the artist gave in the catalogue a quotation from Aubrey's description of the murder of Amy Robsart by her husband Robert Dudley, Earl of Leicester.

123 Henry Stacy Marks, RA (1829–1898)
A Select Committee
$43\frac{1}{2} \times 33\frac{3}{4}$ inches Signed
Walker Art Gallery, Liverpool

Exhibited at the Royal Academy, 1891. The artist relates in his *Pen and Pencil Sketches*, 1894, how he first thought of drawing birds when, at the age of about thirty, he watched some white storks at Amiens. In 1889 he held his first exhibition of drawings of birds, based largely on visits to the Zoo, where he spent much time in the parrot house. He wrote that he 'preferred birds to human sitters'.

124 William Frederick Yeames, RA
Exorcising by Bell, Book and Candle
Watercolour, $18\frac{1}{8} \times 42\frac{1}{4}$ inches Signed and dated 1867
Victoria and Albert Museum, London

This watercolour has more recently been called 'The Administration of Discipline in the Chapter of a Monastery', but the former title was that given by the artist.

125 John Pettie, RA (1839–1893)
 Scene in the Temple Garden
 47 × 72 inches Signed
 Walker Art Gallery, Liverpool

Exhibited at the Royal Academy, 1871. The painting, subtitled 'Origin of the Wars of the Roses', illustrates the scene in *Henry VI*, Part I, Act II, in which Suffolk, Somerset, Warwick, Vernon and Plantagenet (afterwards Richard, Duke of York) pick roses from the bushes in the Temple Garden.

126 James (Joseph-Jacques) Tissot (1836–1902)
 The Ball on Shipboard
 $33\frac{1}{8}$ × 51 inches Signed
 The Tate Gallery, London

Exhibited at the Royal Academy, 1874. The scene is apparently set at Cowes, during Regatta Week.

127 Sir William Quiller Orchardson, RA (1835–1910)
 The Broken Tryst
 $23\frac{1}{2}$ × $19\frac{1}{4}$ inches
 Art Gallery and Regional Museum, Aberdeen

128 Tom Graham (1840–1906)
 The Landing Stage
 $12\frac{1}{2}$ × $21\frac{1}{8}$ inches
 Victoria and Albert Museum, London

The painting has also been called 'Adieu' and 'Going to Sea': a larger version with the latter title is in the Cartwright Memorial Gallery Hall, Bradford. A version exhibited at the Royal Academy, 1893, was entitled 'Last Words, Tyneside'.

129 James (Joseph-Jacques) Tissot
 Too Early
 28 × 40 inches
 Guildhall Art Gallery, London

Exhibited at the Royal Academy, 1873. Louise Jopling, a friend of Tissot's, described this as, 'a new departure in art, this witty representation of modern life'.

130 Sir William Quiller Orchardson, RA
 The First Cloud
 76 × 52 inches
 National Gallery of Victoria, Melbourne

Exhibited at the Royal Academy, 1887. The artist added to the title the quotation from Tennyson:

> It is the little rift within the lute
> That by and by will make the music mute.

The Tate Gallery possesses a smaller replica, painted in the same year. The husband is a portrait of the artist Tom Graham.

131 Frank Bramley, RA (1857–1915)
 A Hopeless Dawn
 48¼ × 66 inches Signed and dated 1888
 The Tate Gallery, London

When exhibited at the Royal Academy in 1888, the catalogue gave the following quotation from Ruskin:

'Human effort and sorrow going on perpetually from age to age; waves rolling for ever and winds moaning, and faithful hearts wasting and sickening for ever, and brave lives dashed away about the rattling beach like weeds for ever; and still, at the helm of every lonely boat, through starless night and hopeless dawn, His hand, who spreads the fisher's net over the dust of the Sidonian palaces, and gave unto the fisher's hand the keys of the Kingdom of heaven.'

The print from Raphael's 'Feed my sheep' illustrates the text. When Alice Meynell wrote about the Newlyn School in 1889, she recognized this painting as one of its early successes.

132 Haynes King (1831–1904)
 Jealousy and Flirtation
 27¾ × 35¾ inches Signed and dated 1874
 Bethnal Green Museum, London

Exhibited at the Royal Academy, 1874.

133 Alfred Edward Emslie (flourished 1867–1889)
 Dinner at Haddo House, 1884
 14¼ × 22¾ inches
 National Portrait Gallery, London

The hostess, the Marchioness of Aberdeen, is seen in the foreground: on her right are Gladstone and the Countess of Roseberry and on her left Lord Roseberry and Lady Harriet Lindsay.

134 James Sant, RA (1820–1916)
Miss Martineau's Garden
12 × 18 inches Signed Painted in 1873
The Tate Gallery, London

135 Philip Wilson Steer, OM (1860–1942)
The Japanese Gown
39 × 49½ inches Signed and dated 1896
National Gallery of Victoria, Melbourne

This painting was brought for the Gallery in 1906 on the advice of the *plein air* artist, George Clausen.

136 Walter Richard Sickert, RA (1860–1942)
Gatti's Hungerford Palace of Varieties, second turn of Katie Lawrence
33½ × 39 inches Signed Painted *c*.1888
Art Gallery of New South Wales, Sydney

This music-hall was constructed in the arches below Charing Cross station by Carlo Gatti, who also introduced ice-cream barrows to London. Katie Lawrence (d. 1913) was famous for her song 'Daisy, Daisy, give me your answer do'. Sickert's admiration for her was not reciprocated; when he offered her a painting of herself she replied, 'What! That thing! Not even to keep the draught out from under the scullery door!'

137 James Charles (1851–1906)
Christening Sunday
62¼ × 49½ inches Signed and dated 1887
City Art Gallery, Manchester

Exhibition at the Royal Academy, 1887. The picture was painted at South Harting, Sussex. The model for the mother was the artist's wife, Ellen.

Notes

The aim of these notes is to direct attention to some of the more recent publications which contain significant new material.

Amongst recent surveys of the whole period are *Victorian Painters* by Jeremy Maas, 1969, and *The Dictionary of Victorian Painters* by Christopher Wood, 2nd edition 1978. *Sir Charles Eastlake and the Victorian Art World* by David Robertson, 1978, contains valuable appendices on the decoration of the Palace of Westminster and on the Royal Academy under Eastlake's presidency. Specialized subjects are dealt with in *Victorian Taste* (a catalogue of the paintings at the Royal Holloway College) by Jeannie Chapel, 1982; *Great Victorian Pictures* by Rosemary Treble, 1978; and *The Substance or the Shadow: Images of Victorian Womanhood* by Susan P. Casteras, 1982.

1 · British painting in 1837

The most recent account of Wilkie is given in the exhibition catalogue *Tribute to Wilkie* by Lindsay Errington, Edinburgh 1985. There is a monograph on Mulready by Kathryn M. Heleniak, 1980, and the catalogue of a bicentenary exhibition in London, Dublin and Belfast by Marcia Pointon, 1986. The standard work on Etty is by Dennis Farr, 1958. The most recent work on Landseer is found in the catalogue of the exhibition in Philadelphia and London by Richard Ormond, 1981.

The definitive study of Turner's oils is the catalogue by Martin Butlin and Evelyn Joll, 2nd edition 1984. For other painters illustrated in this chapter see *The Art of John Martin* by William Feaver, 1975; *Francis Danby* by Eric Adams, 1973; *The Paintings of Samuel Palmer* by Raymond Lister, 1985; and *John Linnell*, the catalogue of a centennial Exhibition in Cambridge and New Haven Conn., by Katharine Crouan, 1982.

2 · Rebellion and official patronage

John Imray's recollections of 'The Clique' were published in the *Art Journal* 1898, p. 202. An account of the scheme for the new Houses of Parliament is given by T. S. R. Boase in the *Journal of the Warburg and Courtauld Institutes* Vol. XVII, 1954, pp. 319–58.

There is a monograph on William Dyce by Marcia Pointon, 1979. For Richard

Dadd see the exhibition catalogue by Patricia Allderidge, 1974, and for John Phillip that by Charles Carter, Aberdeen 1967. For W. P. Frith see the exhibition catalogue by Jonathan Mayne, Harrogate and London 1951, and for Horsley, O'Neill, F. D. Hardy and A. E. Mulready see *The Cranbrook Colony*, exhibition catalogue by Andrew Greg, Wolverhampton and Newcastle upon Tyne 1977.

3 · The Pre-Raphaelites

The most recent survey of the movement and its vast literature is contained in the catalogue of the Tate Gallery's exhibition *The Pre-Raphaelites* 1984.

On individual artists there are, for Rossetti the catalogue raisonné by Virginia Surtees, 1971, for Millais the exhibition catalogue by Mary Bennett, London and Liverpool 1967; for Holman Hunt the exhibition catalogue by Mary Bennett, Liverpool and London 1969, and for Ford Madox Brown the exhibition catalogue by Mary Bennett, Liverpool 1964.

There are exhibition catalogues for Burne-Jones by John Christian, London 1975–76, and for Sandys by Betty O'Loony, Brighton 1974.

There is a monograph on Waterhouse by Anthony Hobson, 1980.

4 · The predominance of genre

Many other pictures of the same kind are discussed in the author's *Painters of the Victorian Scene*, 1953, and in *Every Picture Tells a Story* by John Hadfield, 1985.

There is a monograph on the Faed family by Mary McKerrow, 1981. For Arthur Boyd Houghton see the monograph by Paul Hogarth, London 1981, and for Abraham, Rebecca and Simeon Solomon see the exhibition catalogue by Jeffrey Daniels and others, London 1985.

William Egley's MSS diaries and lists are in the Art Library, Victoria and Albert Museum.

The reproductive engravings are discussed by Hilary Beck in *Victorian Engravings*, London 1973.

5 · The return to Greece and Rome

The most recent account of the painting discussed here is *Olympian Dreamers* by Christopher Wood, 1983, and, in a wider context, *The Victorians and Ancient Greece* by Richard Jenkyns, 1980. For individual artists see *Lord Leighton* by Richard and Leonie Ormond, 1975; *The Paintings of James McNeill Whistler* by A. McLaren Young, Margaret McDonald, Robin Spencer and Hamish Miles, 1980; *Alma-Tadema* by Vere Swanson, 1977, and, for G. F. Watts, *England's Michelangelo* by Wilfrid Blunt, 1975. For Albert Moore there is the exhibition catalogue by Richard Green, Newcastle upon Tyne 1972.

6 · The Victorian exotics

The impact of Africa and the East upon Western painters is surveyed in the exhibition catalogue *The Orientalists: Delacroix to Matisse* by Mary Anne Stevens, London and Washington, D.C. 1984.

For Calvert see the monograph by Raymond Lister, 1962, and for Lewis the monograph by Michael Lewis, 1978.

7 · Later landscape painting; portraiture; and still life

A corpus of portraiture is surveyed in the catalogue by Richard Ormond of the National Portrait Gallery's collection *Early Victorian Portraits*, 1973. There are monographs on W. H. Hunt by Sir John Witt, 1982, and on Albert Goodwin by Hammond Smith, 1977. For Grimshaw see the exhibition catalogue by David Bromfield, Leeds 1979, and for Lear that by Vivien Noakes, London 1985.

8 · Genre painting and the later Victorian era

There is a monograph on Tissot by Michael Wentworth, 1984. For the Scottish schools see *Scottish Painters at Home and Abroad 1700–1900* by David and Francina Irwin, 1975.

The St John's Wood Clique is discussed by Bevis Hillier in *Apollo*, June 1964. Douglas Cooper gives an account of artistic relations between England and France in the second half of the nineteenth century in his *Catalogue of the Courtauld Collection*, 1954. The effect of the social realists on Van Gogh is discussed in the exhibition catalogue *English Influences on Van Gogh* by Ronald Pickvance, Arts Council 1974. There are monographs on Sargent by Carter Ratcliff, 1983, and on Steer by Bruce Laughton, 1971, and a biography of Sickert by Denys Sutton, 1976.

Index